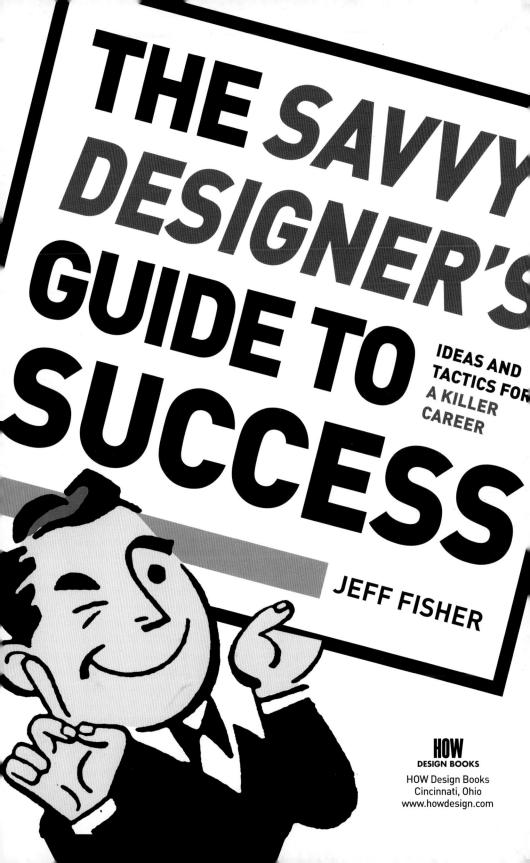

THE SAVVY DESIGNER'S GUIDE TO SUCCESS

IDEAS AND TACTICS FOR A KILLER CAREER

JEFF FISHER

HOW
DESIGN BOOKS

HOW Design Books
Cincinnati, Ohio
www.howdesign.com

ABOUT THE AUTHOR

Jeff Fisher, Engineer of Creative Identity for the one-person firm Jeff Fisher LogoMotives, has designed logos and created corporate identities for over 25 years. Clients have included one-person entrepreneurial companies, education facilities, nonprofit organizations, government agencies, professional sports teams and major international corporations. Stints as art director of a medical association, ad agency art director and creative director for a clothing manufacturer have contributed to his design expertise.

Fisher, a member of the HOW Magazine Editorial Advisory Board, also writes for the magazine. His writing has been published in *Designer* (University & College Designer Association), *Bulletin* (American Society of Media Photographers) and other publications. A regular contributor to CreativeLatitude.com, Commpiled.com, and various webzines, the designer is also an active participant on forums at HowDesign.com, About.com, Designers-Network.com and Graphics.com.

Fisher often speaks on design related topics to Chambers of Commerce, Small Business Development Center educators, professional organizations, creative conferences, college design students and high school art careers classes. He has also made multiple presentations at HOW Design Conferences. Jeff Fisher LogoMotives is located in Portland, Oregon. The firm is online at www.jfisherlogomotives.com.

09 08 07 06 05 5 4 3 2 1

Library of Congress Cataloging-in-Publication Data

Fisher, Jeff, 1956-
 The savvy designer's guide to success : ideas and tactics for a killer career / by Jeff Fisher.
 p. cm.
 Includes bibliographical references.
 ISBN 1-58180-480-6 (flexibind)
 1. Commercial art--Vocational guidance. 2. Graphic arts--Vocational guidance. I. Title.

NC1001.F564 2004
741.6'023'73--dc22

2004052378

Editor: Amy Schell
Designer: Lisa Buchanan
Production Coordinator: Kristen Heller

DEDICATION

I dedicate this book to my best friend, toughest critic and most ardent supporter, my husband Ed Cunningham, who makes each day an adventure—whether we are traveling throughout the world or simply enjoying the comfort of our home and garden. My late grandparents, Truitt & Jean Cantrall and Ronald & Vivian Fisher, assisted in laying the foundation for my professional successes—at times keeping my education, personal life and career on track—and must share in this dedication as I continue to live some of their hopes and dreams.

ACKNOWLEDGMENTS

A first book is an incredible opportunity to thank everyone who has ever played a part in one's life. Unfortunately, editorial space and a diminishing memory don't make that realistic. Apologies in advance to any individuals inadvertently left out of my personal "thank you."

Families often seem to have a love-hate relationship with the career of a "creative type." A great deal of appreciation goes to my parents and family members—especially my sister—for allowing me the freedom to often bitch and moan about my work, offering encouragement when needed, and pretending to understand when they sometimes didn't. My sister Sue, owner of her own creative firm, has always been an ardent supporter of my business, a valuable client, a sometimes editor and an important advisor.

Most children, and young adults, determined to pursue a career in art meet a tremendous amount of resistance and discouragement. Instead, I was rallied on by the likes of Stuart & Mary Compton, Gerry Frank, Myla Keller, Gary Anderson, Nancy Lindberg, Ray Dodge, Steve Sandstrom, Carol "C.B." Davis & her late husband Eldon, Marge & Keith Ridings, Glo Raineri and others who greatly influenced my early career—and were always supportive—whether they realize that fact or not.

Educators have played a tremendous role in forming my personal and professional life. Thanks to my favorite elementary school teacher Tom Tyler; and high school instructors Ken Collins, Robert Voigt and Donna Hamer; for seeing so much more in my abilities than I was able to find within myself at the time. When I was extremely discouraged, University of Oregon advertising professor Roy Paul presented the combination of design and journalism as an exciting education option, for which I am forever grateful.

Client and vendor relationships, some lasting 15 years or more, have developed into precious friendships while having a major impact on my design career. Special thanks to Don Horn, Ron Pitt, Deborah Betron, Kimberly Waters, Lisa Horne, Sara Perrin, Annette Kuhn, Brenda Jacobs, Denny Shleifer, Marcia Danab and Nora McLaughlin. Vendors who have always gone above and beyond the call of duty for me include Tom Switzer, Lee Sitter, Julie Beaver, Tim Trachtenberg, Lowell Stuck and Larry Hill.

Many others have played incredibly important roles in the success of my business over the years. Kathy Middleton, a friend for over 35 years, deserves accolades for just putting up with me for that long. Jerril Nilson, Rick Ohlson, Greg Rutten, Tracy Hayes, Brad Hall, Mike Smith,

Marc Hoffman, Susan Schweitzer, Dorothy Lendaris Kemp, Myra Donnelley, Mary Simon, Anne Kilkenny & Jon Naviaux, John & Diane Martz, Barbara & Al Hahn, Sharon & Walt Nixon, and Shawn Jones & Greg Coyle have all seen me at my best and worst—always remaining friends, advisors and part of an incredible support system. Fellow designer and former neighbor Neomi Vembu was a trusted sounding board and coffee buddy during the process of this book. Chuck Palahniuk has unselfishly shown me how a "real" writer deals with it all.

Thank you to the many writers and editors who have helped me live up to the "media whore" moniker bestowed on me years ago. Special thanks to David E. Carter, Ilise Benun, Connie Sidles, Julie Sims and The Creative Group gang, Linda Formichelli, Jeff Zbar, Maya Kishida, Bettina Ulrich, Clare Warmke, Bryn Mooth, Lisa Buchanan, Pat Matson Knapp, Megan Lane, Doug White, Nancy Michaels and Debbi J. Karpowicz.

Authors Ilise Benun and Connie Sidles should be blamed for this book eventually becoming a reality. For several years, Ilise said, "You should write a book of your own." Connie gave me one final shove towards HOW Design Books. Clare Warmke was amazingly supportive of a first-time author, working with me for months to craft a proposal for this volume, before abandoning me to experience the joys of motherhood. She left me in the more than capable hands of Amy Schell, who humored, babysat, scolded, directed and encouraged me adeptly to a final manuscript. I was thrilled to have the design of this project taken on by the incredibly talented Lisa Buchanan. Many thanks to the entire staff at HOW Design Books and *HOW* Magazine for supporting my work over the years.

I greatly appreciate the time, energy and effort of the many designers, educators, writers and others who contributed to this book. A special thank you to my "cyber friends" on the HOWdesign.com forum and the About.com Graphic Design forum. I hope you all share my pride in introducing this book as a resource for the design community.

And, of course, my undying gratitude to Ed.

"The secret of true genius is to carry the spirit of the child into old age, which means never losing your enthusiasm."

Aldous Huxley

"Dream as if you'll live forever. Live as if you'll die today."

James Dean

"Every child is an artist. The problem is how to remain an artist when you grow up."

Pablo Picasso

TABLE OF CONTENTS

FOREWORD

Jeff Fisher has been writing in bits and pieces about his experiences in the design industry for about as long as he's been a designer—in chat rooms and online forums, in articles for industry publications (such as *HOW* Magazine), not to mention via his self-promotional efforts. But now, finally, all of that wisdom—and much more—is compiled in one place and you're holding it in your hands.

What you'll find in Fisher's *The Savvy Designer's Guide to Success* is all the stuff they don't teach you in art school, real nuts 'n' bolts issues, from what to wear to what to charge—things you don't think about until they come to your mind in the form of a question or a crisis situation you have to resolve.

This book is replete with success stories as well as horror stories, all written with humor and perspective, and with Fisher's irreverent voice coming through loud and clear.

And, of course, Fisher is famous for his shameless self-promotion (of which I approve wholeheartedly), and in this book he reveals all his secrets, secure in the knowledge that giving it away makes it come back threefold—at least.

It's not just Fisher's pearls of wisdom, war stories and hard-won lessons you'll get here. The book is like a roundtable discussion with both well-known and little-known designers from around the world—more than a hundred of them—and it ranges organically from one topic to another, addressing essential (but not much talked about) issues and questions designers face every day, whether they're self-employed or working for someone else.

But what I love most about the book is the emphasis Fisher places on the human side of the design business. He talks about the importance of communication between designer and client, designer and vendor, designer and colleague. He stresses the value of listening to your gut, of not ignoring red flags that pop up when you know a project isn't for you, even though you want a certain client's name on your resumé.

So if you're just starting out, this book will save you a lot of time and heartache. But even if you've been at it a while, Fisher's refreshing perspective can teach even the most cynical "designosaur" (as Fisher calls them) a thing or two about improving business practices and growing the design career you've always wanted.

Ilise Benun
www.artofselfpromotion.com

INTRODUCTION

When I moved to Portland, Oregon in 1980 to begin my design career, I thought I was pretty hot stuff. During my years in school my artwork brought me the pats on the head and the strokes I needed to continue with my artistic endeavors. My drawings and prints were sold in art galleries around my home state. I had several one-man shows by the time I was 20 years old. However, pounding the pavement in a new city looking for work, I soon discovered that in the eyes of most potential employers, I was just one of many inexperienced designers descending upon the city in an annual migration.

I also learned just how little school had prepared me for design work in the "real" world. A freelance client or potential employer might ask me if I had experience in a specific area and I would give them the impression I knew exactly what was expected, whether I did or not. Once back in my home studio I would call a friend—who had been production manager when I worked on the daily college newspaper—and she would walk me through all I needed to know over the phone. In many situations she kept me from looking like a complete idiot.

That's when I decided to become a sponge and soak up as much information as possible from others in the professions of advertising and design.

Instead of asking if firms had available jobs, I basically begged people to talk with me about their jobs and career history.

John Kobasic, the principal of a Portland ad agency at the time, was one of the individuals who said he could give me 20 minutes of his time to discuss the industry. He shared a great deal of advice that I still remember very clearly today. After talking with him for over an hour, I thanked him profusely, and told him I hoped I could somehow repay his kindness in taking the time to meet with me. He smiled and said, "You can show your appreciation by always taking the time to share what you have learned about the business with others interested in the profession."

Since then I have tried to always be helpful to those coming up behind me in the design industry. At times I've actually been scorned and ridiculed by other designers for doing so, as if I were giving away trade secrets that should be learned only in the school of hard knocks.

Over the last 25 years I have had many successes. I've also fallen on my ass numerous times. I like to think I've learned a great deal from both ends of that continuum. With success has come the ability to maintain a degree of humility while using marketing and promotion tools. When I've made

stupid mistakes I've admitted to them, gotten back up, brushed myself off and shared what I learned in the process with others. Hopefully, I have saved some designers from experiencing the same professional difficulties, client nightmares and embarrassments. Hopefully I can help you in the same way with this book.

You may find this book more of a "how-not-to" than a "how-to" reference. I hope it is useful in each way. Many designers—and others from every level of experience—have been willing to share their successes, screwups and advice in this volume. At times they are brutally honest. On occasion the input is hilarious. Some have provided information or advice a designer may not wish to hear. More than a few—including myself—may come across as completely irreverent. But, as I've always told my mother, "It's better to be a smart-ass than a dumb-ass."

From dealing with contracts and pricing your work...to furthering your education and promoting yourself...to avoiding miscommunication and taking on pro bono work, I've tried to cover every topic or roadblock that may come up in the life of a designer, whether self-employed, working in a design studio or agency, or as part of an in-house corporate team.

I have an aversion to the clichés often associated with this profession and used in dealing with the clients or employers on which we depend. I'm not one to be put into a small, square container often constructed from cardboard; therefore I'm not going to be thinking outside of any type of man-made geometric form. I hate putting the *ess* sound in front of the extremely positive term *energy*, producing an overused word which has simply become workplace mumbo-jumbo. I also detest someone reading over my shoulder—which means we will not be reading from the same sheet of paper.

There—I expressed my feelings without using the actual catchphrases that drive me nuts! When putting this book together, I also tried to avoid other clichés I hate so much, so I hope the advice and information conveyed in this book comes across in a much more straightforward manner.

My hope is that with this volume of experiences and wisdom—my own, as well as those shared by design professionals from around the world—I can assist you in your efforts to keep *your* design career on the right track.

Jeff Fisher
Engineer of Creative Identity
Jeff Fisher LogoMotives

CHAPTER 1
BUILDING BLOCKS FOR A CAREER FOUNDATION

So you want to be a designer—

or think you will be able to commit to the

profession for the long haul. While some will

attempt to discourage you, many

others will share their own

experiences and give you

advice to help you avoid—

or deal with—the challenges

along the way to your own

design nirvana. Take a look

at the following pages to see

a myriad of design paths and

possibilities; how others

got started in the field

and how to determine

what *you* really

want to be

doing.

"Experience is not what happens to you. It is what you do with what happens to you."

Aldous Huxley

"I can give you a six-word formula for success: Think things through—then follow through."

Captain Edward V. Rickenbacker

"In order to do things differently, we first need to see things differently; the imaginary can be extraordinarily powerful in shaping expectations."

William Uricchio

WHAT DO YOU WANT TO BE
WHEN YOU GROW UP?

For many years, much to my chagrin, my parents had an example of my elementary school painting hanging in an ornate frame over their bed. Why? Well, of course there's a story—the story of how I knew that I wanted the life of a "creative type."

While doing the tempera still life in my fifth grade class, a friend of mine threw a paint-filled brush across the room at me. It landed in the middle of my painting with a big splash. In an early designerly turn, the messy blob became a flower and the painting was the first work of my art exhibited in a gallery. I knew from that moment that I wanted to be an artist when I grew up.

The histories of many in the design profession begin with the artistic efforts of a child. Habib Bajrami, owner of Bytehaus Studio in Mississauga, Ontario, Canada, had creative beginnings similar to my own.

"I always wanted to be an artist. As long as I can remember I amazed my family and friends with my drawing abilities. I would get in trouble in high school for constantly drawing during classes having nothing to do with art, such as math, social science, physics, chemistry... you get the picture," states Bajrami. "Later, I had mixed feelings as to what I wanted to be—an architect, illustrator or fine artist. I scrapped

The infamous "blob" painting. It was later shown in a gallery exhibition.

architecture due to the fact that I was terrible at math and illustration. Fine arts was out of the picture if I wanted to eat. So I became a designer."

The influence of an early teacher had a tremendous impact on John Sayles, of Sayles Graphic Design. He recalls: "At the risk of sounding saccharin, when I was in sixth grade my art teacher—one of the few people at the time who encouraged me to pursue art as a career—told me many times that if I believed I could, I could do anything."

"I've always known what I wanted to be. Since I was five, I knew I wanted to be a designer; I just didn't know what it was called," adds Sayles.

Valarie Martin Stuart, of Wavebrain Creative Communications, found her design interests piqued in high school

journalism courses. "In high school, I did everything for the school newspaper. I was a writer, illustrator, photographer," states Stuart.

Increasingly disenchanted with her college experience that included too many "ivory tower" professors interested more in their latest book publication than in personalized student instruction, Stuart began taking community college courses in her hometown. There she discovered layout and design classes, smaller class numbers and instructors who knew her name.

Rebecca Kilde, of Windmill Graphics, found herself becoming a designer to meet the immediate need of a customer of the business where she was employed. Her minor in art from a small midwestern college served her well in the emergency, introducing her to a new profession.

"Back in 1987 I worked at Kinko's" relates Kilde. "One night, a guy from Shanachie Records came in huffing and puffing about the musician he hired to do his catalog. It seems the musician never got around to actually doing the catalog..."

Kilde stayed up working on the project for three days, but got the job done. She did two more catalogs for the recording company before it hired its own designer.

"After that, I designed graphics for every one of my employers, but never officially." says Kilde. "When I had my second baby and wanted to stay home with the kids more, I thought I'd give graphic design a formal try."

Amy Silberberg, an in-house designer with Elvis Presley Enterprises, Inc., says, "I knew from the time I was in grade school that I wanted to be a commercial rather than fine artist. Print advertisements and commercials had always fascinated me. When I considered what I would be 'when I grew up,' I never really saw myself in front of a blank canvas with paints in hand."

No matter what your initial career path or educational options, if you have the desire to succeed and learn along the way, no obstacle will be too big for you to overcome.

"YOU'LL NEVER BE ABLE TO MAKE A LIVING AS A GRAPHIC DESIGNER"

Those words of wisdom were repeatedly aimed in my direction when, as a high school senior, I announced to the world that graphic design would be my chosen profession.

It seemed like everyone, from educators to family, quickly discouraged me from taking off in that direction. The "starving artist" stereotype immediately loomed in their minds and a difficult road ahead was forecasted. Still, as I researched the design efforts of Milton Glaser, Paul Rand, Saul Bass, Herb Lubalin and others at the local public library, I had no doubt I would one day be a designer.

Genevieve Gorder of *Trading Spaces* television fame, is in reality an accomplished graphic designer, having attended the School of Visual Arts, worked as a designer at MTV, served on staff at Duffy Design in New York City and operated her own firm, double-g. She is probably best known in the design world as the person responsible for the creation of the Tanqueray 10 bottle and her line of illustrated greeting cards that are sold at the retailer Barney's. Still, as she related at the 2003 HOW Design Conference, even with all these accomplishments, her parents still jokingly ask, "Do you need to take your crayons and paste to work today?"

The choice of an art education or design career may not be be taken seriously, or welcomed, by those expecting their children to have a "real" job. A defining moment, when my family finally recognized my career as legitimate, was when I was hired to design the new identity for the state government agency from which my father had retired after 34 years of employment.

I also got a great deal of personal satisfaction from being invited to speak at my high school a few years ago. Over 25 years after I graduated, the school had established an Art Careers program to encourage various art disciplines as viable options for students planning additional art education and careers in the field. The instructor of the class told me that my talk was especially important to one exceptionally talented student who was being repeatedly discouraged by his family from pursuing a career in design.

Don't be deterred by the input from naysayers in your quest to achieve the goal of being a designer. Thousands and thousands of creative individuals have been successful in becoming designers over the years. If you don't find support and encouragement from family and friends, seek out possible mentors in the form of teachers, vendors or individuals you may use as resources, those in the design and advertising fields, and others with a positive attitude regarding your goals and ambitions. With a well-defined plan for your career, each step forward will be a building block rather than a stumbling block.

THINKING OUTSIDE THE CUBICLE

Experience—as a designer in an advertising agency, design firm, in-house department or other structured environment—can be invaluable as a designer plans a career path. Some designers work best when given a task to be executed under the supervision of a creative director, art director or project manager. Many in the profession require daily interaction with others in the day-to-day workings of their chosen career. Being part of a design team is an important aspect of the outcome of

projects. And finally, beginning designers learn exponentially in their first real jobs out of school, dealing with budgets and deadlines.

In my first "real" job as a designer, I was the graphic designer for the advertising department of a college newspaper. With daily deadlines, I learned a great deal about the workings of the design profession outside the protective walls of academia.

I moved to Portland in the fall of 1980, when the economy was in an upheaval. The week I arrived in town, several design firms and ad agencies closed their doors. Many others were laying off large numbers of staff. There were no jobs to be had at the time and I had bills to pay, so I became an independent designer by default.

Luckily, many people in various firms were willing to talk with me, review my portfolio and send an occasional project my way. I also realized that there was no shame in taking part-time employment to make ends meet while attempting to establish a career. At various times I had jobs in picture framing, modeling, antique and arts sales, and selling menswear. All led to a variety of design projects from my employers or customers.

A designer just getting out of school—or even moving to a new city—needs to be flexible when considering the job opportunities available in a given market at a given time. In-house departments, print houses, publications, government agencies, large corporations, nonprofits, major retailers, educational institutions and other employers all offer possible alternatives to the ad agency or design firm job of one's dreams. Designers may not get their dream job right out of the starting gate; however, a well-planned career path may eventually get you to that job of your dreams with an incredibly valuable resumé of experience and abilities.

ROADBLOCKS AND
SPEED BUMPS

There are bound to be some stumbling blocks along the way as you create your professional persona and fine-tune the direction you hope to take in a career. Often you will have doubts. Many times you will wonder if you have made the correct choice if it sends you off in an unexpected direction. Creative individuals are notorious for creating real—and imagined—limitations on their own abilities and potential successes in the design profession. We're often our own worst enemies.

Valarie Martin Stuart feels she created a major career roadblock for herself by not completing a degree program when she was younger.

Stuart remembers: "Without a degree, I started in the basement of the graphic design career ladder: as a file clerk with a publishing company. In my early years, I slowly worked my way up—proofreader for a yellow pages company, paste-up artist for a quick printer, film strip-

per for a magazine's in-house printing department. I finally landed a production artist position late in the second year of my career for an in-house advertising department of a national women's retailer. After over three years with that company, proving myself over and over again, I was eventually promoted to lead designer over one of the retailer's divisions. It took hard work (and, I suppose, some natural talent) to overcome the roadblocks I'd built for myself by not having a degree."

At times the forces we go up against are beyond our control. None of us can predict the course the economy may take in any given year, although it is somewhat cyclical. Personal health and family crises can get in the way of forward movement in our careers. None of us can be prepared for a natural disaster or an event such as the one that took place on September 11, 2001.

"Luckily, I never had external roadblocks from my parents or employers; everyone was always very encouraging of my efforts to become a designer and learn more about the web and printing," admits Amy Stewart. "Perhaps the biggest challenges were not from people but from external factors such as the hideous economy of the past years."

Self-doubt often keeps designers—or those considering a career in the field—from moving forward with projects or career plans. "Larger projects intimidate me. The whole aspect of *starting* the project is the biggest hurdle for me," admits Von Glitschka of Glitschka Studios. "Once I do start the project, the anxiety about it fades, but the pre-project jitters are a constant for me. I guess an equivalent would be the butterflies someone gets before a public performance."

"I rarely look at a project I finish and really like it. There is always something I think I should have done differently," says the Oregon-based designer and illustrator. "By the time I am done I am usually sick of it and very critical of the work. I guess that is what helps drive me though, too."

Everyone in the design industry faces difficulties and challenges in the course of a career. A designer can't look at such problems as dead-end streets. Instead, they are simply temporary roadblocks or speed bumps that may slow one down for a while. Success in the design field requires passion, dedication and determination.

RAH! RAH! RAH!

While your usual cheering section of family, friends and peers may be adequate at rooting you on to success, a professional career coach may be the solution when you are stuck in a rut or find yourself tackling particularly difficult business problems. A coach is yet another possible team member for your business support system—one that has a

unique advantage over other team members. This advantage is the distance and outside vantage point that are so important in providing any businessperson an unbiased and valuable perspective.

How should a designer go about selecting a business coach? Ann Strong, a business coach whose experience includes working as a designer, has some suggestions.

"The easiest way to determine if someone is right for your needs involves experiencing the coach. Read an article, take a class, have a conversation. Many coaches offer a free sample session."

"If you sense this person has something valuable, maybe even life-changing, to offer you," Strong says, "you may have found your coach." She adds; "You know you have the right coach for you when you instinctively feel you have a good 'fit.' If not, know that continuing to look until you have found the right coach for you will be well worth the wait."

If hiring a business coach is not for you, personally or financially, form your own "rooting section" in your local community. Seek out other small business owners and schedule regular networking sessions to discuss the trials and tribulations of running a business. In the process you may establish a need to share services and products with those in your gathering.

ADVISE, ENCOURAGE AND MENTOR

I am reminded often of John Kobasic's advice about always sharing what I have learned with others. My participation in online forums offers a

QUESTIONS TO ASK A POTENTIAL COACH

First, Ann Strong suggests that you ask the coach about his or her approach, style and purpose.

How do they fit with yours? Do you work best with agendas, schedules, goals and accountability? Or, do you prefer looking at the process and the big picture without specific goals?

Would you like your coach to serve as a 'good parent' or do you desire a business partner? Would you prefer someone who serves as part cheerleader, part minister and part guide?

Do you want to work with someone whose purpose involves greater business success, more life/work balance or better self-love and self-care?

Next, Strong suggests you ask yourself about your experience while gathering information about this particular type of business advisor.

As you listened to the coach answer your questions, did you feel more or less personally connected? Did you clearly understand or feel a bit confused?

When you read an article a particular coach had written, did you feel excited? When you heard her speak, did you feel drawn to learn more? When you talked with him, did you feel open and curious?

chance to share my experiences and learn from those of others. I get numerous e-mails each week asking for career advice. Writing articles for webzines, trade journals and industry magazines also has been a great method of sharing my knowledge and experience with others.

At times, one piece of advice given by an individual whose path you cross will stick with you for years. For me, it was the first time a professor explained the important K.I.S.S. design principle. Ever since then I have tried to follow his advice to "Keep It Simple, Stupid." An educator—or employer—often has a great deal of impact on the future designer.

"On the first day of a class, my professor, a codgy old public relations pro named Mr. Ross, wrote three huge letters on the blackboard: 'CYA,'" says Valarie Martin Stuart. "He then proceeded to tell us that those three letters were the basis of this class, and should be remembered every day as we go forward into our professional lives."

"Little did I know how important his advice was. 'Cover Your Ass' has been standard procedure in my business," says Stuart. "15 years after taking Mr. Ross's PR class, I am now an instructor at a community college, and pass Mr. Ross's 'letters of wisdom' on to my own students, in the form of the big ol' 'CYA' scrawled across the blackboard."

Other designers have had similar motivators throughout the years. It's important to align yourself with such individuals as you begin your career; it's the first step in establishing a valuable support system and sounding board for issues that may arise.

"I cannot remember the precise words that my mentor, Angela Langston, gave to me during the late 1980s, but I do remember that she instilled in me the knowledge that we were a vital and essential part of the organization," Keely Edwards of Carter BloodCare says. "She truly valued the contribution of the in-house designer in the work process. Meeting Angela during the early stages of my career allowed me to grow and flourish at a very important time."

Karen Heil, of spOt creative, found a valued advisor during the course of an internship. "Susan Walther, at the National Museum of American History, taught me about the importance of making allies with printers, clients and other creatives; the value of the industry of design; to not beat myself up over making mistakes; and to 'let it go.'" says Heil. "Striving for perfection is an easy thing to get caught up in."

Neil Tortorella of Tortorella Design considers Russ Moore, consumer marketing manager of the *Miami News*, a mentor extraordinaire. "Russ provided me with business and marketing know-how and the advice: 'Neil, when it stops being fun, it's time to get out,'" says Tortorella. "Another mentor is Bob Davis, a brilliant illustrator and senior art director at the

first ad agency I worked at in Ohio. Bob taught me the finer points of color, balance, typography and the like. I owe them both a great deal."

"Early on, a design teacher was instrumental in helping me make a transition from fine arts to design and seeing the relationship (and difference) between the two disciplines. He showed me that it was possible to have a wet and dry studio, and to pursue both art and design without selling my soul," adds Wendy Constantine of W.C. Design Studio.

It's encouraging to have so many designers relate stories of great mentorship. The book *It's Not How Good You Are, It's How Good You Want to Be* by Paul Arden, the former executive creative director of advertising firm Saatchi & Saatchi, should be on the desk of every designer. It's a guide to making the best of oneself. In a chapter entitled "Do Not Covet Your Ideas," Arden recommends that you "give away everything you know, and more will come back to you." He explains, "The problem with hoarding is you end up living off your reserves. Eventually you'll become stale."

IF I'D KNOWN THEN WHAT THEY TELL ME NOW...

Recently my parents gave me one of the best gifts I have ever received. It was a large plastic storage box containing my entire life, from birth to recent years. My first "award-winning" piece of art, the hospital bracelet worn when I was born, a plaster handprint of a five-year-old, grade school art projects, 12 years of report cards, notes to my parents left on the kitchen table over the years, newspaper clippings about art accomplishments and many other pieces of memorabilia all were included, and neatly organized. As I unfolded a pencil drawing of our home, done when I was in fifth or sixth grade, my father said, "When I first saw that drawing, I knew you were really going to be an artist."

Boy, I wish my parents had shared that with me earlier in my life. I wonder if it would have made a difference in my early education and career choices?

On the other hand, maybe the lack of encouragement I experienced from some people early in my career is what gave me the drive to get my career on track and succeed.

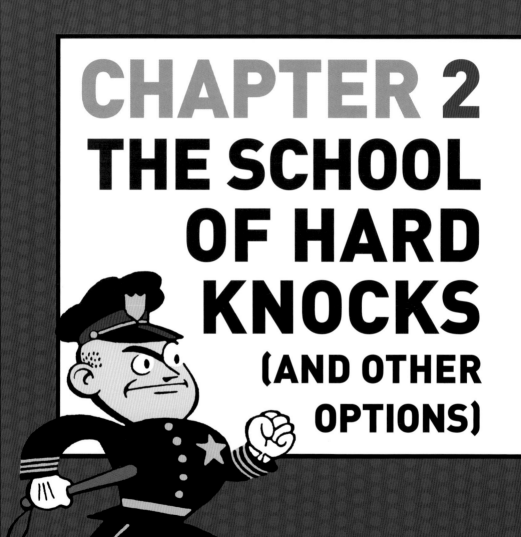

CHAPTER 2
THE SCHOOL OF HARD KNOCKS
(AND OTHER OPTIONS)

An individual can't simply make the decision to become a designer and move forward without some form of educational experience. Through the recollections of others in the field, a variety of education options are presented here. Anecdotes from design professionals will help prepare designers for the reality of the design business outside of academia. You may learn some of what they don't teach you in design school.

"Be more concerned with your character than with your reputation. Your character is what you really are while your reputation is merely what others think you are."

Dale Carnegie

"I have never let my schooling interfere with my education."

Mark Twain

"Imagination is more important than knowledge. Knowledge is limited. Imagination encircles the world."

Albert Einstein

CHARTING A DESIGN
EDUCATION PATH

If you talk with ten different designers, you will most likely find that they took a similar number of paths to get where they are today. Throughout our education and training we often come in contact with instructors who have a great deal of influence over our futures—directly or indirectly.

My own design education was formed through courses at a liberal arts college. Initially I found myself in the fine arts program, with my sights set on a bachelor of fine arts degree, taking courses from an instructor I totally detested. "Constructive criticism" was not in the lexicon of this individual. Design projects were ripped to shreds in nearly violent verbal outbursts. For this professor, a successful project critique usually involved a student ending up in tears. Not only was I never going to make a living as a designer; with my temper barely in check, I probably was not going to be able to get a design education in this environment.

Out of frustration, I considered quitting school completely until it was recommended that I speak to Roy Paul Nelson in the university's journalism school. The following year he became my primary instructor. To this day I consider him the major influence on my design career. I had to totally refocus my education from the rather limited career direction of the fine arts program. While keeping up

my art history, architecture history and interior design courses, I also was required to take journalistic writing, copywriting, marketing, advertising, public relations, typography, advertising design and publication design. The result was a well-rounded education in design as a "business." It made me much more attractive as a job candidate once I left school.

Milton Glaser often tells a story, also related in his book *Art is Work*, about being good in high school science. So good in fact, that his instructor in that subject suggested a future in the field. At the end of that particular school year, Glaser learned he had been accepted into the High School of Music and Art and informed his science teacher of the news.

"One week later he asked me to stay after class," recalls Glaser. "This was usually a bad sign. He took a small package out of his desk drawer and asked me to open it. I unwrapped it nervously and saw that it contained a box of beautiful French conté crayons. 'Do good work,' he said."

"It took me many years to understand that his real gift wasn't the crayons but the blessing he gave me to pursue my own passion and path in life in spite of his own interests." Glaser continues, "Without really knowing it I made an internal resolution to be worthy of his faith in me. Because he believed in me, I believed in myself."

Seldom do I encourage future designers to take a specific plan of

attack in achieving their design education. Finances, locale, current employment, family situations and so many other aspects of each person's life are serious considerations. However, I always encourage those asking me for advice to go for the most education they can possibly obtain.

In my own case, a liberal arts education—with courses in architecture, art history, furniture design, philosophy, marketing, writing, museology, world religions, sociology, interior design, fine arts and other subjects—provided me with a vast archive of information I find myself using in my daily design work. No particular educational path is right or wrong in the design industry. Individuals must take a good look at the options available and decide what will be best for eventually showcasing their specific talents and skills.

WHERE DOES A DESIGNER
"WANNABE" BEGIN?

There are a wide variety of options for any student who wants to proceed with a career in graphic design. Technical schools, community colleges, art-specific educational facilities, large city-based "commuter colleges" and fine arts programs in major universities are all viable design education options. Those desiring a design education can also take advantage of online learning options and focused training programs. Continuing education is available through many of the options listed, in addition to confer-

ences, workshops and seminars conducted by specialists, schools, industry organizations and design publications. Self-education plays an increasing role in the education of "creative types" as technology continues to advance faster than those in the design field can learn of the changes.

The one thing not often mentioned when discussing design education is the need or ability to convey your natural talent and skills, as well as showing prospective employers the piece of paper that says you have an education. A design education—whether it is from a community college program, an associate degree or a BFA—does not mean you have the talent or skills a design firm or advertising agency is seeking. It just means you have successfully completed the required coursework of a particular institution.

Beware of programs with limited scopes. Some focus mostly on how to use the necessary software and, perhaps, how to prepare a portfolio for potential interviews. There may not be much emphasis on the historical perspective of art or design—something of great importance to any designer.

Also, some programs fail to stress the importance of design as an element in a successful marketing or advertising campaign. The emphasis often seems to be on how a design looks, rather than on the issue of why (or if) it will serve the needs of a particular client's marketing and advertising efforts. The bottom line for a

client is that a design must meet the goals of the business or organization, and it must provoke the appropriate response. Business and marketing principles must be part of a designer's education so the designer will understand the client's needs.

"My advice to beginning design students is this: Throw away your computer," says Larry Asher, co-director of the School of Visual Concepts in Seattle. "Put it on a nice high shelf for at least the first year of your training, because you'll need to get it down later. Computers make it possible for you to finesse every detail of a layout, and–unfortunately–that's what many students do when they should be concentrating on the *idea* instead."

"We're not opposed to computer skills. You have to have them to succeed in the design business. We're just saying: Beware," adds Asher. "Learn to think. Learn to draw. Learn to express your ideas with your hands. Then, later, execute on a computer. Some people think that if they learn (Adobe) Illustrator and Photoshop, they're ready to design. To us, that's like saying, just because you know how to run a Skil Saw, you're ready to be an architect."

A designer's portfolio is the essential element when it comes to finding a job or that perfect client. Design students need to plan for that eventuality when charting their education path.

"It's all about your book. Period," says Asher. "Getting the great jobs is all about your portfolio. If the work you show a prospective employer is brilliant, you get the job. If the work you show is mediocre, you don't get the job. Likewise, the only thing truly worth considering [when choosing a school] are the portfolios of a school's recent graduates. If they're fabulous, then you've found your school."

Ask any gathering of two or more designers for their recommendation of the "best" design school and the result may be squabbling, seriously heated discussions or nearly violent histrionics. Today's students are lucky to have more options than ever on their education menu. It is vital to find the right "fit" for you when selecting an incubator where your thoughts, talents and dreams can thrive as you move toward the realization of your professional goals.

TECHNICAL/VOCATIONAL SCHOOLS

Technical schools often are referred to as "trade schools": institutions where individuals attend technical courses that train them for a specific job or career. In the past, many such schools offered alternatives to high school for students more interested in employment opportunities than in continuing their education at the college level.

However, technical and vocational schools are much more sophisticated today.

Anita Parks, graphic design teacher at Metro Technology Centers and

author of *Graphic Arts: Electronic Prepress and Publishing*, sees many advantages of such programs for students interested in design careers. Tuition often is significantly lower than that of higher-education options, and most students can complete their training within a year or two. The curriculum often involves a great deal of hands-on training and is taught through project-based learning; students receive much more practical experience since instruction is based on competency rather than on theory.

"The school you choose depends on your ultimate career goal. If you aspire to become an art director or work for a large corporate entity, you will need a baccalaureate degree. If your goal is to be employed in a shorter period of time, a technical school would be a good choice," says Parks. "I would definitely encourage high school students to take advantage of the opportunities available through their local technology center. This gives these students a head start in the field whether they choose to go on to college or enter the job market upon high school graduation."

"Obviously, a student will have less time in a career and technology program than in a four-year degree program. Students will not receive as in-depth training in the areas of art history, color and design theory and portfolio development," Parks adds.

"Several students with degrees in fine arts or journalism have enrolled in the (graphic design) program to gain additional training in the most current design software applications to increase employability. In addition to the full-time graphic design program, short-term classes are also available for individuals who wish to upgrade their skills," explains Parks.

NONACCREDITED ART SCHOOLS

Whether a school is accredited or not often has little relevance to the quality of education it provides. For some people it is an issue, for others it is not. Researching the educational facility and its successes often can help potential students determine if such a school is for them. The School of Visual Concepts in Seattle is one such example: an institution constantly offering excellent education options and sending talented and prepared designers out into the world.

According to Larry Asher, co-director of the school, "There are three things the School of Visual Concepts offers that are hard to find—in combination—at other design schools. First, all classes are taught by working professionals. Not wannabes. Not used-to-bes. But top people from some of the best studios in the area. Second, we teach mostly at night, so students can pursue jobs and internships during the day and still get a quality education. Finally, SVC is a relative bargain compared to most design schools. We also attract a fair number

of students contemplating career changes because of our evening teaching schedule."

So whether a school is accredited or not, do research on the type and level of classes being offered to see if they will fit your educational and lifestyle needs.

COMMUNITY COLLEGES

For many future designers, a local community college is a viable education option. Convenient locations, lower tuition costs, flexible class schedule offerings, smaller class size and greater individual attention from instructors are some of the advantages of such programs.

John D. Aikman is an instructor and chair of the graphic arts department at Linn-Benton Community College in Albany, Oregon. Aikman says, "The decision about where to study is an important one. Colleges and their programs have personalities and priorities just like individuals do. Some are interested in helping students and are supportive and motivated to work as a team to achieve a common goal. Others may be significantly less interested in student success. It has been my experience, after teaching at three universities and one community college, that one can find great—and not so great—instructors in every setting."

As a student of design, it is important to do your research. Aikman suggests learning as much as much as possible about a potential school: its department, faculty and students. He says that prospective students should personally visit facilities they are considering, looking carefully and critically at the work being produced under the direction of the faculty.

ARE YOU A DESIGNER AT HEART?

Design instructor John Aikman poses the following questions to any aspiring designer. Can you answer yes to them? If so, a career in design may be an appropriate choice.

1. Do you have a naturally curious nature?
2. Do you consider yourself to be creative? Can you usually see more than one way to solve almost any problem?
3. Do you respond positively to a challenge? (How about when given direction and/or criticism of your work?)
4. Do you see projects through to completion? Do you derive satisfaction from doing so?
5. Can you work well under pressure and with others?
6. Do you embrace new technologies, techniques and methods?
7. Have you spoken to more than one working designer about his or her profession?

Conversations with faculty and students—undergraduates as well as graduates—are a must. Make your choice an informed one and the experience will be positive.

Aikman feels a two-year degree from a good community college design program should adequately prepare an individual for an entry-level graphic design position. "I counsel my students to attain their degrees, secure employment and work for a couple of years," he adds. "During this time, work very hard, learn, gain experience and make contacts within the industry. This is the time to explore, work with art directors, other designers, printers and clients. This will help the individual determine what facet of design is most appealing."

DESIGN-SPECIFIC COLLEGES

The names are impressive, the reputations are often flawless and the degree from an immediately recognizable school often is the key that opens the doors of many employers. Although not every potential designer is able to take advantage of a prestigious program, some are.

Steven Heller, educator and writer, is also co-chair of the MFA/design program at the School of Visual Arts in New York. Heller says, "A solid undergrad education is a must. These days, the technology is important—the tools of the trade have become more complex and must be mastered—but more decidedly a student must learn

to think. Thinking leads to creating, creating leads to questioning, and questioning leads to better thinking."

Heller feels too many design students learn technique without the requisite intellectual rigors. He suggests finding a school that offers excellent labs and conceptual challenges. He also adds to the advice of John Aikman: "Then *work* at as many internships and entry jobs as possible (without appearing to be too restless) to acquire as much experience as possible. If after a few years one feels the need for more education, then graduate school is a viable option."

Heller describes the School of Visual Arts undergraduate program as a holistic art and design school that prepares students to work in the design world. Its teachers are highly respected professionals. Although many instructors have been at the school for many years, there is no full-time tenured faculty. Heller states: "A school comprised of working professionals will, in my opinion, provide more hands-on expertise to students than a more academic environment. It will also offer more networking potential. But academic institutions have many virtues as well—including immersion in the theory and practice nexus. The bottom line is a student benefits from strong teachers and passionate students. Whatever school one goes to, the two must be aligned because often one learns as much from one's peers as from the teacher."

The graduate program that Heller co-chairs at SVA is a full two-year program with what he describes as a distinct philosophical leaning. "This is not just design for design's sake or art for art's sake, but products and ideas that can be sold in the broader marketplace. So we encourage students to advance as many viable (and some not so viable) ideas as possible and design them accordingly," says Heller.

"This is an immersion in a community. The student body is an organism that supports itself as it works closely with faculty," he adds. "Our facility is designed like a design firm (students have their own stations and 24-hour access). So our aim is that this program becomes their base and launch pad for two years."

According to Heller, "Design education is best when it invests in the student a sense of desire: to do great work, to become expert in the techniques of the trade, and to truly have passion for the process. If a teacher or school cannot excite or inspire, figure it out for yourself."

COMMUTER COLLEGES

For those designers-to-be in larger metropolitan areas, "commuter college" educational facilities may be the best option. Such schools offer those who are already working full or part time, juggling parenting responsibilities or leading lives on an unusual schedule the opportunity to study within design or art programs that fit their own needs. Evening classes or weekend seminars offer options to those advancing their careers, switching professional goals or returning to school later in life.

LIBERAL ARTS COLLEGES AND UNIVERSITIES

A student graduating from a liberal arts institution often comes away with an incredibly well-rounded bank of knowledge and an expanded outlook on the world. Not only are the graphic design schools of such colleges and universities excellent; some great designers have such backgrounds.

Peg Faimon is an associate professor of graphic design at Miami University, and is also author of the book *Design Alliance* and coauthor of *The Nature of Design.* She advocates a liberal arts education for designers.

"When the study of graphic design is combined with the liberal arts, personal growth and design maturity are greatly enhanced," says Faimon. "An introduction to history, the humanities and sciences provides a greater pool of resources, resulting in a richer, more meaningful visual language, and a greater understanding of the diverse clientele the designer will encounter in the field."

"Liberal arts institutions are uniquely positioned to offer an education rich in the diversity of experience required to developed a strong portfolio of skills for today's profession—everything from writing and speaking skills, to under-

standing the basics of cognition and perception, to knowledge of business and marketing strategies, to the fundamentals of programming."

"As an educator, I have an obligation to my students to reflect the changing world and my evolving discipline through a curriculum that is flexible and always striving for improvement," Faimon adds. "As design becomes increasingly complex, it also interacts on various levels with a growing number of disciplines. Most professionals first discover the importance of integration, connection and context in the workplace, because many educational settings simply don't provide an interdisciplinary curriculum where students of different majors work together to solve multidimensional problems."

Design students seeking a viable education option and a base of well-rounded knowledge should not overlook the possibility of liberal arts schools.

ONLINE DESIGN SCHOOLS

Online educational programs are somewhat new to the industry. Although there are many others, Sessions.edu is probably the best-known online design resource. Founded in 1997, it was the first accredited online school of design and new media. The unique program offers courses and certificate programs in graphic design, web design, digital design, multimedia, and new media marketing.

As with any other education option, those considering registering with an online program should do their research prior to signing on the dotted line if they are not familiar with a school. See what you can learn about the school and its course offerings from sources other than the school's own web presence. Post questions on Internet forums to see if others have had positive or negative experiences with any educational facility. When contacting the school, ask for the names and contact information of recent program graduates so you can ask them about their personal experiences.

TRAINING PROGRAMS AND SEMINARS

Industry-specific training programs and seminars can be an important element in a designer's self-education. Such education vehicles are often sponsored by software companies, hardware manufacturers or private companies.

Lynda Weinman, president of lynda.com, Inc., graduated from college in 1978. Starting a design and motion-graphics career in film and video, she witnessed the introduction of personal computers to the industry. Weinman says: "I had to teach myself everything from the ground up. There were no books or instruction videos, just horrific manuals that were as unfriendly as it gets. Being able to teach myself anyway, and being there

at the beginning, a lot of people in my industry started coming to me to learn how to use computers for graphic and motion design. Teaching came naturally to me, and I discovered that I had a deep love for sharing information and was told by many that I had a gift for making the complex more clear."

In 1997, Weinman founded lynda.com with her husband Bruce Heavin, who is an illustrator. She feels she understands designers and non-technical people because of her career roots.

Lynda.com is a web site and publishing company that specializes in training for creative professionals. The company offers training materials in computer graphics and related issues for the following programs, among many more: Adobe Photoshop, Adobe Illustrator, Adobe After Effects, Adobe Acrobat, Adobe InDesign, Adobe Acrobat Elements, Macromedia Director, Macromedia Flash, Macromedia Dreamweaver, Macromedia FreeHand, Macromedia Fireworks, and Apple QuickTime, with many more titles in the works. They also publish books and CD-ROMs, and have an online movie training library that's available 24/7.

"We pride ourselves on our friendly, approachable and nuts-and-bolts training that speaks to people who hate reading manuals and love creating things," says Weinman.

There are many other training programs out there, ranging from one-

The identity for lynda.com, designed by Bruce Heavin, has become synonymous with the ongoing education of designers through books, video, CD-ROM, seminars and online resources.

day seminars to weekend immersion training. These are perfect for keeping up-to-date on new software or brushing up on some other business skill.

INDUSTRY CONFERENCES

Industry conferences are an important part of continuing education for many design professionals. In addition to teaching various aspects of the graphics business, such activities and events get designers away from their computers and out into the "real" world, allowing them to network with other creatives.

With its annual HOW Design Conference and Mind Your Own Business conferences, *HOW* Magazine is one of the industry leaders in providing graphics professionals with continu-

ing education and networking possibilities on a large scale.

Bryn Mooth, editor of the magazine, notes: "For designers, I think the real value in continuing education doesn't come from classes on using Photoshop so much as from being with and learning from other designers. It comes from learning how other creatives have built their businesses or solved their clients' problems or stretched their creative muscles. People get as much out of elevator conversations with fellow attendees at the HOW Design Conference as they do from listening to speakers. Design is, in the end, a solitary practice; any time you can commune with other people who do what you do, you learn.

"You get out of a learning situation what you put into it, regardless of your level of experience," according to Mooth. She feels that education is pretty much what *HOW* and its programs are all about. "We show lots of cool design work, sure, but we also explain the whys and hows behind creative approaches, business issues

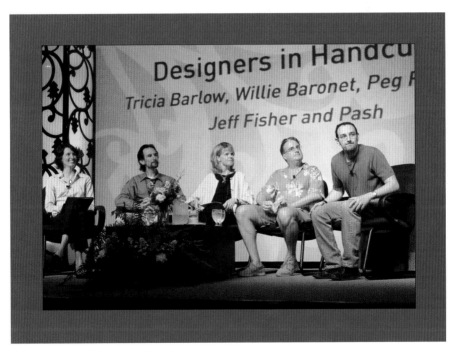

The popular Designers in Handcuffs session at the 2003 HOW Design conference gave over six hundred attendees the opportunity to interact with moderator and HOW Magazine Art Director Tricia Bateman and a panel of designers: Willie Baronet of GroupBaronet, Peg Faimon from Miami University, Jeff Fisher LogoMotive's namesake, and Pash of Digital Soup. Photo: Karen Larson, Larson Mirek Design.

and design solutions. Again, I think the best way for a designer to learn (once they've entered the profession, that is) is to watch other successful creatives—not to copy their work but to learn from their successes."

That's what industry and conferences are best for: getting out of the office and into a new environment, networking with other designers, and adding some new skills to your set at the same time.

LOCAL ORGANIZATION WORKSHOPS AND SEMINARS

Professional organizations such the AIGA (American Institute of Graphic Arts), Graphic Artists Guild, International Association of Business Communicators, University & College Designers Association, chambers of commerce, and many others offer great opportunities for continued learning—along with the chance to network with peers, potential mentors and possible clients—through seminars, workshops and conferences.

Tadson Bussey, executive director and spokesperson for the University & College Designers Association, says, "With budgets tightening and staff being laid off, the role of professional organizations will play a larger part in the continuing education of graphic designers than it does now. A group that members can look to, ask questions of, and

PAPER GOLD

Industry publications from around the world are excellent sources of information and inspiration for any designer, at any stage of a career. The following is a partial list of some the most recognized design-specific magazines available.

Applied Arts (Canada)
www.appliedartsmag.com

Before & After (US)
www.bamagazine.com

Communication Arts (US)
www.commarts.com

Computer Arts (UK)
www.computerarts.co.uk

CMYK (US)
www.cmykmag.com

Creative Review (UK)
www.creativereview.co.uk

Design Graphics (Australia)
www.designgraphics.com.au

Graphic Exchange (Canada)
www.graphicexchange.com

HOW (US)
www.howdesign.com

novum (Germany)
www.novumnet.de

Print (US)
www.printmag.com

STEP Inside Design (US)
www.stepinsidedesign.com

learn from is what a professional organization is all about."

Hands-on workshops may be presented regionally each year and continuing education opportunities are usually regular program features of local AIGA chapters. In the UCDA, rejuvenation and creativity workshops are offered to organization members each year.

As well as providing networking opportunities and a support system for designers, professional organizations offer valuable experiences for continuing education.

SELF-EDUCATION OPTIONS

There are tremendous opportunities for all designers to self-educate (no, I didn't say "self-medicate").

Books are one of my major addictions. If I ever need to enlarge my home, it will be due to the fact that I don't have enough room for my books. There are literally thousands of graphic design books on the market and I have only several hundred at this point. I love to paw my way through the shelves at bookstores like Powell's in Portland and Peter Miller Books—a store selling only art, design and architecture books—in Seattle.

In an industry that changes—in technology and possibilities—on a daily basis, every designer must invest a great deal of time and energy to simply try to keep up with what's happening in the profession.

Graphic-design books and related sites on the Internet make incredible resources available to any individual considering the field for a future profession or current industry professionals looking to jump start their personal learning process.

Designer and writer Chuck Green uses books and the Internet to promote the continuing education of graphic designers and others. His web sites, ideabook.com and Designer's Jumpola, are just two examples of valuable resources available to designers at the click of a mouse. Both offer numerous tutorials, sage advice, examples of design projects and links to additional resources.

John McWade, publisher and creative director of *Before & After* magazine, says design publications, graphics books and industry web sites "all provide design knowledge of one kind or another, with varying levels of competence and usefulness. With a paying readership of over 30,000, McWade feels that the success of his publication as a design tool depends on the ambition of the reader.

"Some readers tell me that *Before & After* has been their entire design education. Others tell me they don't get much out of it. I'm a big believer that you get out of education pretty much what you put into it," says McWade. "People also learn in different ways. Some learn by doing, some by reading, some by watching, some by listening. They process information

differently. *Before & After* is one kind of channel."

With the wide variety of options for anyone considering a design career, or a designer seeking to refresh his or her education, it is important to do a great deal of research prior to making a final decision. In any situation, don't be afraid to contact the school and ask for names of professional designers who have gone through the program of interest and might be willing to share their own insights into the school. Education-related web sites and online forums are a great source of information, literally at your fingertips.

ADVICE FROM THE
SCHOOL OF HARD KNOCKS

Few education programs fully prepare a designer for a professional existence outside their protective boundaries. Advice and anecdotes from those having experienced the reality of the big, bad business world are valuable resources in charting one's own path. Throughout this book designers, educators and others with an association with the graphic design industry share what they have learned along the way. Designers who have "been there" can offer their own short educational career courses to anyone willing to pay attention.

Designer Rebecca Kilde's primary suggestion for successful design efforts is to "shut up, listen to the client and talk directly to the decision-makers." She also recommends that all designers understand their personal limitations. "If a job is beyond your abilities, tell the client that the project isn't a good fit and recommend another designer. I've had people I've sent to other designers come back to me at a later date with a different job."

Maintaining a sense of humor helps all designers no matter what their career path. I know of no one who displays that better than Brunei-based Catherine Morley of Katz <i> Design Group.

"The one major piece of advice I'd give designers is to get a life, a real life," says Morley. "It's easy to fall into working long hours to the detriment of your health and personal life. Draw a realistic line and stick to it. Take time out to see friends and family, work on hobbies, visit museums or travel. Take on anything that doesn't include sitting in front of that box. Shut down the machine, close the door, and force yourself to walk away. And don't worry; it's not wasted time because knowledge of the world around us is brought back into our creations."

"Don't try to freelance full time until you've got at least a few years under your belt at an agency or studio," recommends Valarie Martin Stuart. "There's too much that beginning designers don't know—and they don't

know that they don't know. Most importantly, think before you design. Go through the who, what, where, when, why and how before every project. You'll discover that most of your clients haven't even gone this far and it will add to your 'trust fund' for future projects."

GOING OUT INTO THE
REAL WORLD

"Find your own voice—by experimenting, by allowing the time to experiment, and by taking risks," advises Jennifer Morla of Morla Design, Inc. "Being in school is a luxury. School allows you the structured time to research, analyze, synthesize, ideate, strategize and create. That is what being a designer is all about."

Enjoy your schooling. Bask in the luxury of not being on a time clock. Savor the interaction with other students and the faculty, the freedom to create and the ability to try anything you desire. You are not setting out on one rigid, set-in-stone path. It's just the beginning of finding out what you want to be when you grow up. Besides, the real world will kick you in the rear end as you walk out those school doors for the last time—and your design education will finally begin.

CHAPTER 3
GETTING MORE THAN YOUR FOOT IN THE DOOR

Everyone always talks about "getting your foot in the door" to gain access to a potential client or employer for the advancement of your career. Getting a foot in the door is usually easy. The challenge is to get your entire body, portfolio and history of professional expertise beyond the portal in question. Industry professionals who have kicked down that door—and those interviewing and hiring from the other side of the desk— share their experiences and advice about resumés, portfolios, interviews and nabbing that coveted design job or project.

"Finding the right work is like discovering your own soul in the world."

Thomas Moore

"Go 'above and beyond' everything that is expected of you. Come early for your appointment. Come prepared, really prepared. Send a prompt and well-written follow-up."

John Sayles, Sayles Graphic Design

"Skill and talent alone will perhaps get you an interview or an appointment. Ability to be a good listener, and be a team player, is a requirement to work any design engagement these days. Check your ego at the door."

Clement Mok,
The Office of Clement Mok

IS THIS THE PARTY TO WHOM I AM SPEAKING?

One of the biggest obstacles in introducing yourself to any potential employer or client is the "bulldog" guarding the gate—the receptionist. In many situations the responsibility of the front-desk person is to prevent sales people, cold callers and those seeking possible employment from getting within the inner sanctum of the office. It is always helpful to know the name of the creative director, art director, director of marketing or the individual responsible for hiring design staff or purchasing creative services.

Some designers find developing a relationship with the receptionist to be a key element leading to further discovery of the hidden truths and secret handshake of a firm. Designer and developer Jeremy Wright, of studio:coco, suggests, "Be friendly. I've found I can get discounts, get past receptionists and get meetings with key decision-makers just by having a good sense of humor and the ability to make someone laugh. It works at coffee shops, in interviews, and at fish-and-chip shops the world over. A little laughter can get you in the door."

Perpetua Interactive's Ben Woodward says, "I speak to whomever answers the phone like a person, asking (and repeating) his or her name, and generally trying to get a feel for my chances with the call. Many receptionists enjoy a little break in their workload if you don't treat it like a chore and read word-for-word off a script. It doesn't always work, but when it does, they really have you in their heads and they remember when they hear from you again."

Les Woods of the firm progressive edge concurs: "I have found that good rapport with the receptionist reflects well when they in turn talk to the client. They can also push some work from their colleagues or friends your way. I have had instances where I have not gotten anywhere with a potential client I have targeted, only to get a call from someone who happens to be a relative/friend/colleague of the aforementioned receptionist!"

On occasion, you may be able to glean the name from the person on the other end of the phone line with a call to verify the business mailing address and the name of the person to whom your personal request should be directed. An introductory letter or resumé forwarded from the previous address of a firm shows you have not done your homework in researching the company.

Successful research about a firm, its history, its stable of clients and areas of expertise will go a long way toward getting you face-to-face with the right person. You can use local business publications, the newspaper archives at the library, business license records and directories like *Contacts Influential* to get the names of specific individuals with whom you

COLD-CALL SCRIPT SUGGESTIONS

The following basic cold-call advice is from designer Neil Tortorella of Tortorella Design. It is wise to actually write down a script to assist you when making such calls.

After being put in contact with the individual responsible for purchasing creative services, you first want to ask if it's a good time to talk. You want to let them know you respect their time. Something along the lines of:

"Hi, this is Erin, with XYZ Design. Are you the person with whom I should speak regarding the development of your marketing materials, and is this a good time to talk with you?"

The primary objective of your initial cold call is selling the appointment. Get an appointment on the calendar and get off the phone. Try not to get hung up selling all your services. You'll do that during the presentation. You will want to prequalify the potential client by asking:

"What type of materials does ABC Company produce? Do you regularly work with graphic designers?"

(If not, you may want to let some other poor soul train them.)

If they are interested, they may take over the questioning at this point. However, you will want to ask if they have a proposed project in the works on which you can prepare an estimate and submit a proposal. If so, ask for the project timeline and for budget limitations if established.

"Do you have any projects that are currently in the works—or upcoming projects—that I can give you an estimate on? I'd welcome the chance to work with your company. I'll just need to know the approximate timeline and budget limitations."

After that, set up the appointment to meet in person. Propose a meeting time and place, along with an alternate time to give the potential client the ability to make a choice and feel that they are in control of the process.

"Can we meet on Tuesday at 10:00 at your office, or would Thursday at 3:00 be better for you?"

Repeat the time and date to the individual for confirmation. Then confirm the location.

"I just need to confirm that your office is still at 123 Designerly Way. Is that the correct location?"

Be sure to bring your conversation to a close by showing your appreciation for the person taking the time to talk with you.

"Thank you very much for your time. I look forward to seeing you on (the day that has been scheduled) and learning more about your business."

Keep track of all your calls and the results. Over time you'll be able to find how many calls you need to make to get an appointment. Cold calling will then be easier because you know each call brings you closer to an actual appointment. Don't get discouraged.

Remember, this is a numbers game. As with any marketing or promotion effort, it may take numerous contacts before you see positive results.

would like to meet. Professional organization directories are also a great source of the same information.

Tracey Turner, executive director of The Creative Group agrees: "Research the company you are interviewing with prior to the interview. Nothing leaves a bad impression faster than not knowing who you are dealing with and what they do."

The Internet provides a whole new set of options for researching those with whom you would like to work or do business. A simple search of an individual or firm's name in a search engine like Google.com often presents a vast amount of information at your disposal—or links to additional sources of background material. Industry publication web sites, URLs like creativepro.com and the web pages of business organizations can also be great sources. Do be leery of putting too much faith in such sources, as they may be quickly outdated by people changing jobs, getting laid off or even passing away.

In one of my past jobs I was receiving resumés mailed to a previous art director over a year after I had been in the position. Again, a quick phone call to the company, or an e-mail to the "info" address, will confirm the details you may need to make a good first impression contacting the business in question. Doing an Internet search using the mailing address or phone number used in a blind employment ad will occasional-ly result in links to material about a firm attempting to be secretive about its identity. Such research will provide valuable information for setting the tone of the cover letter or marketing/promotional material that you plan to send to the company contact. You will also come across as knowledgeable and truly interested in the firm when you are able to meet with someone at a later date.

DON'T ASK, "ARE YOU CURRENTLY HIRING DESIGNERS?"

Many designers make their first inter-action with a potential client or employer a question with a high prob-ability of the immediate, blunt answer of "No!" End of conversation. Let the emotional games of rejection begin.

After moving to a new city and beginning my search for design employment, I quickly learned that any time I approached someone and asked if they had a job opening, I gave them the immediate opportunity to shut me down by saying "no" or slamming the door in my face. I changed my tactics to contacting peo-ple, letting them know I was interest-ed in the graphic design field and asking them if I could schedule an informational interview to discuss the local market, or their business, or how they succeeded in the field.

The doors were immediately opened to me. Principals in advertis-

ing agencies and design firms—people with international reputations—were willing to sit down and talk to me for 30 to 45 minutes—or more—about graphic design as a career. Creative directors and art directors actually enjoyed the chance to discuss the projects on which they were working. The discussion usually ended with me saying I would be very interested in learning of job opportunities (either full-time or on a project basis) with their firm.

The informational interview is a tool not often used to its greatest advantage by many seeking admittance to a design firm or ad agency as a potential staff member or independent designer. By not directly asking for a job from the individual with whom you are meeting, an opportunity for a nonconfrontational interaction is created. The person being interviewed is not put in the uncomfortable position of telling you outright that a job is not available, or of having to pass judgment on your work.

When contacting people for such an interview, I never specifically requested a portfolio review but would always bring my book along. Most of the time curiosity would get the best of the person I was meeting and he or she would ask to take a look. It was amazing how many of these people would later call me to let me know of freelance jobs or openings they had heard about—and told

me to use them as a reference to introduce myself to a possible client or employer.

Over 20 years later, one of the ad agency principals I imposed upon for an informational interview will still drop me a note when he reads of one of my accomplishments in the local media. That is how you establish great relationships within the industry. In any career field, whether it seems fair or not, it's often all about relationships and who you know.

SNEAKING IN THE FRONT DOOR, MAILBOX OR COMPUTER

Introducing yourself to a firm through a variety of creative methods prior to actually making a personal appearance can be a great way improve your chances of getting through the front door, past the bulldogs and into a meeting with the person with whom you really want to speak.

Years ago I decided I wanted to work for a specific apparel company to gain valuable experience in an industry I knew little about. I began to read a lot about the firm in the local newspaper and business publications. I did some research at the local library (this was pre-Internet) and found out a great deal about the business.

The apparel company did much of its business in the Asian market, so I decided to use an Americanized symbol of that culture to introduce myself

INFORMATIONAL INTERVIEW QUESTIONS

Here designer Morgan Mann shares an informational interview survey she created to make the process easier for herself and others. Begin your informational interview by briefly summarizing your background and explaining why you are interested in the particular field.

About the Individual

What attracted you to this industry, your company and your job?

What do you enjoy most about this industry, the company and your job?

What aspects of your career have you found most and least rewarding and why?

What are your educational and career backgrounds? What would you do differently if you were starting over?

What do you see as possible next steps for you? What career expectations do you have in the short and long term?

What are you most excited or concerned about for this industry/company/career path in the future?

About the Job

What are your primary responsibilities? How do you spend your time?

How do you value/measure your results and effectiveness?

What do you do in a typical day or week? How much time are you in meetings, on the phone, on the road, and working in teams versus working independently?

About Skills

What skills are most critical to your success?

What weaknesses in a person's skill set would make him ineffective in this business?

How do you keep skills current? What do you read? To which professional associations do you belong? What seminars or continuing education programs do you consider useful?

About the Company

What are the common misconceptions about working in this company?

What do you see as the biggest competitive challenge for your company?

What are some of the defining characteristics of the designers who have been hired by your company in the past for this position?

About the Industry

What are the common misconceptions about working in this field?

What motivates you to continue in this business? What do you like most?

What are the vulnerabilities of this business? What worries you?

What do you expect of people starting out in this field? What educational and personal qualities in candidates attract you? How do you determine a candidate's compatibility for the field, including education, personality and cultural considerations?

About Yourself

What kind of job responsibilities I would expect as a designer?

What strengths and weaknesses do you see in my current background?

Is there anything else you think would be helpful as I consider this field?

Looking at my resumé and portfolio, what advice would you have for me on next steps if I were interested in this industry/company/ career?

as a potential employee. I bought a few large Chinese food take-out containers from a restaurant. At an Asian grocery I bought a couple bags of fortune cookies; then I pulled the fortunes out of them with tweezers. (Of course, I broke many in the process and had to eat my mistakes.)

I then wrote up several different "fortunes" promoting myself: "There is a Jeff Fisher in your future," "Jeff Fisher has designs on your business," and "You would be 'fortunate' to have Jeff Fisher on your team." I typed these on my IBM Selectric (remember, this is pre-computer), cut them out and carefully slipped them into the cookies. These were loaded into a take-out carton, with Easter egg grass for filler, and delivered to the front desk of the company. The only contact info I left with the package was my name and phone number on a hangtag tied to the container with a red ribbon. I heard nothing.

The following week I sent the owners of the firm my resumé, with a cover letter saying I hoped they had enjoyed the cookies. I heard nothing.

The next week I delivered another box of fortune cookies, with revised fortunes including my phone number. A couple hours after the delivery I received a phone call from one of the owners. After asking me to "please stop delivering cookies" to their office, he asked that I meet with him and his partner—even though they did not have a job available.

My research of the business paid off when I met with the owners. They were surprised I knew so much about their operations—including some things they didn't even realize were public information. I entered their office knowing an actual employment opportunity did not exist. I left with a job coordinating their creative department.

In my own situation, I had just pushed the limits of being annoying to the owners of the business—but had not pushed too far. In the end, a clever introduction along with a great deal of research paid off.

Clever, professional and simple promotions catch my eye every time. I suppose this is a result of having been the art director of an ad agency in the early 1980s. All the promotional materials that came into the office ended up on my desk. To be honest, most ended up in the circular file. There were always a few that got my attention and made me want to know more about an individual creative type, or to see some of their work. Usually those pieces ended up hanging somewhere in my office as a constant reminder of the designer or photographer. When just the right job came around, I knew whom to call. When the individual in question made a follow-up call, I knew immediately who it was and what type of work had been produced.

Two such promos immediately got my attention recently. Gary Dickson's corporate identity for his firm, Epi-

Using graphic images not usually associated with design, Epidemic Design literally "dares" you to call.

Tim Frame Design's simple, colorful and visually stimulating e-mail promo is very successful in getting the recipient's attention—even with just a little text.

demic Design, uses simple "warning" graphics and the colors yellow, green and black to attract the attention of potential clients.

The creations are well-designed, professional representations of what could come across as disturbing images if presented differently. The limited text is literally a call to action for the reader—in one case an actual dare. Dickson's postcards pass what I refer to as the "refrigerator test." Both could be saved and potentially used as art pieces on my fridge (which some have called the "Metropolitan Refrigerator of Art").

In the other case, Tim Frame walked a fine line between spam and a successful e-mail promotion with his identity design promo and came out a winner. The subject line of his e-mail read, "Shameless Self-Promotion." Now, who wouldn't open such a message?

When opened, a beautiful JPEG image appeared, featuring thirty logo and symbol samples. Basically, the only text on the piece was Frame's web address and additional contact information. Simple, impressive and to the point—all without a lengthy text message.

In both of these situations, the promo efforts would work as a great introduction to a potential client. In most cases a possible customer would hopefully remember the designer when he or she called to follow up, and the chance of getting more than just a foot in the door increases. Don't introduce yourself to a potential client or employer in the manner used by every designer. Set yourself apart from the others in a memorable display of your creativity and talents.

WHO DO YOU
REALLY KNOW?

Personal recommendations or referrals are a great way to get at least a couple of steps into a possible client or employment environment. However, the use of this method of introduction should not be taken lightly—and misuse seems to be fairly common.

Petrula Vrontikis, author of *Inspiration=Ideas* and principal of the Vrontikis Design Office, considers a personal recommendation from a well-known industry professional a "ten" on the one-to-ten scale.

A truly valuable recommendation should come from someone with whom the employment candidate has previously worked, in a position where "real world" skills and knowledge have been put to the test, examined and evaluated. Unfortunately, some people pad their resumés with the names of people from whom they have not actually requested recommendations. Some even list names of individuals with whom they have had no personal contact—with hopes that the information will never be confirmed.

Vrontikis feels that individuals must ask for permission to use the name of any industry professional in furthering

their career. She adds, "The experience of asking (for permission) is very fruitful in learning appropriate channels and clarifications, and avoids creating professional awkwardness."

Jack Anderson, principal in the identity firm Hornall Anderson, also feels that a third-party endorsement of a design position candidate can be a very valuable asset to getting more than one's foot in the door of a prospective employer. This is especially true when the handwritten recommendation comes from an industry icon such as Ivan Chermayeff, of Chermayeff & Geismar—as it did with one individual who came to Anderson's company. Such an endorsement gives a designer a great deal of credibility.

I have clients with whom I have worked 15 to 20 years. They are incredible resources for the occasional reference I may need for a potential client. As a courtesy, I still always contact my clients and ask if I can use their names as references. Doing so also helps you maintain ongoing relationships with long-term clients and reminds them you are available for work.

THE CHANCE OF A LIFETIME

"You only get one chance to make a first impression. So, make it a memorable one," says Peleg Top of Top Design. And that's where a lot of designers split into different camps over how that impression should be made.

Top recommends that, "if you are sending out a resumé, make it the best piece of paper you have ever designed. Besides noting your technical capabilities and your award list, a potential art director will look at the aesthetics you bring to the table first. Since your resumé is the first thing they see, make it speak about your design work."

He also recommends that designers have a well-designed identity system for themselves. "Invest the money in making it look good. Remember; create the work you want to get. You want to stand out and be remembered. You want a potential client or employer to say 'wow' when they see your stuff."

Others will suggest that your resumé be the most basic of documents: well-designed, simple, to the point and easy to read. You don't want your resumé to tell a potential employer *everything* about yourself— or there's no reason to meet in person for an interview. Keep the resumé pertinent to the job you are seeking. A creative director isn't going to be interested in the fact that you worked at Burger King while in high school. I would suggest not over-designing a resumé. Let your portfolio demonstrate most of your design abilities.

When searching for a job, don't mass-mail your resumé and cover letter to every design firm in a geographic region. Focus on selecting a few firms you wish to contact, then begin

to cultivate relationships with those companies using a variety of methods to introduce yourself to the decision-makers within each business. For every job advertised, a company will receive literally hundreds of resumés. Invest some time in reaching potential employers or clients with creative marketing pieces that will stand out from the volume of mail received.

"Contact a few studios/clients that you'd really like to work for and create a very special mailing just for them," echoes Stefan Sagmeister of Sagmeister, Inc.

JUDGING A BOOK BY
ITS COVER

Sheree Clark, of Sayles Graphic Design, offers some no-nonsense advice for those seeking employment and hoping to get a bit more than just their foot in the door: "Have some talent. I'm not being a smart-ass here. If you're still in school, get some projects in your book—preferably 'live' ones. And please, know some stuff about production; don't show me a great design that is impossible to actually produce."

I have to agree with Clark; a student portfolio is often just that: a student portfolio. If an art director has seen one student portfolio, he has seen them all—especially if a design school or college in the area has just sent a new crop of designers out into the world. Often, every student has been assigned the same class project

and after a while they all look exactly alike. Take it upon yourself to set your work apart from other designers. If it means creating your own project as a portfolio piece, do so, highlighting your best skills.

Kathy Middleton of Opolis Design, formerly head of operations for creative services at Adidas and senior project manager/operations manager for Sandstrom Design, has seen more than her share of portfolio presentations. "Unfortunately, many designers do not present themselves in a professional manner," she says. "It is important that the portfolio have only their strongest work; it should be presented in a creative and unique way."

A professional-looking presentation will help you to be remembered. Elvis Presley Enterprises, Inc. designer Amy Silberberg reminisces, "I had only been working for about a year and a half and had moved to Houston for more career opportunities. When I interviewed with a prestigious local designer, I had the same portfolio case that I had from college; you know, the huge, cumbersome, black vinyl one.

"While she didn't have any positions available, she did give me the best piece of advice I ever got. She told me to get the smallest portfolio I could find and still fit my work in, even make smaller reproductions of the originals so they would fit.

"I took her advice," says Silberberg. "And she was right—all my interviews after that completely

changed in tone and I was received much more seriously than I had been before."

If you are new to a particular market, approach a local nonprofit organization in whose cause you strongly believe. Offer your services to obtain some real-world experience in creating a unique piece for your portfolio. If you are applying for a job with an ad agency, create a print ad campaign selling yourself to the firm. Producing a storyboard about your skill set would be great for someone applying for work with a television, video or film company. Research the design firm for which you would like to work and create a parody of one of their client projects, featuring yourself as the product. Establish a web site for yourself to show a web development company what you can do for them. A creative person must think creatively to attract the attention of potential employers or clients, in addition to developing the necessary skills and talents.

Ellen Shapiro, of Shapiro Design Associates Inc., advises: "Take the initiative. Look around for a poster or an ad or a logo that needs improvement. Dazzle them with a demonstration of how *you* would do it."

Any designer, whether seeking a first career opportunity or heading back out into the big, bad world of job searching, should take advantage of portfolio review opportunities offered by local design organizations or schools. Having a fresh set of eyes take a critical look at your book before you go into an interview situation may help you improve your presentation. Don't be afraid to ask a group of your peers to stand in as guinea pigs for a mock portfolio presentation as a tool to hone one's own performance.

A FEW HINTS FOR JOB-SEEKERS

Sheree Clark of Sayles Graphic Design offers a few suggestions for job-hunters.

- Spell my name right. And get the company name right, too. Details matter in this business!
- Dress one notch above how you think you should dress. It's a job interview, for crying out loud. I am the one doing the hiring, and I am not impressed with your butt-crack, your belly or your mismatched casual wear.
- Don't ask me how much vacation time you get until at least five minutes into the interview.
- Don't make it "all about you" when you're looking for a job. Don't forget that I am in business to make money— not train you while you acquire skills for your next position. A better approach is to tell me what you bring to the party— not what you hope to take away!

Tortellini

A satisfying pasta often stuffed with cheese.

Tortoni

An Italian dessert with cherries and almonds

Tortuga

A tropical island in the West Indies

Tortorella

An island of design excellence in Ohio

With tongue in cheek, Neil Tortorella draws attention to his often mispronounced last name with a series of promotional postcards that pass the "Metropolitan Refrigerator of Art" test.

51

Many times I have read questions posted on Internet design forums by recent design graduates regarding the value of purchasing a $400 portfolio in which to carry their student work to job interviews. In most cases, the designer probably does not have the financial resources to even consider such an item. I'm sure there are people who are impressed by the physical appearance of an expensive portfolio; however, most hope to be more impressed by the creative content within the carrying case.

TAKE A TURN AS
AN INTERN

Internships can be valuable tools for greasing the skids of a future design career. An internship that is a good fit for a specific designer can offer on-the-job training, provide introductions to possible mentors in the design community and give a student a good taste of real-world demands and expectations. The earlier an individual can get into an internship program the better. Many design students wait until they should be seriously seeking paying jobs before hitting themselves in the forehead and exclaiming, "I should have..."

Internships may take the form of programs for college credit, volunteer opportunities, work-study positions for some pay or paid positions. While I was in college (back in the olden days) I had an exhibit design intern-ship with the university art museum that was for college credit. I also had a work-study position—part of my financial aid package—as the graphic designer for the advertising department of the daily college newspaper. Both provided me with a great deal of experience and preparation for future employment. In fact, looking back, I feel that in many ways I learned more from the internships than I did from classroom work.

Karen Heil of spOt creative agrees. "My internship at the Smithsonian gave me valuable hands-on experience and prepared me for the real world," she says. "Therefore, I found the unpaid work experience to be very helpful as I built my career in design."

Many firms in a position to hire designers for full-time employment look at job candidates with a solid internship on their resumés a bit more seriously.

"If you want full-time employment, see if you can intern at a firm," adds Judy Kirpich of Grafik. "Many of our internships have converted into real jobs since (the interns) have proven themselves indispensable. It is like on-the-job training and is a real foot in the door."

Petrula Vrontikis also recommends that designers be selective in choosing where they apply for internship experience. Interning with a recognized firm will open doors when you go to find a real job.

THE VIEW FROM THE
OTHER SIDE

As the art director for a small ad agency many years ago, I found myself in the position of client—or buyer of creative services from outside vendors. It gave me an interesting perspective on how designers, and others, presented themselves for possible contract work.

Many designers would stop by the office unannounced, without an appointment, expecting me to drop everything and review their work. Then, after learning I would not be able to meet with them, they would take their frustrations out on the receptionist who was attempting to set up an appointment for my one portfolio review day that month. Like she wasn't going to make a note of their reaction and report it to me? I was amazed at how often this happened.

From her experience as a client and supervisor, Sara Perrin, director of marketing for Dark Horse Comics knows that "good companies are always on the lookout for promising talent."

Again, getting to the right person is the key. Perrin adds, "You can call the company president all you want, but they are not usually the (best) contact; the person hiring for the work is your biggest ally. Don't nag a busy person to meet with you. They'll either say yes or no. If they ask you to call back at another time... do. If they say no, believe them."

In her previous employment situation, Perrin was the director of creative services for several athletic teams, including the NBA's Portland Trail Blazers, the WNBA's Portland Fire, NFL Seattle Seahawks and the Rose Garden Arena. After dealing with many design firms, ad agencies and independent designers on a regular basis, she suggests: "When you are presenting, it is helpful to tell the story behind the work: the issue or problem, the context and the resolution (your design). Tell it quickly and clearly. When we had freelance jobs, we'd look for designers with some experience for the specific job for which we were hiring."

THE DEPENDENCE ON
INDEPENDENT DESIGN WORK

I hate the word *freelance*. To many it implies that

1. a designer does something for "free."
2. a designer doesn't have, can't get, or is between "real" jobs.
3. a designer is not serious about the *business* of graphic design.

I always tell people that I own a design firm or that I am an independent designer. That seems to make people take me a bit more seriously as a business person.

The fact is that for many years I continually experienced what many independent designers deal with on a regular basis: attempting to get

more than my foot in the door for every potential project rather than for a single, full-time position. Many of the suggestions made in this chapter have to be used daily by those out on their own.

Art Chantry, the subject of the book *Some People Can't Surf*, speaks out on this topic. "I've survived solely on freelance. That means you have to spend an inordinate amount of time seeking project work. My best advice is based on what has actually worked for me, and that is the personal interview."

"The client really doesn't hire you based on your resumé or your education. They hire you based on their personal confidence in your ability to do the project well (as *they* define 'well')," says Chantry.

Chantry continues, "The only way they will ever feel secure enough to give you their money to perform your magic is for you to convince them, in person, that you are capable of doing it. Once in the door, you have to be able to connect in a way that allows you to walk out with work."

AVOID HAVING THAT DOOR HIT YOU ON THE WAY OUT

Be honest when selling yourself and your skills. If you try to pull one over on a potential employer or freelance client it will somehow come back to bite you in the ass. The design industry may be large in numbers but it

truly is a small community. If you develop a reputation as someone who can't perform up to the level you professed, that reputation may follow you around for quite some time.

Many years ago a friend of mine, working as the creative director for a large company, interviewed an impressive young woman for a position as a staff designer. The interview was going very well until the applicant began to show her portfolio. She turned the page to a brochure she claimed to have designed, but my friend recognized the work as a piece I had created. She questioned the now-flustered young woman repeatedly about aspects of the project. The designer dug a deeper and deeper hole for herself. Finally my friend stood up and announced that the interview was over. She suggested the woman not claim to have designed the work of others if she wanted to be successful. The mortified applicant was immediately shown to the door.

Another method of bringing a quick close to what otherwise might be a long and wonderful business relationship is to bad-mouth others in the industry, whether it be another designer, a vendor, a client or another creative firm. It's simply too small a world to take such chances. In business situations I've always found it best to take my mother's advice: "If you can't say something nice, just keep your mouth shut."

Perrin agrees. "Never dirt a client during a presentation, portfolio review or job interview. You just never know what relationships the person has... that client could be their sister-in-law or their cousin."

An anecdote that circulated around the local market a few years ago is a good example. A firm was invited by a nonprofit organization to make a pitch in an effort to take the nonprofit's design and marketing efforts in a different direction. The principal of the firm presented his thoughts to the nonprofit's board of directors.

Throughout his presentation, he was hypercritical of the work done by the creative company currently under contract. In fact, he said little about his own firm's talents, efforts and past successes. Had he done a little research on his potential client, he would have learned that the president of the company providing creative services at the time was a member of the organization's board—and she was among those he was addressing at the meeting. Needless to say, his firm did not get a new client that day.

Instead of bad-mouthing the work of others in presentations, try to convey the positive aspects and strengths of your own skills and body of work.

FOLLOW UP WITH THOSE
LENDING A HAND

As a kid, I hated it when my mother sat me down at the kitchen table to write thank-you notes for birthday or holiday gifts. However, it was a great life lesson—and a way to always make brownie points in the design profession. Thank individuals for taking the time to see you, for reviewing your portfolio, for referring you to someone else, or for supplying you with some needed information.

There is also great value in simply keeping touch with those who have given you the gift of their time, wisdom and advice. "No, we are not hiring now" doesn't necessarily mean that a company might not be hiring at a later date. The individual with whom you've established contact may hear about a job elsewhere and refer you when reminded that you are looking for work. Keep such people on your mailing list for promotional pieces.

I still send many such people my press releases. Make sure you keep these individuals updated with regard to your contact information. If you see them at an industry event, reintroduce yourself. Drop a note of congratulations in the mail when you read of some accomplishment. If you need career advice, ask the person out to lunch or for a cup of coffee. So much can depend on establishing relationships within the industry.

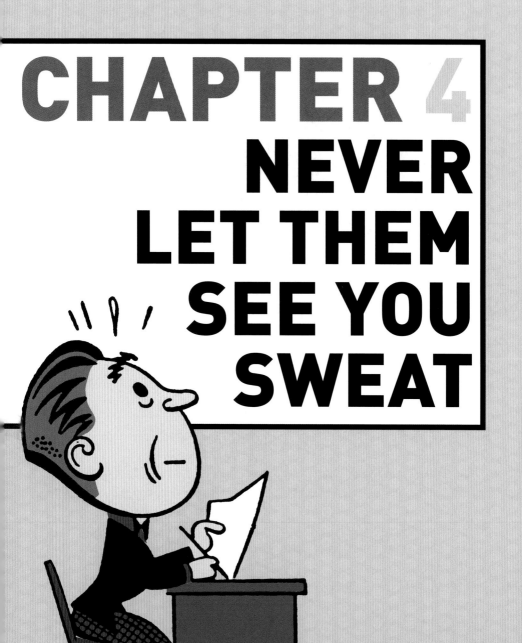

CHAPTER 4
NEVER LET THEM SEE YOU SWEAT

Designers love to talk about their careers, sharing anecdotes and advice with others in the profession. Stories of pratfalls and pitfalls from those who have been there allow us to learn great life and business lessons. The advice of industry professionals and the suggestions given to them along their own career paths may help you as well.

"Ah good taste! What a dreadful thing! Taste is the enemy of creativeness."

Pablo Picasso

"An essential aspect of creativity is not being afraid to fail."

Dr. Edwin Land

"Nothing in the world can take the place of persistence. Talent will not; nothing is more common than unsuccessful men with talent. Genius will not; unrewarded genius is almost a proverb. Education will not; the world is full of educated derelicts. Persistence and determination alone are omnipotent."

Calvin Coolidge

DON'T TELL BLATANT LIES
ABOUT YOUR WORK

On a recent *Today Show*, I saw an interview with Jesse Ventura, the former governor of Minnesota who is more famous as a professional wrestler. The interviewer was asking him about his success in his new career as a politician, a field in which he had no previous experience. Ventura stressed the need for honesty. He said his response to questions about certain issues was often, "I don't know, but I'll find out."

"I don't know, but I'll find out"—that's the key. Just be honest when not knowing what a client asks and your honesty will be appreciated. Think of all the stress—and long-distance phone charges—I could have saved myself early in my career. In my desperation to get the client or the project, I would fib to the client and then scramble to demonstrate I might know what I was talking about. Most clients are not stupid.

Designer Jeremy Wright of studio:coco admits that, in the past, he has told an employer he definitely knew how to do something when he didn't have a clue. "I got my ass kicked. Not necessarily by my boss, but certainly by the hours I had to put in to either correct my 'foot-in-mouth disease' or to learn what I'd said I already knew. Only promise what you can deliver, and then over-deliver."

Les Woods of progressive edge found himself in the situation of lying to a client about his level of expertise —once. "It almost backfired, so I make a point of knowing my limits as this way I can deliver to highest standards and not destroy my clients' faith in my abilities," says Woods. "I vowed never to take something on for the sake of it when I was not one hundred percent sure I could deliver the goods."

"Lying is way too risky!" says Neil Tortorella. "I have always told employers and clients I don't personally know how to do this or that—that it's out of my area, but I know someone who does know how to do it. My rule: Never do for yourself what someone else can do better.

"I bring in specialists and we all meet together," Tortorella continues. "My clients rely on me to pull everything together, but they are always aware of who is doing what on their project."

Honesty is the best policy. In many cases it will result in establishing a valuable level of trust with a client or employer. Self-respect and maintaining client relationships are bonuses in such situations. Admitting a lack of knowledge about a specific topic is not going to bring about the end of the world.

DOES A "WHITE LIE" HURT
NOW AND THEN?

When in doubt, you may wish to pad the time or expenses on an estimate for a project. A designer always looks better coming in under budget and

prior to a proposed deadline. I do this quite often in dealing with the turn-around times on services contracted to outside vendors on projects—especially with printing.

Designer Les Woods finds himself doing the same. "I would use a white lie, but only if I was sure it would not irreparably jeopardize a project and client relationship," says Woods. "I usually add a day or two onto print deadlines and tell the client they can have their item (say, a brochure) in five days instead of three. This way, a delay with the printer does not cause as many problems—but most of all I can deliver a day early and look really efficient!"

Ben Woodward is another designer who sees where a little fib might be appropriate at times. "If you lie and can't deliver, there's obviously a problem. But if you offer a bit of a cryptic answer at the time and let your client know you'll 'look into it,' that's good enough for me," according to Woodward. "I could care less if you lie by telling me you can create gold from silly putty and a Jell-O mold; the problem comes when The Big Day gets here and all you've got is silly putty and a Jell-O mold."

Jeremy Wright has a different reaction to telling little white lies. "Everything you do in business catches up to you. If you lie, that catches up to you. If you are full of integrity, that catches up to you. The question is, what's going to hit you when it catches you—

will it be failure or success? Praise or a lawsuit? Managing your future exposure to something catching up to you is just as—if not more—important than managing your literal exposure."

Neil Tortorella of Tortorella Design agrees when it comes to white lies: "It's just plain ol' bad business. It gets too complicated to remember what you told whom. It's just easier to be up-front and tell the truth. As I mentioned, I buy what I don't know. This is a large part of my marketing. I promote the fact that I use a pool of talent and skills from a group of good folks. My clients can get the benefits of a larger firm without having to pay for all the overhead."

Manipulating the truth a bit can be a very effective business tool. However, before doing so, weigh the results from every angle. Damage to your business reputation, or loss of a valuable client relationship, is not a desirable result.

SAVING YOUR OWN
PROVERBIAL REAR END

Part of the success in surviving a mess is due to proper handling of the crisis after acknowledging your own stupid actions.

When there is a major issue with a project or a client, you must immediately go into self-preservation mode—or perhaps career-preservation mode—to overcome the situation without

looking like a complete idiot. This does not mean throwing in the towel, going back to bed or fixing yourself a cocktail. Ignoring a major design business issue is not going to make it go away—or make a client any less annoyed with you. When the going gets tough; the tough need to give the difficult situation or problem a good "head butt."

The "dog ate my homework" excuse did not work when you were a child and it will not work any better now.

Ben Woodward recommends doing whatever is necessary if you become trapped in a situation from having stretched the truth. "From my younger days of telling fibs, I remember the best way to resolve that situation was to crack open the honesty, once you're pinned to the wall. Most folks are appreciative when you say to them, 'All right, look...I was hoping to be able to do this, but...' I've found that helps almost 99 percent of the time. As they say, if you lie to cover up a lie, you just keep digging a deeper hole."

I CANNOT
TELL A LIE

"There is always an alternative solution to lying," says Julia Dudnick-Ptasznik of Suazion. "The Internet is a great thing in terms of contacts, and the several years I've been involved in the online community resulted in an extensive network of colleagues from all creative specialties.

"I personally specialize in writing and design. While I can code a basic web page, it's generally not a good

IMMEDIATE "BUTT SAVING" RESOURCES

Immediately "fess up"—tell the client the truth and beg for mercy.

"Round up the wagons" and call in outside resources. This includes calling in favors from vendors with whom you have great relationships.

Tap the wealth of information from your bank of design-industry peers, both in reality and cyberspace.

Log onto the Internet and do a Google search for answers and advice regarding your immediate problem.

Access software company web sites for tutorials on the software issue that has stymied your progress.

Keep the client posted as to progress in resolving the situation or problem.

Run as fast as you can to the local library or bookstore to research the issue in question.

Pray for a natural disaster to delay your impending deadline.

When all else fails, stick pins in your personal voodoo doll or light candles at the altar on your desk.

use of my time," continues Dudnick-Ptasznik. "So, I align my firm with several technical people. When a client asks if Suazion can do this or that, I can answer 'yes' without lying. It is an educated guess, because usually what I do know for a fact is that I can hire good people to do it."

"Every firm should have a list of services that are often requested by clients, from those directly related to design (like photography, illustration and typography/custom fonts, etc.) as well as not-so-directly (research, proofreading, translation, programming and so on)," Dudnick-Ptasznik says. "This list should include contacts who work within these areas and their niche specializations. That way, you never have to lie and put yourself into a situation where you personally are negotiating a learning curve on top of a deadline."

A very good method of handling a client question about your service abilities is to simply tell them that you do have team members capable of providing the service they are requesting and you are not able to provide personally. As Dudnick-Ptasznik mentions, alliances for outsourcing a variety of services are easily formed if needed.

WHEN "GOING SOUTH" (FOR ANY SEASON) IS NOT A GOOD THING

When a project goes bad, it can really go bad. Designers must do every-

thing in their power to salvage or correct the problem. I have been in situations—some recently—where it seemed things were just destined to go wrong. In some cases, I have eaten time. In others, I have made adjustments to invoices. In a few instances, the project has been given to the client gratis. In most situations, the long-term client relationship is not worth losing simply to prove myself right.

"If things go south, which they will from time to time, I'll sit down with the client and simply ask what I need to do to make it right," says Neil Tortorella. "Sometimes that means adjusting an invoice or giving credit for a future invoice. I did eat a couple of printing bills early on. Learned from those right quick!"

"The trick is to be up front," he continues. "Also, proof everything—a lot! Give yourself plenty of time for unexpected stuff when setting a deadline. If you can't make the deadline, be honest. Better to lose a single project and keep a client rather than lose the client altogether and possibly your shirt in the process."

"If I screw up, I go to the client right away," Tortorella adds. "People tend to have more respect for you if you own up to an error. Conversely, if you try to hide it, or argue, you'll lose the client faster than two shakes of a lamb's tail. Plus, you can expect to get a lot of bad talk in the business community. You may win an argument

that can end up costing you a client—or worse, your business."

BACK IN MY DAY WE HAD TO WALK THREE MILES TO
SCHOOL IN THE SNOW—BAREFOOT...

Some creative types seem to have difficulty taking the advice of others who have greater experience in the field. The advice of others, especially design "elders" or "designosaurs," can go a long way in helping a newbie designer. It seems that each generation, including my own, comes out of school feeling that only they can possess all the knowledge needed for a successful design career. Those coming into the field should welcome the wise advice of those who have learned from their past successes and failures.

Learn as much as possible about the history of graphic design and typography. Designers can't be successful if they don't understand the past that has allowed them to be where they are today. Involving yourself in the historical aspects of design also gives you a greater respect for the work of others in your field—past and present.

Stimulate your creativity by pushing yourself away from your computer. Get out in the world to experience what others are actually doing, instead of sitting at a desk thinking about what you would like to be doing. Travel, garden, paint, write or do whatever you most enjoy to get your creative juices flowing and give you a fresh perspective on the project with which you are struggling.

One of my favorite snippets of brilliance is from a man I admire a great deal. At a 2003 HOW Design Conference "Master Series" presentation, Milton Glaser said, "You can't work very well for people you don't like. Unless there is genuine affection it is difficult to achieve excellence."

Jack Anderson, Hornall Anderson Design Works principal, also recommends that you consider your emotional connections with clients, staff and co-workers. "When creating a client following, (choose) people you feel good being around," he says. "It should be the same with those in your office."

"In the field of design you must present yourself authentically and realistically," Anderson continues. "A good designer has excellent social and people skills. The best designers are listeners, talkers, communicators..."

According to Anderson, designers introducing themselves to the world need to "think of themselves as a brand, presenting their abilities with an attitude and confidence of knowing and patience. It is necessary to crawl, then walk, then run, to be a real good designer," says Anderson.

"Know what you love and love what you do," is just the first bit of advice from Peleg Top of Top Design.

"Try to specialize in something that you are passionate about. Design can be a highly stressful career with many demands, so if you are passionate about the work you do, it will make the journey easier," Top continues. "Also, remember that design is, after all, commercial art. It communicates on behalf of your clients."

Veteran designer Clement Mok recommends broadening one's vision. "We are often blinded by our bias and our predisposition to things that are visually interesting: posters, CD-covers and logos," he says. "Instead of polishing and buffing one's craft in just creating objects of desire, go find problems in places (that are) visually challenged. Apply your gift and make things more understandable. Make the abstract tangible and transform thoughts into actions."

"It's in these untapped areas that designers can truly demonstrate and provide value," Mok adds. "Pursuing this course, one will be rewarded intellectually and financially. Be honest about what you do know and what you don't know. Be a student of life and not just design."

Petrula Vrontikis agrees."Designers can be a bit myopic about their world, combined with all the idiosyncrasies of their own confidence.

Young designers don't understand what is needed to back up visual solutions, expertise and a comprehension of business principles. Many can be like a car with no wheels."

"Develop a personal integrity based on what you think is right and wrong," says Art Chantry, "then hire a lawyer to figure out how to legally protect yourself from the criminal behavior of other 'business' people."

Stefan Sagmeister cautions: "Study graphic design only if you love it. If you wanna be a fine artist and study graphic design because of some vague promise of earning money, don't. It won't work. The people who love it will always do better work. And they will earn the money."

Tracey Turner, executive director of The Creative Group, suggests: "Be proficient in more than one area. Traditional print combined with at least one multimedia application will make you all the more marketable."

"Adjust your expectations," begins Sheree Clark of Sayles Graphic Design. "If you work at a firm or agency, you'll probably be involved in endless —not always interesting— meetings with clients and your own colleagues. "You'll have timesheets to fill out and a plethora of other B.S. to attend to."

"If you own your own firm," she continues, "you can look forward to fighting with the phone company, unplugging the toilet, worrying

about money, worrying about employees."

John Sayles, Clark's partner in Sayles Graphic Design, offers this counsel: "Get used to being misunderstood, especially by your own family. Hell, my parents still don't know exactly how I make my living—even when I point out a package in the store or something else I have designed."

Nigel Holmes, principal of Explanation Graphics, recommends that designers specialize. "By specializing, a potential client (or company that might hire you) will know exactly what you do," he says. "This worked for me. I specialize in a very narrow field—information graphics—but have been able to expand out of that after getting my start."

Elizebeth Murphy, Emspace Design Group, advises designers to "sell yourself as a problem solver. Clients are looking for solutions, not problems. Take yourself out of the equation and think about what the client needs. Provide solutions that answer their goals—not yours. If you can solve their problem, they'll come back—again and again!"

"This means being proactive—thinking ahead for your client," adds Murphy. "The easier you make their lives, the more you solidify the relationship. And the more profitable your business will be."

David Lemley, of the Seattle firm Lemley Design Company, puts it more simply than most with, "You will get the kind of work you do."

Such gems of advice are out there for any designer to gather. The lessons learned by those who have been in the industry for some time are worth repeating for those just coming into the field.

ADVICE GIVEN TO THOSE
NOW GIVING ADVICE

In the course of their own careers, those doling out advice about the graphic design field usually have been very open to accepting the advice of others. Few in the design world have made it to the peak of their profession without valuable assistance along the way. Many have shared advice with me and I have sprinkled some of those directives throughout this book. Others in the industry have had similar wisdom conveyed to them over the years.

Ellen Shapiro offers the advice given to her by Herb Lubalin when she began working for him in 1972: "Send the stuff out first that other people need to work on, so that they can be doing it while you're doing your part."

Grafik's Judy Kirpich shares the following: "One of my graduate professors at Harvard, Toshiro Katayama, said that 'the difference between art and design is that in art you can go ahead and do anything that you like; you have no one to please but yourself. With design you have con-

straints: budgets, clients, and problems to be solved. If you do your job well you can get design close to art.'"

From the late Tibor Kalman came the advice most valued by Stefan Sagmeister: "The toughest thing when running a design studio is not to grow."

The best advice given to Nigel Holmes early in his career was to "deal with things as soon as they come up."

Holmes also recognizes the value of access to great advice. "Walter Bernard, who hired me at *Time* magazine, always kept his office door open so that whoever needed to talk to him could interrupt almost anything that he was doing," Holmes says. "But if your question wasn't important, he'd let you know in no uncertain terms, so you didn't abuse this access to a very busy man."

Petrula Vrontikis got similar advice from prominent Los Angeles annual-report designer Doug Oliver. The advice he gave her was: "Return phone calls promptly—you'll be way ahead of 90 percent of designers."

FAVORITE QUOTES OF
THE QUOTABLE

Many quotes I've come across in my career are found at the beginning of chapters in this volume. Those contributing to this book in many ways have provided a wide variety of such pearls of wisdom.

Ellen Shapiro says "This quote is about the stand-up comedy field, but it applies to the graphic design field just as well. It was made by Jerry Seinfield when he decided to return to comedy clubs. In response to the question of why he returned, he said, 'The reason, I guess, is that I really love stand-up. It's fun and it uses everything you have as a human being.'"

Shapiro adds, "I really love graphic design. It's fun and at its best it uses everything I have as a human being."

It makes sense that the favorite quote of information-graphics specialist Nigel Holmes is from a pioneer in the field, Otto Neurath. "Remembering a simplified picture is better than forgetting the numbers" are his words.

Holmes explains, "From the twenties to the forties, Neurath perfected a simple, illustrative way of doing charts that both excited the eye and also was 'statistically accountable'—also a phrase introduced by Neurath."

Peleg Top contributes as his favored quote Jean Cocteau's phrase: "Style is a simple way of saying complicated things."

Jennifer Morla, of Morla Design appreciates the following quote from Chip Kidd's novel, *The Cheese Monkeys*: "Design must always be in service to solving a problem, or it's not design, it's art."

The favored quote of Petrula Vrontikis is: "Practice safe design—use a

concept," from a promotion by photographer Don Miller.

"Design is a good idea" was used by the font foundry Émigré on a mouse pad several years ago. It is Elizebeth Murphy's favorite saying about the art form.

"Design is a good idea—lots of them," adds Murphy. "And those ideas make our world a more joyful place."

Sara Perrin, director of marketing for Dark Horse Comics, has two quotes she enjoys sharing with others in the design business. The first, "If at first the idea is not absurd, then there is no hope for it," is from Albert Einstein. The second, from Eleanor Roosevelt, is: "The future belongs to those who believe in the beauty of their dreams."

An icon in American art, and an early leader in the field of commercial art, uttered Stefan Sagmeister's favorite saying relating to design. Norman Rockwell advised, "If your image does not work, put a dog in it. If it still does not work, put a bandage on the dog."

From Art Chantry comes a quotable statement from musician Lou Reed: "Trying to be cool almost killed me."

Clement Mok doesn't need to go far from the source to find a favorite quote about graphic design. He offers his own statement: "It's not rocket science. It's social science."

Wherever you find your inspiration, use the words daily to help yourself stay focused on what is truly important in your career.

WHY ARE WE IN THIS BUSINESS OF UNREASONABLE DEADLINES, LESS REASONABLE CLIENTS, CHALLENGES IN EARNING A LIVING, AND IMMEASURABLE DAILY STRESS?

As designers, we all seem to bitch and moan about clients, projects, vendors and other aspects of the profession on a daily basis. Why do we put ourselves through the agony, torture, sleepless nights and sometimes concern if the rent will be paid at the end of the month?

THE PITFALLS OF GRAPHIC DESIGN

We all have those moments in our design careers when we wonder if perhaps a job flipping hamburgers might be a better idea. Dealing with the battles of a project we knew we should not have taken on, working twice as hard to get paid by a client than on the actual job, the constant justification of rates and invoices, and competing with anyone with a computer calling themselves a designer can impact anyone in the industry.

For Nigel Holmes, the ultimate stumbling block for the designer is

"dealing with a middleman who intervenes between you as the creator and the actual client. This often happens in advertising, but not nearly as often in magazine work, where the art director is usually 'the client.'"

Having to be the "bad guy" presents a struggle for Sheree Clark of Sayles Graphic Design.

"Because I am the 'suit' in our operation—meaning I am the one meeting with clients—I am also the one who has to tell our creative staff when a perfectly wonderful idea has been shot down," Clark explains. "It's like I have to live the terrible experience twice: once, when the client gives me the word, and then back at the office, when I have to pass that word along to the people who created the work."

Collecting late payments from clients, responding to e-mails and "half of the day spent tied to a keyboard" are the design-business pet peeves of Petrula Vrontikis.

Clement Mok says that "trying to professionalize the design profession" is what he likes least about the business.

"Coming up with fees that potential clients will agree to and that will allow us to remain in business" is the most difficult task for Ellen Shapiro. "This was not a problem until the last couple of years, but pricing is getting increasingly difficult to deal with."

Peleg Top finds the least pleasurable aspect of graphic design to be "having to always fight for our rights as designers."

Art Chantry is frustrated by the constant need to secure more business. "It cuts dramatically into the time I would like to spend on the actual work. The constant search, alongside the demands of simply running a business (paperwork, etc.) dominates my time," according to Chantry. "It's probably around a 90-to-10 percent ratio, with the creative work being the 10 percent. I'm often astonished at the huge volume of work I've managed to produce; how did I ever find the time?"

THE JOYS OF GRAPHIC DESIGN

For me, many negative aspects of the design field are mitigated by the positives of loving what I do for a living, using my skills and talents to visually solve the problems of clients, and the rare moments of great creativity. I love those occasions when everything comes together: the idea seems brilliant, the approval process is quick and painless, the completed design piece is just as imagined and the client is thrilled and lets you know he or she is pleased. While these instances may be few and far between, they are what make a life and career as a designer ultimately worthwhile and gratifying.

Peleg Top gets that same feeling from "being able to create something that makes a difference, that pro-

The beautifully expressive illustrations of Montreal-based Elise Gravel project a sense of the joy of graphic design and being able to work successfully in one's chosen career.

motes a cause or that makes profit for someone."

Sheree Clark most enjoys getting to work with people who have a positive attitude and purpose. "Nobody comes to a graphic designer because they are terminally ill or they need an expensive engine overhaul," says Clark. "Our clients—for the most part—are companies and individuals with a story they want to tell the world. They come to us to help get their message out; they come to have us help them be more successful; they come because things are going well and they want them to go better. People look forward to meetings with me and my firm because they value our creativity and our advice."

"Making an impact and helping others understand an issue," is what Clement Mok most enjoys about the design profession. In addition, he appreciates "making the experience of the everyday and the mundane more enjoyable."

Petrula Vrontikis finds her greatest pleasure in solving problems and facing interesting challenges. She says she likes learning what makes businesses and organizations "tick" as part of the design process.

"There is nothing more thrilling for me than doing good work," adds Art Chantry. "In a way, it's the ultimate triumph."

All in all, graphic design is a great profession. As in any chosen field of endeavor occasionally there will be difficulties, challenges and times when murder may seem like a viable means of solving some problems.

Genevieve Gorder of double-g explains it in her own way when speaking about meeting the goals, demands and desires of clients.

"Fear is the biggest problem in design," says Gorder. "It's the fear of the unknown for people who don't know design. What they want, they could have done a hundred times over and they haven't," she adds. "Don't give them what they don't want, but rather what they need."

Former Saatchi and Saatchi executive creative director Paul Arden takes that message further. "A client often has a fair idea of what he wants. If you show him what you want, and not what he wants, he'll say that's not what he asked for," Arden comments. "If, however, you show him what he wants first, he is then relaxed and is prepared to look at what you want to sell him. You've allowed him to become magnanimous instead of putting him in a corner."

Arden continues, "Give him what he wants and he may well give you what you want. There is also the possibility that he may be right."

Designers need clients. The clients need designers. Designers need to remember that graphic design is a business. But who says you can't have fun along the way?

CHAPTER 5
BUT, I THOUGHT YOU SAID...

The act of designing can be a confusing form of communication. Add the more recognizable communication forms of talking and writing to the mix and things can get even more jumbled in the course of your work efforts. Hopefully, through examples from a variety of industry resources, you will be able to perfect the art of avoiding miscommunication.

"The greatest compliment that was ever paid me was when someone asked me what I thought, and attended to my answer."

Henry David Thoreau

"Never mistake legibility for communication."

David Carson

"The single biggest problem in communication is the illusion that it has taken place."

George Bernard Shaw

COMMUNICATE,
COMMUNICATE,
COMMUNICATE ...

The business of design is intertwined with the art of communication. In basic terms, graphic design is visual communication. If that is the case, why aren't more designers able to communicate effectively when dealing with those with whom they come in contact on a daily basis? Many designers are very poor writers, others aren't good on the phone, some freeze up when meeting clients of prospective employers in person, and a large number have not mastered the etiquette of e-mail as a communication tool.

"Use everything from smoke signals to e-mail and voice mail. Overcommunicate," says Steve Fleshman, of the firm DR2. "If I think I'm overcommunicating, I'm probably just right. What I think is obvious isn't always to my clients."

In these days of high-tech communication solutions, one of the most basic methods is often overlooked or neglected by designers.

Kathy Middleton is not a designer, but her current position as an account manager for Opolis Design has offered a multitude of communication opportunities with designers, vendors and clients at all levels. She puts it very simply: "Designers should have the ability to clearly communicate their ideas and how those ideas connect back to the clients' objectives. A designer also needs to be able to write well,

communicating ideas in a clear and succinct manner, since most communication today is via e-mail."

GOOD WRITING EQUALS GOOD DESIGN

Bill Cahan, of Bill Cahan & Associates, says, "Writing is very, very important. It's always been one of the most important issues to me because if a designer can't express himself through the written idea—unless the piece is a picture book—(the clients) are not going to understand the content. Writing is design."

"It's a critical communication piece that seems to be missing with most designers," Cahan continues. "A designer must be able to articulate the overall idea—in writing. If the designer can't articulate his or her own ideas it usually shows in some dysfunctional way in the design itself.

"Writing forces you to understand the issues involved at a deeper level," says Cahan. "Once you understand the issues (in depth) it's easier to be abstract in your design."

Cahan has shifted the design process from simply meeting with the client, going to the computer and then creating a "nice" design. At his firm, copywriters may end up sketching while designers often do some of their own writing. In many cases, he finds that clients provide copy and want the designers to develop the bigger idea behind the piece to be created. Often the supplied text doesn't work or jibe

with the design concept. Members of his staff are told to begin the design with the writing.

"When designers get to have authorship there is more on the line and the designer becomes vested in the piece being created," says Cahan. "The result is the words being seamlessly integrated into the finished design."

"Good writing equals good design," he adds. "However, it takes a lot of homework and research on the part of the designer."

THE WRITE STUFF

"Ever notice that nearly all forms of entertainment–from comic books to opera, from literature to sitcoms, from movies to music–are essentially stories?" asks Juliet D'Ambrosio, creative director of Iconologic Brand Design. "No wonder; a love of storytelling is hardwired into our brains. It's how our ancestors, without the benefit of their Macs, passed on vital experience and wisdom throughout the ages."

She continues, "Design, at its heart, is about telling stories. It's about creating a visual narrative that both entices the viewer and delivers a message. And stories, as designers know, don't get told just with words. In fact, that's one of the reasons graphic design works as a commercial communicative tool: it enables the viewer to 'get' a company's whole story, at a glance, through the use of image. Which is good news for today's time-crunched and overstimulated audiences. Com-munication's got to happen fast if it's going to happen at all."

"More than ever before, designers must tell their client's story. It's not enough to create visually engaging artwork, typeset a headline or two and call it a day," says D'Ambrosio. "You've got to define a message: a unique story your client can tell that helps establish their place in the minds of an audience. The hard part? Finding out what that story is in the first place."

D'Ambrosio concludes, "That's where writing comes in. By training yourself to tell a story with words, you can far more quickly and accurately hone in on the primary message your client should communicate. Which in turn will help your design deliver more than just pretty pictures."

With my own educational background in journalism, advertising design and copywriting, I am often able to see a grammatical error in a client's text that has slipped by a series of reviews by staff, editors and the powers that be. Knowing how to write has also helped me to better communicate a client's message in a design and, in many instances, allowed me to assist clients in fine-tuning the written message they really want to convey in a design. When necessary, I have been able to step in as the copywriter on a project. I've also been able to write my own marketing pieces and press releases. Being able to write well also helps me to communicate my thoughts

WRITING SUGGESTIONS FROM JULIET D'AMBROSIO

It's a strange paradox: so many designers whose work speaks so fluently in visual language flee in terror when called upon to communicate with the written word. After all, designers are nothing if not communicators, and communication is most fully realized when image and word unite.

It's time to conquer that fear. One look through any recent annual's credits will confirm that in this era of shrinking budgets, designers are more frequently called upon to serve double duty as writers—from tag lines to full-blown annual reports.

And all it takes is some practice. Here are some tried-and-true verbal brainstorming techniques designed to help you find the right words for your next project.

Begin with the words

While it may feel more natural to begin the process by sketching images, starting with the words will help you more quickly zero in on the concept—and will help inspire images in line with the language.

Find the key(s)

Creative briefs are rife with key words, which should serve as your verbal guideposts to the brainstorming process. Identify and compile a master list of those words that evoke an emotion, those that seem particularly important to the client, or those that just speak to you.

Create a Mind Map

Take every word on your list and free-associate. What other words does that one bring to mind? What images does it inspire? Where are there connections? It's also a good idea to get comfortable with a dictionary and thesaurus. Many words have nuances in meaning or unexpected synonyms that can provide fertile ground for ideas.

Get to know the territory

Pore over the annuals—they're rich with examples of excellent writing. Read and absorb the winning entries, take note of the techniques used by those you admire, and get a feel for how the format you're working in—ad, brochure, web site, whatever—sounds and feels.

Get it all out

When it's time to actually sit down and write, it's often best to just let yourself go creatively. Allow yourself to write your thoughts as they come, not stopping to second-guess or edit anything. Don't even use full sentences. It's surprising what can come from these stream-of-consciousness rambles.

Organize and edit

Sift through what your subconscious produced in the previous step and whip it into shape. For long copy, focus on one main point or theme; every sentence you write should support it. Work with an outline, if it helps. For short copy like headlines, select your top five and refine. Share it with someone whose opinion you trust, and keep your mind wide open to feedback.

Simplify

Be merciless with your red pen. Always remember: the fewer words you use, the better.

graphically with more detail, direction and confidence.

All designers should hone their written communication skills. A designer who can't write a complete sentence is not going to gain the confidence of a client. Something as basic as a poorly written cover letter can derail a business relationship before it ever begins.

PREACHING THE
GOSPEL OF DESIGN

In addition to being able to write, designers need to be able to effectively communicate verbally with clients, vendors and others in the course of their day-to-day work. Coming across as a great orator is not necessarily the desired effect. Still, anyone in the profession should be able to clearly project his or her thoughts and ideas, whether it is in a client meeting with one other individual or before a large group.

Just as when you're preparing to write, you must determine what your intended audience might desire to hear. Create an outline of what you want to say. You can use notecards or write a script to make sure your words come out in the right order.

Practice before you preach. Go into any situation where you must make a verbal presentation well prepared. Rehearse the presentation of your topic several times in front of family, peers or even a mirror. Make sure the flow of the speech is smooth and seamless. Avoid simply standing at a podium to read your speech. Practice

moving around the "stage" and perfect some hand gestures to stress important points.

In *It's Not How Good You Are, It's How Good You Want to Be*, Paul Arden writes: "Words, words, words. In a song we remember firstly the melody and then we learn the words. Instead of giving people the benefit of your wit and wisdom (words) try painting them a picture. The more strikingly visual your presentation is, the more people will remember it. And more, importantly, they will remember you."

Remember that in many cases the "entertainment" value of your verbal performance—to a client or a large audience—will close the deal and bring you the desired result. If you are enthusiastic and animated about your topic, others will be drawn into what you are saying.

COMMUNICATION IN A
STRUCTURED ENVI-
RONMENT

The team players of a design firm, ad agency or marketing company may be able to communicate very well with those outside the company walls. However, when it comes to communication within their own business environment, the "rules" may produce a lot of static and the channels of discussion may not be totally clear.

Bob Kilpatrick, senior web developer for Ben & Jerry's, explains how the

company worked toward creating some "rules of the road" for the environment in which the web team for the legendary ice cream performs on a daily basis. "Recently we sat down as a team and established a set of norms that we all try and live by. By following them we are able to maintain a strong team with healthy interpersonal relationships." According to Kilpatrick, "The most important piece is communication. One of the hardest things to do is go and talk to a co-worker right after you have had a conflict with them, but it is also one of the most important. If you can talk about conflict in a proactive way, before too much time has passed, you will avoid all kinds of long-term dysfunction."

In a workplace environment, it is often helpful to have guidelines in place to limit possible conflicts. If individuals fail to deal with conflicts in a proper manner, or someone gets out of line, it is then easy to call them on it and let them know they need to go back to the rules, or "norms," so they can communicate their feelings about a particular issue in an appropriate way.

THE VALUE OF "VENDOR-SPEAK" AND SPEAKING
THE LANGUAGE OF THE CLIENT

"I'm very glad I learned about print production from the printer's side first," says Amy Stewart of Stewart Design. "I often recommend to other designers interested in print produc-

tion that they spend some time working for a printer. It's good to be able to 'talk the talk' with your vendors. They immediately warm to you when they see you understand what they do. A printer is a designer's best friend."

Ask questions. When dealing with clients and vendors there literally are no stupid questions. You can devel-

GUIDELINES FOR FOSTERING TRUST IN A BUSINESS ENVIRONMENT

Here are the norms established by the Ben & Jerry's web team. Foster trust by following these guidelines:

- Start with good intentions, giving every person and situation the benefit of the doubt.
- Engage in collaboration, utilizing each other's strengths.
- Demonstrate a positive attitude, valuing each other's differences.
- Strive to provide excellence in solutions, customer service and support.
- Engage in constructive problem resolution by being willing to respectfully give and receive feedback.
- Family and friends are important; support each other to help balance work, home and personal needs.

op great relationships with vendors, save yourself a great deal of frustration and grief and have projects run much more smoothly by asking stupid questions prior to actually designing a project. By doing so, you can also save the client time and money by not pretending to know everything about how to prepare a project for a service bureau, printer or some other vendor responsible for the final output of a designed piece.

The never-ending process of designer educating the client plays into successful communication efforts as well. The business and art of graphic design is a foreign land to the vast majority of clients, and "design-speak" is a very strange lingo. It often takes a great deal of time and patience to teach a client to understand concepts and specific terms from the "design-industry dictionary."

If all else fails, you may want to give serious consideration to the tongue-in-cheek suggestion of Genevieve Gorder and simply yell, "'I'm the designer—shut up!'"

Research the client and company. Study the products or services they offer. Most importantly, learn the written and verbal language of the firm so you can communicate with the client effectively, and then successfully convey the client's message through your designs.

THE INTERNET—OUR SALVATION OR A CURSE?

The World Wide Web is a relatively new communication tool. The initial purpose for many a web site was to serve as nothing more than an online portfolio—a simple way to visually communicate with potential local clients. No one could have foreseen how the web would totally alter the way business is done.

Before the advent of the Internet, I had worked successfully as an independent graphic designer for about 18 years, with a client base primarily in the metropolitan Portland and Seattle markets. For the most part, the success of my business had relied on face-to-face consultations and in-person design reviews with my clients. That was about to change in a dramatic fashion.

Two months after my web debut, I received a voice-mail message from Kay Johnson, a motivational speaker who lives and works outside of Denver, Colorado. She mentioned having seen examples of my work on the desk of Ann Strong, a designer she knew in Denver, and that she felt I was the person to create the identity of her business. She included her e-mail address in the contact information left in her phone message. I e-mailed a reply, giving her my web address to review additional examples of my work, and soon we were in business—without

The design firm Larson Mirek conveys a consistent corporate image while communicating directly via the Internet with potential clients about their capabilities and process.

ever speaking directly to each other on the phone.

In this particular case, the process included overnight shipping of materials to the client for deliberation. Johnson was soon e-mailing her deci-

sions back to me. In two months the project was finalized and logo files were sent through cyberspace to her printer, video producer, web site designer and others. As we were finalizing the project she left a voice-mail

SHOULD YOU CREATE A CLIENT PROJECT SITE?

The Internet provides all kinds of valuable opportunities for improving communication and interactions with your clientele—including using a client project site for communicating, display design contact and getting feedback. A project site is a site that accompanies a project and contains all vital information pertaining to that project. It is a tool for sharing information between the project team and the client. It is always based on the same visual template, but the information is customized to a particular client.

The benefits of creating a project site are:
- *It facilitates 24-hour access to information pertaining to the project and enables long-distance sharing of that information.*
- *It cuts printing costs for documentation, and less paper means more trees live longer.*
- *It is organized and keeps all information pertaining to a project in a single place.*
- *It lets the client know that you are technologically savvy and that you have structured processes.*

The detriments of creating a project site are:
- *It consumes extra time. (This is minimal after the initial template is built.)*
- *There is a risk that the site will go down during a major presentation. (Always have a plan B.)*
- *Clients likes tangible documentation. (Let them print it out and incur the costs.)*
- *Security issues. (Use a password to protect access to your project site.)*

The content that a project site presents may include: project documentation, comps and revisions, meeting notes, and contact information. The Project Documentation section may include a Project Charter or Proposal that sets the scope of the project. The Project Plan then details the schedule of the project. A Needs Analysis Document assesses the project problem and is refined in the Requirements Document that defines the solutions to the project problem. The Design Document details the design of the project, including site architecture, database architecture, process flow charts, etc. Finally, there might also be documentation pertaining to project testing and a plan for delivery and training.

This information was written and provided by designer Beth Cherry. For additional information, and many other resources, visit her web site at www.TheStudyofDesign.com.

message for me that required an immediate response. For the first time, I picked up the phone and actually spoke with my client.

In a relatively short period of time you can go from primarily a local designer to one with international connections—all because of the incredible capabilities of the Internet, web sites, overnight delivery services and e-mail. A designer constantly complaining about the job or project

opportunity limitations of a local market no longer has a legitimate gripe. There are no boundaries for a designer making effective and efficient use of available technology.

Nigel Gordijk, a designer based in Brighton, England, also finds himself working remotely quite often. Still, he doesn't want working out of the sight of his clients to translate to being out of their minds.

"Regardless of where I'll be executing the project—my home office or the design consultancy's office—I always try to have the project briefing face to face if possible," says Gordijk. "There are always questions that arise in meetings that may not be apparent to either party when writing an e-mail or talking on the phone. It gives me an opportunity to get to know the client and, more importantly, for them to know a bit about me."

According to Gordijk, "Communication is essential. When working from home, I e-mail weekly progress reports to the client, describing what I achieved in the past week and what remains to be completed. It's important that the client is aware that you're still alive and working on the project, not slouched in front of the box watching daytime TV and billing it as research. Also, I find that asking questions about an ongoing project shows that I'm continuously thinking about it. No one will think you're dumb if you ask for clarification; on the contrary, it looks good for you if you raise intelligent points."

Travis Bellinghausen's mindart logo clearly and simply communicates the play on words that he created when coming up with his corporate identity.

"Ask for regular feedback from clients, but set deadlines for their comments, preferably in writing or by e-mail," Gordijk recommends. "There are two reasons for this: it allows them to feel part of the project, while setting a deadline keeps the whole thing moving along. If they fail to respond by your deadline, then you may have a useful fallback position if the project timing slips."

Whether doing business with a company down the street or across the world, it is important to set parameters and clearly define the work process before you begin, so problems that may arise along the way can be easily resolved.

IMPROVED TECHNOLOGY DOESN'T NECESSARILY MEAN BETTER COMMUNICATION

E-mail, one of the wonders of modern technology, has its disadvantages. You may be having e-mail

GLITSCHKA STUDIOS
von r. glitschka
▸ art director
5165 SYCAN CT. SE • SALEM, OREGON 97306

ph. 503.581.5340 • **fx.** 503.585.8190
von@glitschka.com
▸ www.glitschka.com

CONTACT NAME:_____
BUS. NAME / PRODUCT:_____
PROJECT DESCRIPTION:_____
GS JOB NUMBER:_____
(WILL BE ASSIGNED WHEN PROJECT QUOTE IS APPROVED)
ATTENTION: ALL INFORMATION DISCLOSED ON THIS CREATIVE BRIEF FORM WILL BE KEPT STRICTLY
CONFIDENTIAL BETWEEN GLITSCHKA STUDIOS AND THE FORE MENTIONED CLIENT.

GLITSCHKA STUDIOS CREATIVE BRIEF FORM

PURPOSE OF A CREATIVE BRIEF: The springboard into the creative process. This internal communication clarifies direction, outlines the target market, the key message and the desired results. The creative brief is something that we will use to make sure that we are both focused and on the same page. We will refer back to it often during development of your project.

Once established, we go full-throttle with the creative process and start conceptualizing ideas. (For logo development see flow chart provided) We continue to hone our creative thought until it is an ad campaign, a logo, a Web site or a compelling print collateral piece.

We follow this process no matter what the project, the medium or the challenge. Adhering to this process is what equips us to produce award winning, effective and consistent work.

When answering the questions below keep them brief. After all that is what this is called 'A Creative Brief'.

SIGNATURE:_____
CLIENT NAME:_____ DATE:_____
BY SIGNING THIS BRIEF THE CLIENT AGREES AND UNDERSTANDS THAT THE INFORMATION CONTAINED IN THIS FORM WILL BE THE SOLE REFERENCE POINT FROM THIS POINT FORWARDS IN DEVELOPING THE CLIENTS LOGO / IDENTITY.

1. WHO ARE YOU?
WHAT DO YOU DO?

2. YOUR OBJECTIVES
WHERE DO YOU WANT TO GO?

3. DESIRED RESULTS & VISION
HOW WOULD YOU LIKE TO BE PERCEIVED?

4. TARGET MARKET
WHO IS YOUR AUDIENCE? DEMOGRAPHIC?

5. COMPETITION
WHO IS YOUR PRIMARY COMPETITION?

6. SUCCESS CRITERIA
DEFINE HOW YOU WILL JUDGE A SUCCESSFUL PROJECT?

7. DESIGN CRITERIA
WHAT DO YOU WANT THIS PROJECT TO SAY ABOUT YOU?

8. COLOR PREFERENCES
FAVORITE COLOR?

LEAST FAVORITE COLOR AND WHY?

9. MARKETING
WHAT METHODS HAVE YOU USED IN THE PAST? (CHECK ALL THAT APPLY)
☐ DIRECT MAIL ☐ BROCHURE ☐ ADS/LOCAL ☐ CABLE TV
☐ NEWSPAPER ☐ DOORHANGER ☐ BILLBOARD ☐ RADIO
☐ POP ☐ ADS/REGIONAL ☐ BUS ☐ OTHER

10. KEYWORDS
WHAT WORDS BEST REFLECT YOUR COMPANY? (CHECK ALL THAT APPLY)
☐ DEPENDABLE ☐ ESTABLISHED ☐ ENTHUSIASTIC ☐ FUN ☐ PRECISION
☐ PROGRESSIVE ☐ EDGY ☐ UNIQUE ☐ SERIOUS ☐ ORIGINAL
☐ TRADITIONAL ☐ STRONG ☐ INTEGRITY ☐ HI-TECH ☐ MAINSTREAM

11. CREATIVE FEEDBACK
WHO'S INPUT WILL YOU RELY ON MOST? (CHECK ALL THAT WILL APPLY)
☐ TARGET AUDIENCE ☐ BUSINESS PARTNER ☐ SECRETARY
☐ MARKETING DEPARTMENT ☐ YOURSELF ☐ CLOSE FRIEND / SPOUSE
☐ COMPANY EMPLOYEES ☐ FOCUS GROUP ☐ GLITSCHKA STUDIOS

12. ADDITIONAL INPUT
ANY OTHER THOUGHTS?

TEMPLATE LAST UPDATED: 07.14.03

Glitschka Studios' creative brief form makes a strong statement in initiating the process of communication with clients. By having the client fill out this form, the designer is able to clearly understand the client's motivation and goals early in the process.

difficulties or the client may be having the same on the other end. At times it is difficult for the client to put what are basically emotional reactions to specific designs into the cold, hard text of an e-mail.

However, there are also advantages. When phone conversations are not possible, an e-mail question and answer series works to fine-tune the client feedback about particular issues. Another advantage of communicating via e-mail is that each person involved in the project can respond on their own time without consideration for established business hours or the hour of the day in another time zone.

E-mail can also be an annoying communication vehicle if not used properly. Spam has become the irritating dinner-hour telemarketing phone call of our time. Unsolicited sales messages, hawking everything from mortgages to Viagra, litter our e-mail in-boxes each day. Designers marketing themselves via e-mail must take care to communicate professionally and with concern for the impact on the individual receiving the sent message.

"Communication is a tricky business," states Bettina Ulrich, editor-in-chief of the German design publication *novum*, in a 2004 editor's message entitled "E-mail Nightmare." "But with the advent of e-mails the whole thing has gotten even trickier. Sometimes it seems like a hopeless task trying to distinguish any real 'communication' in the flood of 'communications' arriving electronically.

"To be honest, if I can't make out any sender's name or specific information about what the whole thing is about, then my finger moves swiftly over to the delete key," adds Ulrich. "Just what is so difficult about writing a subject line that actually reveals the name of the event or product being discussed?"

While a follow-up e-mail may be overkill in cases such as a press release, where you simply want to disseminate information, in other cases it may not be best to assume that an e-mail has been received. Touching base with a client who may be expecting e-mailed information, design concepts or proofs of a job would be a wise move for any designer using e-mail as a business communication tool.

"WHAT WE HAVE HERE IS A FAILURE TO COMMUNICATE ..."

A simple lack of communication between designer and client, account executive and designer, or any other combination of individuals participating in a project may have dramatic results on design efforts. Necessary information may be relayed incorrectly or, in some cases, not at all. The resulting misunderstandings can bring an end to a client relationship or leave those involved with a great deal of egg on their faces.

A completely different set of issues can arise when you are not allowed direct contact with the client. This often occurs in situations where designers are contracted to do work for ad agencies or design firms. The firm hiring the designer may not want the client to know an outside resource is being used for the job.

In one particular case, after receiving the project specifications from the account executive handling the client, I began work on a logo design for a government agency. The project began to drag on, with the AE telling me the client simply wasn't happy with the results. I was really stymied, as I'd never experienced such a frustrating project. I finally convinced the ad firm to allow me to meet with the client. In our meeting, the woman expressed her frustration at my inability to come up with a satisfactory design and described what she was seeking. I reached into my business folder and pulled out one of my first design concepts. She looked stunned, and said "Where did that come from? That's perfect for our new logo." I explained that it was one of my initial designs. We discovered that the ad agency had selected only the design concepts *they* felt the client should see from those I had submitted.

Brandon Luhring, of Luhring Design, found himself in a situation where his former boss was blocking access to the client for approvals on a web-design project.

"I'd make suggestions about including the owner and sales team, only to receive a blank stare. 'Really, I think it's all up to us,' he'd say. 'The owner just wants to see some results.' He'd go on to claim that he had worked right alongside the owner for twelve years and that he knew how to satisfy him.

Luhring relented. The designer created site structures and navigation flowcharts, which were forwarded to his supervisor for client approval. A day or two later the boss would bring them back and say they were perfect. In addition, Luhring would post designs online for the client to review and send an e-mail out informing all parties that a review was possible. However, oddly enough, Luhring's supervisor was intercepting all his e-mails and the client was not seeing the designs.

"At the end of the project we got everyone together to look at the nearly completed site. It turned out that only one person 'approved' my layouts and flowcharts: my supervisor. They never left his desk!" according to Luhring. "Then, he had another staffer tell the owner someone else had informed me to handle the project in the manner it had been coordinated!"

Communicate. Communicate. Communicate. And, if you're not getting the information you need or the answers you require, communicate some more. I don't think it is unreasonable for a designer to demand

E-MAIL ETIQUETTE

Address people properly and with respect.

E-mail has become a casual method of business communication. However, that does not mean a person sending or responding to an e-mail should be unprofessional in addressing others. Use Mr. or Ms. (or Dr. or Professor) if appropriate.

Consider who *really* needs to receive the e-mail message you are sending.

When sending an e-mail within a company, organization or group, determine if it is really necessary to send the message to all on your mailing list. Everyone receives enough unwanted e-mail as it is. The same goes for replying to a message in your inbox.

Use BCC as a courtesy to avoid exposing the private e-mail address of all recipients of a mass mailing.

Many e-mail addresses on your mailing list may be private for a reason. The use of BCC will prevent additional broadcasting of e-mail addresses if someone were to use Reply All in responding to a message. Privacy is also an issue to consider when forwarding a message. It is also courteous to remove the e-mail addresses of other recipients before forwarding.

Consider the connection speed of those receiving your message.

All e-mail users are not yet on DSL or cable modems. Be considerate when sending e-mail containing HTML or attachments. It may be wise to send an e-mail asking if such messages are appropriate.

Give people the option to *not* receive your e-mail newsletter or press releases.

Everyone may not be as excited about your business news as you. Always give people the option to "unsubscribe" from your e-mail list.

Avoid excessive quoting.

While it may be prudent to respond to an e-mail with the previous message—or a quote—retained as a reference, avoid sending excessively long threads, or chains, of a series of e-mails sent back and forth.

Don't automatically forward virus and potential urban legend messages.

Nothing is worse than getting a large number of people in a tizzy by sending an e-mail conveying false information. Avoid looking foolish by verifying viruses and other potentially false information at sites such as Symantec.com, UrbanLegends.com or through an Internet search engine.

Reconsider sending attachments during virus scares.

During any well-publicized virus scare it may be wise to ask if sending e-mail with attachments is acceptable to a client or vendor. Some ISPs (Internet service providers) may automatically reject such messages during the threat of a virus or worm.

Name e-mail subject matter appropriately.

Don't leave the subject line of an e-mail blank, or type in an unhelpful phrase such as "Hello Stranger" or "Hey" when sending business e-mail. It is the perfect invitation for an impor-

tant e-mail to be deleted if the recipient does not recognize the sender or subject matter.

Don't use the subject line for the body copy of your message.

The subject line is intended to present a brief description of the message contained within the body copy of your e-mail—not for the input, or pasting, of an entire message. It may be inappropriate to have the content exposed in the message preview display of a computer monitor available to all eyes.

Attempt to reply to all e-mail in a timely manner.

Many e-mail users are now expecting an immediate response due to the advanced technology used to send e-mail messages. Such a reaction is simply not always possible. If you are particularly busy, send off a quick reply that you have received the e-mail in question and you will reply at greater length as soon as possible.

Don't be rash in your response to an e-mail

Do not be too quick to respond to an e-mail that generates an immediate emotional response from a quick reading. Take a moment, reread the message, write your response, and calmly read over your own message before hitting the send button. Hasty responses are too often followed by regrets.

Don't *rely* on e-mail in very important situations.

It is often a good idea to follow up a very time-sensitive or important response with a short e-mail or quick phone call to make sure the message has been received and understood.

Use a spell-check resource.

It takes only a few seconds to confirm that your message contains no spelling errors and will appear professional to the person to whom it is sent.

DON'T USE ALL CAPS IN YOUR EMAIL MESSAGE!!!

No one likes to feel as if someone is yelling at him or her. Besides, all-cap e-mail messages are very difficult to read.

Use priority options, *urgent* and *important* sparingly—or not at all.

Most e-mails are not an immediate matter of national security. E-mail priority markers, or the words urgent *or* important *in the subject line, are overused.*

Consider the professional appropriateness of forwarded e-mails.

Remember that nonprofessional e-mails do play a part in creating the image of your business. Forwarding e-mails containing offensive or obscene remarks, even in the context of a joke, is not wise. Petitions for political or social causes are usually an annoyance to someone already receiving too many e-mails.

Include a business signature in your e-mail.

It's good business to include a signature in all your e-mail with your name, title, e-mail address, Internet URL, mailing address, contact numbers, and any other important information.

Keep it short—*Enough said!*

direct contact with the client decision-maker on a project. Good communication in the course of a project doesn't guarantee success, but ineffective communication almost always assures mistakes and problems.

THE LOST ART OF THE
THANK-YOU NOTE

The value of a simple "thank you" can't be emphasized enough. It will be one of the most important communication tools throughout your professional career. In addition to be being a common courtesy, you are conveying that the value of another person's time or effort on your behalf is understood and appreciated. However, expressing appreciation has seemingly become a lost art in day-to-day business dealings.

When David E. Carter publishes a book featuring a designer's work as a result of one of his design competitions or some other effort, he sends a complimentary copy to the contributor. I've made it a practice to make sure I send a thank you to Carter each time I receive one of his publications to add to my collection. In 2001 I received a copy of his book, *Blue is Hot, Red is Cool*, exhibiting several examples of my work. I sent off a thank you, in e-mail form this particular time. I was stunned when I got Carter's response: "Thanks for the nice note. You don't know how much I appreciate your taking the time to do so. (I know, you are supposed to send 'thank you' notes; parents all

taught us that. But of the 70+ copies of the new book I sent, I have received exactly two 'thank you' notes.) Best wishes."

Everyone has busy schedules, but it should be a regularly scheduled activity to take time to jot off quick notes to those who have done something worthy of a "thank you." Doing so makes a huge impression on people.

"We always send a handwritten note of some kind after a first meeting with any potential client thanking them for their time and consideration," contributes Gary Dickson of Epidemic Design. "Sometimes it is a card that we have produced, but if not, we are very careful to purchase a unique card that cannot be found in a typical store."

No matter what form you chose to communicate your thanks, making the effort is a must—and the recipient will remember it. All designers need to make it an element of their daily communication, marketing and promotion efforts.

APPRECIATE THE CLIENT;
SHARE THE GOODWILL

Sometimes a little more than a thank-you note is in order. It's up to you to determine when and how much is appropriate, but the extra effort is often appreciated by clients.

Appreciation should go in all directions. While it's being passed around, make sure that clients, your staff, ven-

dors and others involved in any project are made aware how much you, or others, appreciate their efforts.

"At the end of each year I send a nice gift basket to larger clients and send out a annual promo package usually based around some sort of theme," says Von Glitschka of Glitschka Studios. "I also share freebie art goodies with them like custom-designed desktop pics and fonts I've designed. I've found that taking the relationship a step further than the modus operandi service requested, or service rendered, is always beneficial and takes things to a personal level," says Glitschka.

Karen Larson of Larson Mirek Design, also takes things to a personal level. "At the holidays I usually create a handmade gift card to attach to gifts—and if they're lucky, they might receive an original Karen Larson painting. Last year I gave away sets of PalmArt cards," she says.

Cindy King of King Design Group adds, "I do think showing appreciation has lost its sentiment. People want to feel like you took the time out of your day to think of them. I would certainly appreciate it if I were in their shoes. My clients are always touched by my sentiments. And I'm not trying to 'kiss butt'; I just want to make their day more special."

"Everyone needs to feel appreciated. Designers for my ad agency often lament that clients (and account executives) rarely compliment them on

Honolulu-based John Wingard Design communicates a message of class and professionalism with personalized gifts of wine as an introduction to his firm or in showing appreciation to a client.

their work," says Sue Fisher, president of TriAd, an advertising, marketing and public relations firm. "Often praise has been given, but in our hectic world we sometimes forget to pass on the compliment. Take the time to share. Praise is great for morale and is a useful creative tool.

"Tell clients they are doing great work. Tell them they make your job easier and that helps keep their costs down," continues Fisher (who is my sister.) "This is how you keep those good clients for years to come."

I suppose I should take this opportunity to again convey my thanks to all who have contributed to this book. I have a lot of handwritten thank-you cards to get started on.

CHAPTER 6
WORKING IN YOUR UNDERWEAR

Projecting a professional persona in an image-conscious industry is serious business. Learn how to establish a reputation for yourself, present your business professionally and set up something that resembles an office. Learn from designers in and out of the cubicles of the profession. Whether looking for a job as a potential employee or establishing a presence as an independent resource, early on every designer needs to begin the process of creating a career presence and making a name for him- or herself.

"Associate yourself with men of good quality if you esteem your own reputation; for 'tis better to be alone than in bad company."

George Washington

"The future belongs to those who believe in the beauty of their dreams."

Eleanor Roosevelt

"If you have built castles in the air, your work need not be lost. That is where they should be. Now put the foundation under them."

Henry David Thoreau

LITERALLY MAKING A
NAME FOR YOURSELF

When you start your own business, you are beginning a "brand," if you will. The product has a name. There may be a reputation associated with the product—a documented history of achievements, accolades, failures and more. Interestingly enough, this product has the same name as you when you go to introduce yourself to a potential client, a possible future employer, a peer with whom you may one day collaborate or a vendor who will be able to help you out of a bind.

In their book, *Off-The-Wall Marketing Ideas*, Nancy Michaels and Debbi J. Karpowicz stress the importance of making a good first impression in any industry. They write, "As a small business owner, you become the embodiment of your company; you also become a public persona, which has its ramifications. Whether you are running a grocery store—or a business meeting—it is important that you create a positive reflection of your company."

My own identity went through a process of evolution. When I found myself working independently as a designer in the fall of 1980 due to the job-lite economy, I had not yet made a name for myself as a professional or a business. Initially, I thought I would come up with a clever, attention-getting name. The result was art-werks, ink. A problem surfaced immediately. Nobody knew who I was. The name soon faded and

was replaced with the much more banal Jeff Fisher Graphic Design.

In late 1986, after almost eight years as a graphic designer using the name Jeff Fisher Graphic Design, I decided that I needed a business name that reflected my interest in logo design, combined with my lifelong fascination with toy trains and actual locomotives. The examples to the right show the development of a logo for my original name, Logo Motive Design. The first drawing was executed in ballpoint pen on a notepad, re-created with a Rapidograph pen (this was before most designers had computers), and then reversed out to final art. The logo appeared only in one print ad. It was not met with positive feedback from friends and clients, who felt the emphasis on my personal skills and talent required my own name in my business identity. So, the idea was shelved and I continued as Jeff Fisher Design.

As more and more of my design work involved identity efforts, I revisited my original concept for the business name Logo Motive. I attempted to create a logo combining the necessary text and a symbolic art element in an integrated emblem, while also conveying my own creativity and identity design ability. I again received negative feedback from clients and associates regarding such a name, making my efforts seem impersonal and too corporate. Still, I began using the business

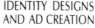

IDENTITY DESIGNS
AND AD CREATION

The logo designer without a logo struggled with the evolution of his identity for ten years.

name Logo Motive in 1995 to identify what was unintentionally becoming my primary business focus. Frustrated because it did not convey a strong enough image, I again halted my own logo project, and resuming the effort became a low priority due to an ever-increasing workload.

By 1997, about 80 percent of my design projects involved logos. Clients, potential clients and friends frequently asked why a logo designer did not have a logo of his own, so I decided to finally finish the logo project I had begun ten years earlier for my own worst client: myself. Embellishing the rough design of a few years earlier by simply adding my name, I was able to "brand" myself...giving the logo the personal sense it had been lacking. The result was a logo with which I was pleased at last. Numerous new clients tell me they decided to hire me because of my personal logo. It has become my greatest—and most recognizable—marketing tool.

Jacci Howard Bear, guide for the About.com Desktop Publishing forum, has some common-sense advice for beginning the quest for a business name. She says, "Choosing a business name can be fun and frustrating. To do it right you need to pick a name that you can live with for a long time, that reflects the nature of your business, and isn't already being used by the business down the street."

This basic principle of using your own name worked very well for Houston designer Mark Wilson, a designer of logos—or *marks*. He named his business Mark of Design, linking his first name and his area of expertise. He even goes one step further with the directive tagline, "Make Your Mark."

Some firms tackle the naming game from a totally different angle. Pigtail Pundits, the Mumbai, India web development firm founded by Ranajit Tendolkar, is not a name one is likely to forget; it stirs up all kinds of interesting mental visuals when you read or hear the moniker. "Christening our organization was one of the first tasks we set about as soon as we decided to set up shop," Ranajit Tendolkar says. "We wanted to create a name that is unique, Indian yet international, easy to remember, capable of standing above the clutter, and of course with visual possibilities."

It seems to have worked. Every potential client has inquired about the name, making it a success in (the firm's) eyes. No matter what your naming strategy, coming up with a clear, explanatory, clever name is always a challenge, but it can be your most important introduction to the world at the same time.

THE GLAMOUR OF THE DESIGN OFFICE

Design students often have an unrealistic expectation of immediately get-

ting into the "glamorous" world of design after school. Over the years, television, movies and other media have skewed our perception of what makes the perfect office setting for the creative professional. In the 1960s *Bewitched*, Darrin Stephens (both of them) went to work each day in the rather boring New York offices of McMann & Tate, always wearing drab business suits in the drab work setting. Nevertheless, advertising design seemed like a cool job.

In the 1980s show *thirtysomething*, Michael and Eliott designed advertisements in the fun and funky offices of "The Michael and Eliott Company." It seemed like a place all of us would want to work. Those and other media representations of a creative office are where design students thought they were headed.

Undoubtedly, the space in which any designer works does play a part in the professional image—or the public perception of that image—for the individual or firm.

My initial "glamorous" design office—for my first real job—was the converted attic of an old four-square-style Portland house. From the cramped quarters, attainable only by walking up three flights of stairs, my staff and I slaved over the production of a group of medical publications. The only advantage of our garret space was that "The Powers That Be" seldom ventured upstairs to check on our work progress.

My next office location was much more in line with my ideal of the "happening" (remember, this was the early 1980s) design space. I was sharing space with an advertising agency in a renovated historic building in Portland's Old Town. The office was new, polished and shiny. After my previous situation, my great joy was having an elevator.

The last "real" office I had was the most unreal. I was working for an international clothing manufacturer in Seattle. The offices were in a converted warehouse. It induced a sensory overload with a conglomeration of colors, shapes, lights, signage and apparel. The offices were divided by cyclone fencing and the "doors" were fence gates on wheels.

Following these experiences, I realized that I was at my best working for myself. My living situation at the time really didn't allow for a home office. I wasn't sure what I was going to do until one of my clients, a magazine publisher, suggested I take up residence in a space he had available. The large, open space, with freestanding walls dividing individual offices, was home to a theater company, a nonprofit advocacy group, the Seattle Men's Chorus and the publishing company. A common conference room was shared by all in the retrofitted, turn-of-the-century building. Three of the four tenants were clients, so I didn't need to go far for project meetings.

The offices of Hornall Anderson Design Works in Seattle project an inviting image of creative energy in a space dedicated to productivity and fun with openness, warmth and well-planned gathering places.

The low monthly rent would be paid in design work for the publisher's projects. It really was an ideal situation. One of the best aspects of that office was the interaction with a variety of people from different businesses and organizations.

The office of Sandstrom Design is located in what was a Portland furniture store for many years. While very "office-like," the space is inviting and interesting. It suggests that people actually produce work there. The recognizable client work displayed in the lobby area provides an instant introduction to the high-calibre work created by Sandstrom's successful design team.

Hornall Anderson Design Group, of Seattle, is another firm located in a renovated older building. The multi-floor office is full of light, energy and excitement. The open floor plan makes everything visible to anyone entering the space. Teams of designers and staff can be seen collaborating in windowed meeting rooms and around desks in the open areas. I was immediately drawn to the "wall of logos," right off the foyer, highlighting the efforts of this internationally known identity firm. A client walking into such a vibrant workspace could not help but be drawn into the creative energy of this idea factory. It's the kind of place in which almost any designer would want to work.

MOVING OUT, MOVING UP

A work location outside of the home, whatever form it may take, often provides the separation of personal life and business needed by designers. In *The Business Side of Creativity*, Cameron S. Foote writes: "An official office gives you a place to head for each morning, provides the psychological reaffirmation that you have taken the first step into the future, lets you meet clients in an atmosphere conducive to business, makes it easier to employ help, and provides the businesslike environment often needed to do your best work."

Probably the largest drawback to any designer or firm is the overhead cost associated with an office space. The added cost of a lease, utilities, parking, office furniture and all the necessary equipment will contribute a lot to the bottom line of a company. Those expenses have been the downfall of many creative firms in bad economic times, as the cash flow used to cover such costs is impacted.

Les Woods of progressive edge has a practical office space away from home. He says, "In the United Kingdom many design agencies have trendy offices with beautiful varnished wooden floors and fantastic view points. I cannot afford that sort of office, but I find that as long as the office is bright, fresh and clean then the clients are more than happy with it."

Catherine Morley seems to have the best of both worlds with a "real" office and a home work space. "I have an office downtown but I prefer to work and meet out of my home office (when there is the rare meeting) with the majority of my clients," says Morley. "If I'm meeting with high-powered clients for the first time, I either use the conference room at Katz <i> Design Group or meet in their offices, or a place in between" such as a restaurant for a client lunch or dinner.

"I feel that each client has an expectation of how they want you to present yourself, and learning how to gauge this is important," adds the Brunei-based creative. "My clients, high-powered or not, love to come to my home office because they can put up their feet and enjoy the meetings (and my coffee) without the constant interruptions that inevitably come from meeting in offices or restaurants."

The location and décor of a designer's office space are not necessarily the most important aspects of a graphic design operation. However, no matter the type of space, the work environment needs to be comfortable and conducive to creative inspiration.

HOME IS WHERE
THE OFFICE IS

Many designers are a bit conflicted over the issue of having a home office while attempting to present the image of a professional design firm. The obvious advantages of a home-based office are low overhead, no commute to work, the ability to set one's own schedule and possible tax benefits.

"I recently moved my studio out of a rented space and back to my home," says Wendy Constantine, of W.C. Design Studio. "I've found that having an 'office' outside the home hardly meant anything to my clients."

She adds, "I needed the separation from my work, and for a few years, it worked. Many of my 'clients' are other freelancers working from their homes as well, so there is little reason to hide the fact that I work from home."

Neil Tortorella is another designer who has abandoned his outside business office for the home studio. "I did the fancy office bit a while back. Too much overhead. Too much ego. Too much blood pressure," states Tortorella. "Now I work out of my house and it's never been a problem, with either clients or suppliers."

Valarie Martin Stuart, of Wavebrain Creative Communications, acknowledges some challenges in a home studio operation. "While this presents logistical problems occasionally when the need for meetings arises, I don't hesitate to let my clients know the office situation. If I'm comfortable with a client, I conduct meetings in my dining-room-slash-conference-room. And I'm always happy to meet with clients on their turf. As far as vendors, this is a non-issue. I mainly meet with vendors at their locations or over the phone.

There's never been a need for a vendor to do more than a pickup at my office. And there's a spot on my front porch specifically for courier pickups."

There are a few concerns to address if you are a designer using your home address as your business address. First of all, you don't necessarily want clients, potential clients, designers seeking employment and vendors showing up on your home doorstep as if it were a traditional office where they could stop by at any time during the business day. Such visits can totally disrupt a designer's workday.

Another issue is that of personal safety. By using your home address in your marketing and promotional materials, you announce to the world that you work out of your home and are likely to be alone most of the day. That may not be the wisest decision.

So how can you circumvent the mailing address issue? At one time, I was able to make use of the address of the answering service I was using. It provided me with what appeared to be a somewhat prestigious street address in downtown Portland. A post office box is also a convenient, easy solution.

PROFESSIONALISM AND SANITY IN A HOME STUDIO

Home-based designers can adopt a more professional attitude about their work by treating their home studios in a more professional manner. It's too easy to get lax about professionalism when working out of your living space. By creating a more professional space, a designer can project a more businesslike persona outside the home.

Inside that home space—especially if you live with others—a separate phone line or a business-specific cell phone is a must. When that business line rings, you then know that the caller is a vendor, client or business prospect and you, as the business owner, are able to answer the call in the manner you deem appropriate. It just isn't professional for a child, who may not understand proper phone etiquette, to answer what is supposedly a business line.

Another important thing for me is to have my workplace in a separate area of the house from where my day-to-day life takes place. Years ago I lived in a beautiful place on a river. My office had a big window looking out on the water—perfect for designer-ly daydreaming. However, my desk was also in a room that could not be closed off from the rest of the living area. Whenever I was in the living room watching television, entertaining friends or listening to music, I was staring right at my desk. I was never completely away from work. I always found myself wandering into the office to work on something that should be done.

When my partner and I first saw the house we ended up buying, I was thrilled. The two rooms upstairs were

perfect for an office area. My work could be totally out of sight. We made the office area "official" by putting in a door at the bottom of the stairs. It really has made a huge difference in separating work from my home life. You need to do so to maintain some sanity as a work-at-home designer.

Setting office hours is an important issue for any home-based designer. The fact that your desk may be within steps of your primary living area does not necessarily mean you should be working at all hours of the day. Your clients have office hours; why shouldn't you? I do make a major effort to have a home life. I try to avoid working when my partner is home so we have personal time together. I may be up working at my desk at 5:00 a.m., but I very seldom work beyond 6:00 in the evening. I almost never work weekends. When I am finished with my work in the evening, I come downstairs and shut the door—and my office is closed.

THE HOME OFFICE
CONFERENCE ROOM

Most home-based designers don't necessarily want to conduct business meetings in their personal space. I never have client meetings in my somewhat-cluttered home office. While very conducive to my work, it's just not a space that is well-suited for client meetings and presentations. On very rare occasions I will have client meetings in my living room, dining room or garden. Usually these particular clients are also friends, or clients that have become friends over the years of a business relationship.

Like many other independent designers, when I do have that rare face-to-face client meeting, it is most often conducted either at the client's place of business or the neighborhood coffee shop. My conference room of preference is the wonderful DiPrima Dolce, an Italian bakery located in my neighborhood. Not only is it convenient, but I appreciate the fact that I am supporting another small, independent business owner. It's also easy for clients to find and provides plenty of free on-street parking—considerations when asking clients to go out of their way to meet you.

For some, the law regulates meetings conducted in a home studio setting. Steve Fleshman does not conduct business in his Falls Church, Virginia, home studio, as it is actually against the terms of his city business license to do so. Such a situation demonstrates the importance of researching possible home office restrictions in your local area.

Wendy Constantine conducts business in a similar manner. She will meet clients at their office, or suggest a restaurant or coffee shop.

"I like to preserve my privacy, and it's easier on the client to meet them on their turf," according to Constantine. "Only in the case of collaborative working arrangements with other

freelancers will I hold a meeting at my home."

Tortorella Design's meetings are often held at the client's office, but there is also the occasional lunch meeting at a restaurant or the casual cup-of-coffee meeting at Starbucks. Because the coffee meetings are so frequent, Neil Tortorella jokes that Starbucks is planning to open a location in his living room.

"I never have clients to my place, for a couple of reasons. First, I provide a service and it's often easier for them to meet at their place," says Tortorella. "Secondly, my place is small and I have several primitive masks and medieval broadswords around. I think it scares them."

Valarie Martin Stuart also schedules business meetings in more traditional settings. "I try to meet at the client's place of business, unless I am familiar with the client and know that meeting with me is one of the only chances they get to escape the office, and that's a perk for them," says Stuart. "By meeting at the client's office, it's a 'convenience' factor for them, and shows that I'm willing to meet their needs and cater to them."

Not all home offices offer the best environment for face-to-face client meetings. When office meetings are not possible, select a clean, convenient business establishment to conduct a coffee or lunch meeting. You may want to touch base with the owner of the establishment to make sure such meetings are acceptable. A work-at-home neighbor of mine, attorney Sandi Pellikaan, solved the potential problem of clients meeting in her home among her children's toys by making arrangements to have meetings at an occasionally shared conference space in a nearby office building.

THE SMOKE AND MIRRORS OF THE INTERNET

The World Wide Web has dramatically altered the perceptions and realities of the design business—and business in general. An Internet storefront puts the smallest business on a somewhat level playing field with major corporations these days. The small, home-based, one-person design firm is now often perceived as a much larger business entity—and that's not necessarily a bad thing.

Neil Tortorella was previously of the mindset that appearing bigger was better with regard to his own business. "Before, when I had a staff, that was an honest position," explains Tortorella. "Now, it's just me, and I work out of my house. It would be less than honest to try to look like a bigger firm.

"When I was writing the copy for my site, I was using stuff like, 'we can...' and 'our philosophy is...' When I was reading it back, I realized that there ain't no 'we.' It's just little ol' 'me.' And that's OK. Clients hire me. They deal with me. They want to know I'm the one doing the work. So, I decided to slant my copy that way. To bring it

'up front.' Everything is in the first person, very conversational and loose, not stuffy. I feel it conveys more integrity. My clients know my capabilities. They also know that if I don't do something or can't provide a certain type of service, I can usually find someone to partner with who can."

"The Internet is amazing, and having a web site presence can really alter or enhance the perception of my company and business to potential clients," says Travis Tom, of TNTOM Design. "Although my personal site reflects that I am an independent designer and illustrator, it is possible to give the impression that I am a small five-man shop or even a big agency. Hopefully the quality of my work shown on my site is responsible for landing projects."

"I've heard several people say after visiting my web site that they thought I was a design 'firm,' meaning a multi-person and multidiscipline studio," says Massachusetts-based Wendy Constantine of the assumptions made by potential clients. "In reality, I'm a very versatile designer with experience and contacts with other freelancers in a variety of different fields."

PROFESSIONALISM IN
DESIGNER'S CLOTHING

Presenting an image of professionalism has much more to with the manner in which a designer does the work, rather than the appearances projected by attire and office spaces.

For Wendy Constantine, conveying professionalism means "taking responsibility, meeting deadlines, understanding client needs and wants, owning up to your mistakes, and presenting inspired work that communicates (the client's) message."

"Presentation, tact, efficiency and attention to detail" are the major elements of professionalism considered by Les Woods when he meets a potential new client for progressive edge.

"I never point out glaring mistakes on the client's existing brochure, website, business card, etc.—only if it is brought to my attention or if I feel that not to mention it would seem like I am not paying attention," explains Woods. "You must remember that they may be responsible for commissioning that dreadful brochure, and by trashing it, you are actually making fun of them!"

Being a businessperson is the primary focus of designer professionalism in Neil Tortorella's mind. "That means understanding that if you want to please *yourself*, you go into the fine arts or write a novel," according to the Ohio-based design principal. "As a professional designer, you act, well… professionally. You understand that your job is to communicate a message and, usually, to motivate an audience to *do* something—buy a product, request more information, make a donation, learn something—and you behave like a businessperson."

Tortorella credits his cohort, writer Tim Kraft of WordKraft in Canton, Ohio, with one of his business mantras: "Be fun to work with, but be professional."

"I try to be fun and funny to work with. The truth be told, this can be an awfully stressful gig, for both my client and myself," says Tortorella. "I choose to see the humor in things, but also get the work done. Sure, there are times when all the humor in the world won't help, but by and large, humor helps."

DO CLOTHES MAKE
THE DESIGNER?

In his book *Footnotes*, retail wizard and marketing guru Kenneth Cole writes, "As individuals we use fashion to define ourselves and tell the world who we are. When we get up in the morning, what we put on is very much a reflection of how we see the world and how we want it to see us. Our bodies become our own medium of communication, and every day becomes a chance to reintroduce ourselves to the the universe.

"We can't always control the reality of our life the way we can control the perception of it," adds Cole. "We are given an uncensored opportunity, every day, to be who we want to be."

Of course, having a home office and seldom having to meet clients face-to-face may result in a unique reflection of one's business. In an article for a monthly publication, writer Marc Acito of *Just Out* wrote, "Jeff

Fisher works in his underwear. No, he's not a go-go boy, he's an award-winning graphic designer whose internationally acclaimed design studio, Jeff Fisher LogoMotives, is housed on the second floor of his North Portland home. With the majority of his clients communicating with him electronically from out of state, Fisher can roll out of bed and go straight to work in his skivvies."

At a friend's party one evening I discovered a whole cult of work-at-home professionals, male and female, who were proudly telling others that they worked in their underwear. I have yet to determine if such attire is truly a positive or negative attribute of the new manner in which I do business. I do know I will not meet with clients in my boxers or briefs. However, that did not stop me from making a presentation to attendees at the 2004 HOW Conference in a Logo-Motives T-shirt and black silk boxers from Veer (the stock photo, illustration and typography company).

Still, every designer needs to take appropriate business attire into consideration. Designer and design educator Valarie Martin Stuart sees this issue from the perspective of someone preparing young designers for a future career. "A professional designer needs to keep one very important word in mind: *professional*. If you want your work to be taken seriously when dealing with clients concerned about their business image (and that's your job,

after all) care should be taken in presenting a professional image."

Stuart continues, "As an example, I'd like to mention one of the most talented and creative students I've seen in the community college program where I teach. This young woman has incredible talent. Her work is professional quality, and better than many professionals I've encountered in the field. However, she has three or so lip piercings, multiple ear and eyebrow piercings, tongue piercings, one of the strangest hairstyles I've ever seen, and doesn't wear any piece of clothing unless many inches of the fabric drag dirty along the ground. While I would not hesitate to hire this young woman for my own firm, I would never consider bringing her to a client presentation unless I was presenting to, say, a tattoo shop or a punk rock recording label."

"While I think a creative can be a little more lax in apparel and style with clients, first impressions are still important. It's human nature to judge others upon a first meeting; therefore, it's in my best interest to appear like my clients. People like people who are like themselves. And let's face it, this business is also about building relationships with clients."

Travis Tom takes the chameleon approach, dressing to fit the circumstances. "I would want to wear attire similar to that of the situation. If I was meeting with a bunch of 'suits' then I would want to be in a suit—but preferably a blazer without a tie if I could get away with it. I feel uncomfortable all dressed up. And of course I wouldn't want to be overdressed in a situation if the meeting was casual."

WORKING INSIDE THE CUBICLE

For some, presenting their personal take on professional attire involves fewer options. Unfortunately, some companies in corporate America put the damper on their employees' clothing creativity. Hopefully, with "casual Friday" sneaking into many larger

PROJECTING A PROFESSIONAL IMAGE

Neil Tortorella offers the following guidelines for projecting a professional image to clients, potential clients and others with whom a designer comes in contact. If you're a true professional:

- You're on time for meetings.
- You deliver what you promise—neat, clean, accurate and on time.
- You stick to the budget.
- You act with honesty and integrity.
- If you screw up, you own up to it and fix it as best you can.
- You don't undercut yourself or others in the profession.
- You charge a reasonable fee and you know how to back up that number.
- You remain cool under pressure and don't blow your stack.
- You make a profit.
- You keep accurate records.

companies, a more casual—but still appropriate—business look will become the norm.

"We walk a fine line between needing to look creative and still appear accessible. I'd say the power is in the details so, you should accessorize, accessorize, accessorize," says Andy Epstein, creative director for Gund. "I wouldn't plan on coming to work in torn jeans and Hawaiian shirts, but a classy earring for men or a funky watch, jewelry or notepad gets the point across that you're creative and can think outside the box, but you're still a team player."

In-house designer David Hollenbeck, of Ohmeda Medical, feels that corporate hierarchy and office politics also play into the fashion decisions to be considered when working within a company design department. "I tend to dress similarly to my co-workers. I don't think I have the same flair with fashion that I do with design. I tend to think that as long as you are dressed to the same level others are, even if it is a little more unusual, you present a professional image. But if you dress significantly lower than your co-workers, you'll have trouble."

"If I were a freelancer, I doubt I would wear a suit for anything but the most formal presentations and meetings," says Hollenbeck. "Otherwise, I would dress professionally casual—if that isn't an oxymoron."

"My view is that the creative department should be a place where business people go for solutions and a little levity," says Austin Baskett, brand manager for American Crew. "I really don't care if my designers are naked, just as long as the company knows that we can solve its communication and branding problems in a quick, responsive and strategic manner. However, most companies of any size (i.e. ones that have in-house creatives) have a base level dress code."

The very nature of some companies allows for a more relaxed dress code in a more casual environment, as Bob Kilpatrick attests. "At Ben & Jerry's we have a very loose dress code," he says. "Many of us just wear T-shirts and jeans. Anyone in all-black designer mode here would stand out in the crowd, though they would of course be accepted. Hey, we've even been known to take in reformed tie-wearers. My personal style reflects my vision of the brand and of myself: laid back, fun, ready for action, but not unprofessional."

No matter what you wear or where you work, keep the basic rules of decency and professionalism in mind and you will be on your way to establishing a career presence.

CHAPTER 7
IS THE PRICE RIGHT?

Designers of all experience levels are constantly questioning whether they charge enough for their creative efforts. I've always felt that if they have doubts about their fees, the question has already been answered. Through anecdotes, writing and examples others share suggestions about setting fees, calculating and justifying rates, determining markups and dealing with the evil of speculative work.

"Business is like riding a bicycle. Either you keep moving or you fall down."

Frank Lloyd Wright

"Lack of money is no obstacle. Lack of an idea is an obstacle."

Ken Hakuta

"When your heart is in your dream, no request is too extreme."

Jiminy Cricket

THE EDUCATION OF THE DESIGN CLIENT

Any designer has to remain competitive in the marketplace, especially in smaller communities with a small town's perception of what services are worth. Part of the process is educating the client base about the cost, value and time investment of design services. That's been a twenty-five-year process for me—and it continues on a daily basis.

I break down my fees on my estimate sheets and invoices so clients can see exactly where the time is, on any project—and how much it is costing them. The breakdowns are:

- Design/Illustration
- Art Direction
- Copywriting
- Production
- Consultation
- Research
- Misc. Client Services

I also have expenses broken down as:

- RC Paper/Film/Neg Output
- Scans/Camera Services
- Conversions/Computer Services
- Misc. Materials/Shipping

You also have to educate the client about how costs can go up as a result of their actions or lack of action. If the project is a rush job—most often due to poor planning—I'm going to charge them a premium. If an identity project drags on and on due to the client's multiple revisions or indecision, it is the client who causes the cost of the project to increasing—not the designer. When people have legal questions about their business, they expect to pay an attorney who charges them $200 to $350 per hour. Yet, when they place the image of their company in the hands of a professional designer, is that designer's time worth one-tenth the value of that legal advice? I don't think so.

Many designers undercharge for their work, especially when working in an independent capacity. Part of this is the fault of the designers, who may not assign an adequate value to what they do for a living. Another part of the equation is the perception of many clients that such designers don't have "real" jobs and therefore their time is worth less than that of other professionals. As previously mentioned, that is one reason I don't call myself a "freelance designer." When people ask if I'm a freelancer I say, "No, I have my own design firm." It's odd to see how that statement changes their attitude about me as a businessperson.

The client also needs to understand that the average lifetime of a logo—one of the company's most valuable marketing asset—is about ten years. When you pro-rate the cost of an identity project out over that period of time, it becomes a fairly inexpensive investment. It is also worthwhile to have a professional take on the job and do it correctly the first time.

THE BUSINESS OF PLANNING A BUSINESS

Neil Tortorella, of Tortorella Design, is always sharing his expertise, experiences and advice with those in the design industry. One of the best pieces of information he's ever shared is his rough outline for a designer's business plan:

Administrative/Management Plan

- *Business summary*
 - *Your business structure*
 - *Your background*
 - *Key clients*
 - *Services you will provide*
 - *Recent accomplishments and awards*
- *Job descriptions for employees and yourself*
- *Insurance options and needs (health, life, business, etc.)*
- *Your rationale for setting up the business*
- *Leases, contracts and other legalities*
- *How you will manage projects*
- *Key vendors*

Financial Plan

- *Setting your rates (accounting for salaries, overhead and profit)*
- *Setting up your billing*
- *Credit policies for clientele*
- *Setting up your books/accounting system*
- *Pro forma projections for one, three and five years (This should include both revenue and expense projections)*
- *Balance sheet (assets and liabilities)*
- *How you're going to get working capital and lines of credit*
- *Investment strategy and retirement planning*

Sales & Marketing Plan

- *Competitive overview*
- *Geographic marketing area*
- *Profile of targeted prospects*
- *Market potentials*
- *Defining obstacles*
- *Your specialization(s) and why*
- *Your sales techniques (cold calls, networking, etc.)*
 - *Phone scripts*
 - *Intro letter(s)*
 - *Closing methods*
- *Memberships in various organizations*
- *Promotional planning*
 - *Mailings*
 - *Web-based promotion—including a site*
 - *E-newsletters*
 - *Direct mail*
 - *Press releases*
 - *Paid advertising*
 - *Specialty items*
- *Presentation techniques*
 - *Powerpoint*
 - *CD(s)*
 - *Web-based*
 - *Board presentations*
 - *Case studies*
 - *Other presentation materials*

Odds are, your competitors won't have done this kind of homework and that will put you at a competitive advantage. If you do the planning as suggested, your business will be a business. You'll be in a proactive position and not reactive.

You should have enough capital in the bank to carry you for a minimum of three months. Six months is better. A year is great. You'll be spending most of your time doing sales and marketing in the beginning.

A few years ago, a law firm contacted me in a panic to basically save its rear end. Earlier, the firm had opted to cut corners in designing their identity by utilizing the services of a major client's daughter, who purported to be a graphic designer. Through a difficult process, the partners finally settled on a design—although nobody really liked it—and the logo was reproduced on all the print materials for this fifty-person firm. When it came time to invest over $3,000 for a bronze sign for the company, however, one of the partners balked.

When I was brought in to redesign the logo, no one ever questioned my rates. I was stunned when I first saw the original design—the initials of the names of the partners were not even in the correct order of the company name. Within a few days I had recreated the identity and the company began the process of reprinting every piece of printed material it used. This identity project ended up being very expensive—especially because the firm had the privilege of paying for everything twice.

There is this odd perception in the marketplace that if something costs more, it must be better; if the product or service is presented in a professional manner, it must be of higher quality and value. The same phenomenon occurs when people buy clothing with designer labels even though those items are more expensive than similar products made in the same factory for a discount store. Much of this is due to the marketing and promotion of a brand or name.

Often, after I present a potential client with an estimate, the individual will have a bout of initial "sticker shock." Frequently the person comes back to me and says, "The estimate was more than I expected, but you come highly recommended and I want to work with you. If that's what it costs; then that's what it costs." I realize that some smaller companies have severe budget limitations. If the client interests me enough, I explain what the job is worth, based on my estimated investment of time in the proposed project. I then ask what the company's budget allows for such a job. If I can work within that budget figure to take on the commission, that's my prerogative as a business owner. I usually just make the client swear never to tell anyone what I charged for that specific project. In addition, I usually end up donating five or six projects a year to nonprofit organizations, based on guidelines I established for myself.

The bottom line is, if you produce a quality product, work professionally to establish a reputation, market and promote yourself creatively, and take the time to educate potential clients, you should be able to charge clients whatever you feel your time is really worth. If you don't take your

business seriously, clients and vendors won't either.

PRICING: THE VALUE
OF YOUR TIME

If a designer asks "What should I charge for my work?" my immediate sense is that this person should not be in business. Such a request for information tells me that the individual has not done the research and homework necessary to put out his own shingle. Do such designers honestly believe there is one blanket answer to determine the value of one's work?

There is so much more to establishing a pricing structure than just pulling a number out of the air. A designer must seriously consider every factor that determines one's hourly worth. What is your level of experience? What are the going rates in your market or area? What are clients in that market willing to pay? What fee structure is going to give you an edge in soliciting clients—without hurting your ability to make a living?

When it comes to pricing design work, most in the profession seem to have greater concern for the dollar amount attached to the completed project than for the real issue of importance. Your major consideration should be whether you are adequately compensated for one of your most limited commodities: *time*. As a designer you have only a limited number of hours each day, week, month or year. You can't collect or obtain any additional time. When charging clients for work, every designer should seek the greatest value in the marketplace for that limited commodity. It's the old business principle of supply and demand. Your supply of time is predetermined and limited, so the demand for that commodity should help you determine its values.

"I'm a big believer in project rates versus hourly rates. Of course, the project rate relies on an estimate of hours needed, but clients appreciate a known investment," says Michelle Elwell, creative director of SolutionMasters, Inc. "I don't feel a designer needs to worry about being the lowest-priced designer in the area. When you do, you start selling a commodity versus a service. That becomes a trap. Sell your service, sell your experience; no one else out there has you to offer."

"Figure out what your overhead is. Figure out what your time is worth," suggests Rebecca Kilde of Windmill Graphics. "Don't underestimate the time it takes to do all the non-design aspects of maintaining a business. Figure out how much you want to work during the year. Make a pretty good guess."

"Pricing is really tricky. It really depends on the client and their budget and the size of the client," according to TNTOM Design's Travis Tom. "I would suggest going with a figure that the designer feels comfortable making a profit from."

TortorellaDesign
GRAPHIC DESIGN CONSULTANTS

estimate

1419 SCHNEIDER ROAD, NW
NUMBER THREE
NORTH CANTON, OHIO 44720
PHONE: 330.305.1554
FAX: 330.305.0825
E-MAIL: ntortorella@neo.rr.com
Web: www.tortorelladesign.com

client:

date:

purchase order number:

terms: invoiced monthly on the 15th for
activities during previous month

project description:

preliminary design
[insert tasks & deliverables]

$000.00

design refinements
[insert tasks & deliverables]

finished art preparation
[insert tasks & deliverables]

project expenses
[insert itemized expenses]

estimated total

$000.00

please see reverse side for terms and details

Neil Tortorella's estimate form provides clients with a good overview of the time and money required to execute their project, while projecting a professional and "we mean business" attitude with its combined estimate and agreement.

"The only way I see to set rates is though a solid calculation that addresses the designer's specific salary and associated personnel costs (taxes, FICA, insurance, etc.), overhead and a profit," says Neil Tortorella. "Without doing the math, you'll never know what your bottom line is—the minimum you can charge and still make money."

ONE DESIGNER'S HUMBLE SUGGESTION ON PRICING

Designer Charles Hinshaw, of [r]evolve, gave many designers a lot to consider when he posted his pricing ideas on the HOW Design cyber forum. He has allowed his comments to be "posted" here as well.

"The entire concept is built around a single idea: It doesn't matter what I charge for an ad, it doesn't matter what the guy down the street charges for a brochure, it doesn't matter what the *GAG Handbook* says about the going rate for that logo and it certainly doesn't matter for what fee your potential client's nephew will design a web site—you have your own business, your own expenses, and you are offering something completely different from any of us. Why would your rates match any of ours?"

"It is my humble suggestion that when it comes to the description of *creative professional*, the word *professional* is the more important of the two. That is to say that, despite what your art school education may have taught you, you are running a business, not being an artist.

"What does this have to do with pricing? My experience in business tells me that I have monthly expenses, and there are only so many hours I can work in a month. So, if I take those expenses and divide them by my maximum hours, I have a minimum amount that I can charge—because I don't enjoy paying to design, and if I charge less than that, I'm in the red."

"How much would I advise someone to charge for something? It really depends on the situation, the market, your needs, your desires, and how many shiny things demand your money. Being able to justify your asking price and having clients that can afford you are two different things entirely. If the kids next door wanted me to do an annual report for their lemonade stand business, I could easily 'justify' a large fee. The fact that they only have 75 cents to pay me just means that I am looking at the wrong market."

HOW IT ALL NEEDS TO ADD UP

In his article "How do you rate?" which was posted on the About.com graphic design site, Neil Tortorella provides a conversational explanation of how a designer should go about establishing an hourly rate for services.

"The best way to approach the problem is figuring out your bottom

line: where you need to be to really make money. Go below this point and you're paying your client for the honor of working for them. The more work you take on at the wrong rate, the deeper the hole you'll dig for yourself. You can actually 'sell' yourself right out of business with a rate that's too low. Go too high and you'll price yourself out of the market. Once you know your true costs of doing business, you can make sensible decisions.

"The place to start is you. What's your target salary? And let's be realistic here. If you have employees, you'll need to add up all the salaries. On top of that, you'll need to figure in other associated costs like taxes, FICA, insurance, etc. A safe figure is 25 to 30 percent. I lean toward 30 percent. The math looks like this:

- Salary: $40,000
- Associated costs at 30 percent of salaries: $12,000
- Total: $52,000

"Well, that's a start. So how many work hours are there in a year? I'll save you the trouble of digging out that calculator: it's 2,080 hours. Again, if you have employees, you'll need to multiply that by the number of employees.

"Now, if you're like most people, you probably would like to spend a few holidays with the family and you may get a bad cold now and then and need to take a day off. Let's factor

those things into our equation (based on a solo practice):

- 7 legal holidays: 56 hours
- 2 weeks vacation: 80 hours
- 5 sick days: 40 hours
- Total: 176 hours

"Take that off the top of our total hours and we're left with 1,904 billable hours. But, you probably do other things around the office like invoicing, sales calls, surfing the net and reading articles. Well, you can't bill for that time so we'll need to axe those hours too. If you've been a good designer, you've kept time sheets. A review of a few weeks can give you a pretty good idea how much 'down time' you have. Let's use 25 percent down time for this example.

"That brings our billable hours into the more realistic area of 1,428 per year. Now we're getting somewhere! Now simply divide your billable hours into the cost of salaries and voila! You have a rate of $36.41 ($52,000/1428). This is the amount you must charge to get your salary and its associated costs.

"You've got stuff. We all need stuff. Designer stuff includes things like office rent, utilities, phones, computers, software, paper, ink, marketing materials, yada, yada, yada. Now it's time to start adding up all your stuff. The accountants like to call this overhead. Let me pull a number out of the air. Say for our example your overhead costs $35,000 per year. We need to find the percentage of salaries this

overhead represents. Simple. Divide the overhead ($35,000) by the salary ($52,000) and you come up with a little better than 67 percent. Add this to the base rate we calculated earlier:

$$\$36 \times 67\% = \$24.12$$

"36 bucks plus the $24.12 for overhead is a whopping $60.12.

"And there you have it. Now you know you need to charge at least $60 per hour if you want to eat and pay your rent. We also know that we need to contract at least 1,428 hours per year, or 119 hours each month, to make this mark. Pretty neat, eh? We not only solved our rate problem, we also set a sales goal.

"Well, I guess that's about it. What's that the accountant is saying? There's one more thing? What else could there be? Oh! We need to make a profit. Profit is that money that allows our business to grow and expand. It's the left-over nest egg that gives us the ability yo keep employees on when things get slow. It's what allows us to replace the old G-3 with a nifty new G-4 and a Titanium Powerbook to go. Yup, we need to make a profit.

"How much profit do we need? I'd say not to go below 10 percent. 20 percent is better and that's what we'll use for our target. We've established our base rate at $60. 20 percent of 60 is 12, so we need to tack $12 on top. Our final rate, to recover salaries, overhead and a healthy profit, is $72.00. If you're like me, you'll round this amount up to a tidy $75. It just sounds better and adds a slight fudge factor.

"Now that wasn't too bad, was it? The final rate is the number you'll use to do your estimating, whether you charge by the hour or by the job. It's the number you can't afford to go below. No more wondering if you can afford to take on this job or decline that one. You have facts to back up your decisions."

Tortorella's suggested method of coming up with realistic numbers should be very helpful in setting a profitable direction for a design business.

DON'T BELIEVE EVERYTHING YOU READ ABOUT PRICING

Industry books, national association publications, design web sites and graphics magazines are all great sources of information about the issue of pricing. However, designers must realize that most offer only suggestions, guidelines and recommendations to the fee-structure issues faced by those in the profession.

I often hear fresh new designers exclaim things like, "What do I do? I live in Keokuk, Iowa, and my local clients would never pay the rates published in the *Graphic Artists Guild Handbook of Pricing & Ethical Guidelines*. I'd be laughed out of their office and out of business in a week."

First of all, take a deep breath. Second, while the *Graphic Artists Guild Handbook of Pricing & Ethical Guide-*

lines may be considered one of the "bibles" of the industry, that doesn't necessarily make all that is written in its pages the gospel. Use the information and rates published in the book as a guideline for establishing what will work in your own city. What works in the towering offices of New York City is not likely to make a potential client happy on the main street of Keokuk.

Another incredible resource for any designer is *Business and Legal Forms for Graphic Designers* by Tad Crawford and Eva Doman Bruck. In the introduction to their book, the authors write: "The knowledge and use of good business practices are essential for the success of any professional or company, including the graphic designer and the design firm."

Their book provides the information systems and forms needed to run a professional design firm—with a CD-ROM of the forms included. Again, this book may not provide the documentation that fits your needs exactly; however, it is full of ideas on how to effectively operate a successful design business.

Be realistic. Be smart. Do your research. Don't be afraid to look stupid occasionally when asking the questions to which you need answers to make a success of your business. Set realistic prices that are not so high they discourage work from coming your way, but at the same time are not so low that you are going to be considered a "bargain basement" designer. It's not going to happen overnight. You may need to play with your pricing a bit to see what works best for *you*, at *your* level of expertise, for *your* clients located in *your* market.

JUSTIFYING THE VALUE OF YOUR WORK

When I first started charging for art and design work, in my early teens and throughout high school, I actually felt guilty charging for something I enjoyed doing so much. Many of those pre-college projects were commissioned without any real conversation or agreement as to the final cost of the job. I'd complete the project and then say "I don't know" (while looking at the floor and shuffling my feet) when the client, often a family friend, asked "Now, how much do I owe you for this job?"

These days I'm much more direct about the value of my work. Initially, I inform the potential client of my rates and attempt to provide some education as to the value of such services. If a possible client balks at my fees, or asks if I can do the work for a lesser fee, I usually inform them that I am not the designer for the project. I'm not going to invest my time, energy and abilities in an effort to satisfy a client who has budgeted $200 (as requested more often than I ever would have imagined) for a logo to introduce and represent their business.

Illustrator Joe VanDerBos has become an entrepreneurial type designer in a break from his "day" job. Design work also helps him rake in a bit more revenue.

With the international market opened up by the Internet, it can be much more challenging for designers to convey the value of their work to clients with no previous experience with professionals in the field. The $19.00 logo web sites, the online "designers" of $50.00 web pages, and Internet bidding sites—with design projects going to the lowest bidder—make demonstrating value even more difficult at times.

"Most clients understand that they are hiring me for an expertise that they do not possess," says Wendy Constantine of W.C. Design Studio. "If an explanation is needed, I tell them that I can help them visualize solutions to their identity/communications issues and work with them as a collaborative team member to give form to their business strategies."

"It's an old sales phrase, but you sell benefits, not features," says Michelle Elwell of SolutionMasters Inc. "You show them examples of other work for similar clients (not necessarily in the same industry but with similar goals) and explain how you were able to help them. Show clients pretty designs that will use the newest cutting-edge technology and their eyes will often glaze over. Show them a postcard campaign that delivered a 30-percent return response resulting in a 15-percent increase in sales for the quarter and suddenly they are shaking their heads *yes*."

THE MYSTERY OF
MARKUPS

Prior to the design industry's becoming one of digital imagery, e-mail, PDFs and the other wonders of computer technology, annual out-of-pocket expenses for client projects was quite high. The cost of art supplies, typesetting, stats/PMTs, film output, printing and the services of other outside vendors was automatically marked up 15 percent and passed on to the client.

Today expenses for client projects are minimal. At this point, I still mark up such expenditures by only 15 percent as a cost of doing business.

"If I pay for it, I mark it up 20 percent," says Neil Tortorella. "I don't run printing through my business, though. It's always billed directly to the client for two reasons. First, it's a lot of dough to cough up if the client doesn't pay or if there's a problem. Second, I think that printing markups may have the client wondering in the back of their mind if certain solutions and printing techniques are really needed or valid. After all, a 20 percent markup on a die-cut, embossed, foil-stamped four-color plus vanishes brochure is going to be a whole lot more than a simple two-color job. By not marking up printing, I feel my 'believability' in the client's mind is much stronger when I present a solution. They respect my objectivity."

"I consider most out-of-pocket expenses a service to the client. I mark them up a bit to cover my expense in finding and purchasing them, and add that cost to mileage expenses," says Rebecca Kilde.

"We handle the majority of the printing costs by marking up the project accordingly," says Catherine Morley of Katz <i> Design Group. "For pro bono, not only does the client handle the costs, but they deal directly with the printer and any problems that occur. If a client wants to handle the printing (and this rarely happens) we charge a handling fee to cover any problems that may have to be sorted out with the printer."

Any way you want to handle it, it's often smart to mark up any expenses you have to cover, to make up for lost time and coordination hassles.

ENDING THE SPECULATION
ON SPEC WORK

A request for spec work by any potential client is nothing but B.S. That may sound harsh, but if a client can't make an educated decision to hire a designer—based on a portfolio of past work, the recommendations of others and a personal interview—the designer should run as fast as possible from the potential customer's office. Don't buy the argument that clients should be able to "test drive" a designer as one would test drive a car. A designer has only a limited amount of time in any given day, week or

year. As much of that time as possible should be billable. Designers do not have time to play a lottery in an attempt to "win" a client.

"As any other pure-blooded professional, I am strongly against speculative work," says Bytehaus Studio's Habib Bajrami. "It undermines me as a creative professional and undermines the entire industry, drives prices down and is downright unethical. Whenever I get a chance I voice my opinion and fight against it. To sum it up, spec work is a fruitless tree."

"I do not take on spec work for any project, as I believe the client should value the design process and involve the selected designer collaboratively in providing a solution," adds Wendy Constantine.

At times a speculative project can slip in under the radar if you are not closely paying attention. The potential client has called with a great project. As a designer you are thrilled at the opportunity to work on such a piece. The adrenaline is pumping, and undoubtedly you've already told a few friends or peers about the upcoming job, when suddenly you are knocked on your ass with the realization the whole thing is a spec job.

Such a situation drew me in and stunned me this past year. For a week and a half, a potential client made numerous attempts to arrange a meeting to discuss designing the identity for a new restaurant and bar—which eventually would go nationwide. His secretary called several times over a period of ten days, changing the time and place (already wasting my time before any kind of client relationship has begun). The secretary would not give me a mailing address to send any marketing materials or additional info in advance. (RED FLAG!) I finally tracked down a mailing address on the Internet and mailed a marketing packet, which explained how I did business.

I finally got to the meeting, when the first thing the guy said is that he hadn't taken any time to look at the

JEFF'S RULES ABOUT SPEC WORK

1. Always trust your gut instincts. Unfortunately, slimy people are everywhere and you don't need to waste your time, energy or talent on project situations that make you feel uneasy.
2. Do no work for anyone (concept or otherwise) without a contract or as a condition to be hired by a potential client for future work.
3. Feel good about telling the potential client that the manner in which you do business does not include speculative design—and explain why.
4. Don't let people attempting to take advantage of you "sour" you on the graphic design profession. They are the problem, not you.
5. If the project initially sounds too good to be true, it probably is.

work on my web site because he knew what he wanted and would be able to tell me so when he saw it. (RED FLAG!) He patted the packet of material I sent him and said he "didn't have time to read such things." (RED FLAG!)

Then he mentioned another designer had presented him some rough concepts and "he didn't know where that guy was coming from." Another designer? Nobody had mentioned another designer. (MAJOR RED FLAG!)

Next he started showing me rough designs he had done himself on his home computer and said, "You might even see something here you like that you could fine-tune for fifty bucks or something." (HUMONGOUS RED FLAG!!) I listened to all he had to say—already knowing I was not going to work with this guy. The clincher was when he said, "Why don't you just put a couple hours into some rough concepts and we'll see if we will hire you to do this job." (MAYDAY! MAYDAY! MAYDAY! WHOOP! WHOOP! WHOOP!)

That's when I told him I do not do speculative work. I told him I was obviously not the right designer for his project, thanked him for his interest in my work and wished him all the best on his venture.

Shortly after this experience I drove by the newly opened eating establishment. The logo on the signage appeared to be much like some of the designs the owner had done on his PC at home, and would not translate successfully to many applications. Since then the restaurant has gone out of business.

"Years ago I was approached by a bank for a rush job," explains Catherine Morley. "It was Saturday, late, and they needed the design by Monday—pleeeease! As it was such a rush, I neglected to get the contract and deposit taken care of. I jumped to the challenge, working through to Monday to get the three designs finished.

"On Monday, I sent the project by courier. Silence. Then I faxed the details I neglected to take care of before starting the project. Silence. As I knew time was running out, I went over my contact's head and called the manager, only to be told the project had been sent out to several design companies. It was a spec job. Because I didn't follow my own rules, I was sitting there with three very nice designs and no one was going to pay for them."

"Personally I'm not an advocate for doing spec work," says Michelle Elwell. "Personal experience tells me it is possible to get both large and small jobs without it. Ad agencies have basically created a monster that has come to expect to be fed. If they were to suddenly deny the monster, someone else would be ready to feed it."

Elwell identifies a factor that potential clients may use to justify requests for speculative work. Many

advertising agencies have good-sized staffs, a number of minions, and large budgets to cover the costs, time and energy needed to compete with similar firms for the dollars of a possible client. This simply is not necessary for small or independent firms, and you can save yourself a lot of trouble (and time and money) by refusing to do spec work.

NO ONE EVER SAID
IT WOULD BE EASY

In *The Graphic Designer's Guide to Pricing, Estimating & Budgeting*, Theo Stephan Williams sums it all up. She writes: "I promise you that the three hardest things you will ever do in the business of graphic design is figure out how much to charge for your services, how to do an estimate, and how to manage project budgets completely and efficiently."

The only thing worse than a potential client who does not value the efforts of a professional graphic designer is a designer who doesn't appreciate the value of his or her own time and work.

WHY SPEC WORK IS BAD

In an article published in the Fall 2000 edition of Exchange, the semi-annual journal of the Toronto-based Design Exchange, Julia Dudnick-Ptasznik outlined her major objections to speculative design requests. The piece also appeared on the web site VisualArtsTrends.com.

Spec work is a problem because:

1. It's exploitative. It requires the designer to perform services free of charge, without any guarantee of compensation. Further, it is inappropriate for small-scale design projects, because the work performed often constitutes the entire project.

2. It's unethical. It essentially amounts to buying new business and doesn't fall far from bribery. It also fosters an unhealthy competition environment among designers and firms bidding on the same project.

3. It offers no future potential. Many designers hope this is going to lead to future ongoing business, whereas the reality is that clients who adopt this vendor selection method tend to apply it to every project.

4. It can lead to copyright infringement. There are numerous cases where a design house, initially told that it has not been awarded the project, has found its work used either in its entirety, or as the basis for creating the actual project, without the original designer's knowledge, consent, and without appropriate compensation.

5. It negatively impacts the entire design industry. As long as there are designers providing services free of charge, the practice is going to continue to flourish and to erode the professional status of designers in all disciplines.

CHAPTER 8
SIGNING ON THE DOTTED LINE

Why are certain designers, with not a clue about business, in business for themselves? Ask them directly, and one may get a response such as, "Well, it's about art, not business" or, "I always thought it would be fun to have my own business." Get over those thoughts right now. Graphic design may be an art, but for you to successfully make a living at it you have to realize that it is a business. You had better be prepared for a good dose of reality and some very hard work as well.

"The hardest thing in the world to understand is income tax."

Albert Einstein

"No one should drive a hard bargain with an artist."

Ludwig Van Beethoven

"Common sense is the knack of seeing things as they are, and doing things as they ought to be done."

Harriett Beecher Stowe

WHO'S AFRAID OF THE
BIG, BAD CONTRACT?

Working without a contract is a sign you don't take your business seriously. I often hear designers comment that it takes too much effort to deal with contracts. In fact, without a contract, you may expend much more time and energy working to collect the money you have already earned.

If the word *contract* frightens you or your potential clients, change the name. My own contract is called a "project agreement," which is a much less threatening term. It also better explains the purpose of the document: to simply outline the project terms the client and I are agreeing upon. My agreement document has evolved over the years, with information gleaned from a variety of sources, including the *Graphic Artists Guild Handbook*, Ed Gold's *The Business of Graphic Design*, other published sources and my own experience. I also had my attorney review the document in its original format, and whenever it has been edited or altered over the years.

I've always kept my project agreement to one page, in an effort to avoid possibly scaring away the good clients with too much legal mumbo-jumbo. With that limitation, the type size has gotten smaller and smaller over the years as I've revised and altered the document. Some designers send potential clients multipage contracts, written in language only an attorney could decipher. Receiving such a document might make some clients reconsider working with the designer putting it in front of them for a signature.

In *The Graphic Designer's Guide to Clients*, Ellen Shapiro explains that dealing with a contractual agreement does not need to be a scary process— for designer or client. "A contract or a working agreement doesn't have to be long and complicated," writes Shapiro. "It can be short and sweet. It can even be part of your proposal, a page that sets out the terms and conditions of the relationship that, in hiring you, the client has agreed to."

Shapiro stresses, "It's important that at least the following is covered: A description of the work you will provide. The fee. What items are not included in the fee, such as out-of-pocket expenses, and how they will be billed. How the client will pay, and when. Who owns the rights. Clauses like client's responsibility for errors and omissions and for getting copyright clearances are important, too."

On the other hand, if your contract or agreement does scare a potentially bad client away with a good dose of reality, to quote Martha Stewart, "It's a good thing."

"Want to find out if a prospect really intends to hire you or is just yanking your frank?" asks Linda Formichelli in her 1099.com article, "Are Your Prospects Worthy?" "Show him a typical contract (if you have one). If he runs screaming in the other

PROJECT AGREEMENT:

JEFF FISHER

LOGO

MOTIVES

Date:

Company: Contact:

Address:

City, State, Zip:

Phone: Fax: E-mail address:

PROJECT DESCRIPTION:

ESTIMATED COSTS:

☐ Labor fees (design, art direction, production, copywriting, client services, etc.) are estimated at a total of $_____ or ____ see attached estimate sheet for specifications.

☐ Consultation fees are estimated at a total of $ _____ or ____ see attached estimate sheet for specifications.

☐ Materials costs (RC/film/neg output, scanning, project specific materials, etc.) are estimated at a total of $_____ or ___ see attached estimate sheet for specifications.

Total estimated cost of project: $_____ Project estimates are valid for 90 days from the date of estimate. Project may be reestimated if, upon receipt of all project elements, the designer determines the scope of the project has been altered dramatically from the originally agreed upon concept. Printing fees will be estimated separately and payment arrangements made between client and printer.

PAYMENT SCHEDULE:

☐ A deposit in an amount equal to 25% of the total estimated cost is requested prior to execution of the project ($_____).

☐ Payment in full or the remaining balance is to be paid upon delivery of the completed project. A cash discount of 5% of the total project **labor and consultation** cost is offered to clients paying upon delivery of the finished project.

☐ Payment in full or the remaining balance is to be paid 15 days from receipt of the final invoice for the completed project. **Finance charge of 1.5% per month (18% annually) on all overdue balances.**

☐ Additional payment arrangements:

REPRODUCTION OF WORK:

☐ The client assumes full reproduction rights upon payment for completed project.

☐ One time reproduction rights for the specified project, at the agreed fee, are granted to the client. Any other usage must be negotiated.

☐ All reproduction rights on the copyrighted work are retained by the designer. The work may not be reproduced in any form without consent from the designer.

☐ The designer retains personal rights to use the completed project and any preliminary designs for the purpose of design competitions, future publications on design, educational purposes and the marketing of the designer's business. Where applicable the client will be given any necessary credit for usage of the project elements.

REJECTION/CANCELLATION OF PROJECT:

The client shall not unreasonably withhold acceptance of, or payment for, the project. If, prior to completion of the project, the client observes any nonconformance with the design plan, the designer must be promptly notified, allowing for necessary corrections. Rejection of the completed project or cancellation during its execution will result in forfeiture of deposit and the possible billing for all additional labor or expenses to date. All elements of the project must then be returned to the designer. Any usage by the client of those design elements will result in appropriate legal action. Client shall bear all costs, expenses, and reasonable attorney's fees in any action brought to recover payment under this contract or in which LogoMotives may become a party by reason of this contract.

COMPLETION/DELIVERY OF PROJECT

The estimated completion date the project is _____. Any shipping or insurance costs will be assumed by the client. Any alteration or deviation from the above specifications involving extra costs will be executed only upon approval with the client. Any delay in the completion of the project due to actions or negligence of client, unusual transportation delays, unforeseen illness, or external forces beyond the control of the designer, shall entitle the designer to extend the completion/delivery date, upon notifying the client, by the time equivalent to the period of such delay.

Post Office Box 17155
Portland, OR 97217-0155

ACCEPTANCE OF AGREEMENT:

The above prices, specifications and conditions are hereby accepted. The designer is authorized to execute the project as outlined in this agreement. Payment will be made as proposed above.

Phone: 503/ 283-8673
Facsimile: 503/ 283-8995

Client's signature _____

jeff@jfisherlogomotives.com
www.jfisherlogomotives.com

Designer's signature _____ Date _____

A combination of research in industry business publications, consultation with an attorney, and personal experience resulted in the project agreement used by Jeff Fisher. The digital document is easily customized to the specific client or the concerns of the designer.

direction, chances are he was unqualified to hire you.

"By qualifying or screening your prospects—and culling out tire kickers—you can spend more time with those who are serious about hiring you and less time with those who are merely lonely and looking for a friend," Formichelli continues.

Valarie Martin Stuart is a design instructor as well as a designer. In her teaching, she stresses the importance of business principles.

"Every semester, I introduce a discussion on the business of graphic design," says Stuart. "This always includes the following: 'Never do work without a contract. (Rinse, repeat, ad nauseum.)'

"I dedicated one lecture to contract and copyright law, and had an exam on the subject," Stuart adds. "Question no. 1, verbatim, was: 'If you are working as a freelance designer, what should you always have before you start a project?' I'm pleased to report that all my students got this one correct. In fact, the majority of the answers were written out like this: *A CONTRACT!!!!!*"

CREATING A CONTRACT WITH TEETH THAT WON'T COME BACK TO BITE YOU

A generic business contract is probably better than nothing, but few of those on the market or available online are really going to fit your specific needs. Many designers create their own contracts, letters of intent or project agreements, but designers are not lawyers. There is always the possibility that a self-created document may not hold up in a court of law. Have an attorney, especially one with experience in the creative fields or business law, look it over and tweak it a bit with some "legalese." The more professional your document reads, the more seriously it will be taken by potential clients.

Numerous examples of design contracts are available for review. The About.com Graphic Design site has several posted for review and liberal "borrowing" by those in the design profession. There's nothing wrong with this. It's often helpful to begin with a model and tailor it to suit your needs. We are in this together; when designers throughout the profession start demanding that their clients sign contracts, graphic design itself may be taken more seriously, and its practitioners may be regarded with a higher degree of professionalism.

Ed Gold's industry standard, *The Business of Graphic Design*, gives examples of possible business documents for those in the field to use. *The Graphic Designer's Guide to Pricing, Estimating & Budgeting*, by Theo Stephan Williams, provides readers with a great deal of valuable information and proposed text for business documents. *The Business Side of Cre-*

ativity, written by Cameron S. Foote, is also an excellent resource, as is his web site, CreativeBusiness.com, which provides documents and business-related articles for free and subscription downloads.

ELIMINATING THE ASSUMP-TIONS OF A BUSINESS
RELATIONSHIP

Designers should always use a contractual agreement—especially with friends and family. With a contract—for a friend, a family member or the business down the street—all details of a project are spelled out in black and white. Each party knows what is expected of it, the scope of the project is described, deadlines to be met are specified, the transfer or retention of rights is detailed, and the financial terms of the business transaction are explained. Nothing can be assumed, down to the smallest detail of a business arrangement or the expectations of each party involved.

Michelle Elwell's firm, Solution-Masters, Inc., always uses a contract in some form. "Many of our projects are with clients that do repeat and continuing business with us. As for whether I believe that a contract makes potential clients take us more seriously, I would think that it does. A good contract protects both the client and the vendor. We would both be remiss to forgo one."

Rebecca Kilde, of Windmill Graphics, also feels that a contract makes clients take her more seriously. She adds, "It also shows the client that I am taking them seriously."

"The question of using contracts?" says Julia Dudnick-Ptasznik of Suazion. "The answer is yes, always, without exception. Unfortunately, many of us learn this necessity the hard way, through instances of non-payment, other project-related losses of revenue and legal problems after the completion of a project."

"I work with an informal project agreement most of the time," says Travis Tom of TNTOM Design. "I think it makes the process more professional by letting each party know terms of ownership and milestones for when payments are due."

Independent designer Neil Tortorella explains that he doesn't use a legal document for every project. "When I

BASIC ADVICE FOR DESIGN BUSINESS SUCCESS

Clement Mok offers these suggestions:
1. Be clear about what value you bring to the table.
2. Be clear about why you are in the design profession to begin with.
3. Be clear about what role you want to play: will you lead, or play a supporting role?

first sign a new client, I use either a signed proposal/contract or a letter of agreement that covers our working relationship for subsequent projects."

Once the "rules of play" have been established with a client, you may not wish to require a signed project agreement for each individual item you design. With an initial agreement in place, and a successful series of projects under your belts, it's easy to proceed with clients in such situations without taking the time and energy to establish documentation for each individual piece to be designed. Time is of the essence with some larger corporate clients, and attempting to guide numerous project agreements through the maze of corporate channels necessary to get a signature could waste valuable time. Still, having that first contractual agreement signed and on file will give you evidence of the client's understanding of the particulars of the business arrangement, the manner in which work will be produced, and the expectations of both client and designer.

The bottom line is that every designer should use a contract for every project. It shows the client that you mean business and conduct that business in a professional manner.

THE TERMS OF ENDEARMENT AND GETTING PAID

Each designer needs to establish his or her own comfort level when it comes

to getting paid and setting up payment terms in a contract or agreement.

I require a signed project agreement and a deposit of 35 percent of the estimated total, prior to even beginning work on any design project. That is enough of a commitment for me to feel that the client is really serious about the effort and that it is safe to proceed. Unlike some other designers, I do not require a mid-project payment. When the job is completed, I invoice the client. My invoice states that net payment is due in fifteen days. Overdue balances are addressed with a monthly statement and a finance charge of 1.5 percent per month.

Different designers use the payment methods best suited to their own specific business and cash flow needs. "In days gone by," says Neil Tortorella, "I used the 'three-thirds-phased' method. First third due on acceptance of the project; second on presentation of the comps; and the final third on completion. The problem was that many projects I worked on were larger, multipage brochures that took six months or longer to develop. The cash flow was too stretched out. I've since changed to billing monthly for tasks completed during the previous 30 days."

SolutionMasters, Inc. deals with payment issues on similar terms. "We generally work on larger projects that enable us to split the client investment into three payments: one-third at contract signing, one-third after

design comps are delivered and approved, and the final third upon delivery." Michele Elwell goes on to explain that "smaller projects are broken out into one-half at contract and one-half at delivery. We don't extend terms. Any changes to spec are billed monthly at an hourly rate; or in cases where they are quite large, we will treat them as a second project and bill them under a separate agreement with appropriate deposits made."

"I usually require a 50 percent deposit and the final invoice is payable upon receipt," says Habib Bajrami of Bytehaus Studio. "On projects that span over few months, I bill on a monthly basis for work performed during each month."

The payment terms for your work should match your comfort level with your business finances. Once you establish the boundaries within which you are most comfortable working, stick with them and don't back down when negotiating specifics with a potential client.

TEMPORARY INSANITY:
WORKING WITHOUT A CONTRACT

We have all done it at some time in our career. We trust that great client that we just met and decide to take on the project dangled before us like a carrot on a stick—without using common sense and getting a signed contract or project agreement.

I remember the first time I really felt like I was getting burned by a client. Admittedly naive, I had taken on and completed a design project without having a signed agreement or getting a deposit check. I delivered the invoice with the finished artwork, hoping the client would pay soon because I needed the money. A few weeks later I had still not been paid and I put in a call to the client. I sent a second invoice—adding the finance charge noted on my original invoice. Nothing again. I stopped by the client's office one day and was told he was in a meeting. This went on for several months.

Finally, I got pissed off. First, I sent a certified letter to the client, which he had to sign. A receipt was sent to me as verification he had gotten my letter and yet another copy of the invoice. Nothing happened. So I then went to the local courthouse and paid the necessary fees to file a small claims action against the client and have him served with papers by the sheriff's department. A court date was set and I was a nervous wreck. Although I had a couple of signed proofs and some other documentation of the project, I had no signed contract authorizing the job. By now I assumed I would never collect my money. In addition, I was out the filing fee, the serving fee, the cost of the certified letter and a lot of time.

The court date came and I figured the client would not even bother

showing up. I arrived at the courthouse by myself and saw that the client had appeared—with his attorney. When the case was called, the judge asked me to explain what had happened and present him any documentation I had. As I completed my presentation I saw my client squirming in his chair as he whispered to his attorney. The judge looked over at the client and said, "It is very clear that you owe this individual for his services. Why have you not paid this bill?"

My soon-to-be ex-client actually said, "I thought the invoice was for something I had already paid."

The judge scolded the client for making no attempt to contact me for clarification of the invoice and for allowing such a matter to end up in court. He was ordered to pay the $400 he owed me (this entire matter was over $400!) and reimburse me for all court costs before he left the building. Then the judge looked over at me and said, "Young man, I would suggest that you always use a contract in your future business dealings."

Julia Dudnick-Ptasznik relates the story of one of her near-fiascos: "One relatively recent example was a print newsletter, which had a big textual mistake in it. Upon realizing the mistake, the manager on this project had wanted to protect herself by having my firm correct the mistake, reprint the newsletter, and cover the cost—which would have resulted in a loss of about $10,000. I immediately pulled

out blueprints signed, "approved for production" by this manager. Her response was, "I never read the entire thing at the blueprint stage; I only check that specific corrections have been made."

At which point, I pulled out the contract, which explicitly states: 'The employees of Suazion carefully review all work supplied to client. However, it is the client's responsibility to review and approve all production art and to proof and approve all final materials.' She couldn't argue with that."

Use a contract for every project, so you have a safety net to fall back on if things should get ugly.

THE BUSINESS OF PLAYING
THE BUSINESS GAME WITHIN A BUSINESS

Being a member of an in-house design team opens up an entirely different set of challenges for anyone in the design profession. Justifying annual budgets, getting lost in corporate paperwork, playing nice with other team members, attempting to communicate the value of "making pretty pictures" and doing the "tip-toe dance" around office politics is sometimes enough to make a designer long for the days of spray glue or fixative fumes.

"Each department creates a budget for itself every fall and submits it to our executive offices," says Amy Silberberg of Elvis Presley Enterprises, Inc. "My director asks me to submit

any upcoming expenses or proposed expenses that I feel need to be included in the budget. Occasionally, if there are several new expenses on the list, I'll prioritize them, in case everything requested can't be approved."

Presenting proposals, or projects to the "decision-makers" can often be an obstacle for the in-house staff. "Sometimes quality has to come before price and you have to defend that to the individuals that will decide, when sometimes all they see is the bottom line," adds Silberberg.

Keely Edwards, manager of graphic services for Carter BloodCare, concurs. "Very often it is necessary to defend or explain the value of a project. I call this 'pitching the job.' Some positions have called for me to do this more than others," she says. "I've often had to formulate and communicate definitive approaches. It is an excellent method to strengthen communication between your creative service department and other departments within the organization. It is also an excellent exercise in exploring and understanding your own creative approaches."

Andy Epstein of Gund feels their design department would "fall apart" without the documentation to track projects. He says, "We have a project request form, sign-off/approval forms and vendor spec forms and we use them religiously.

"The single biggest challenge I face at Gund," explains Epstein, "is com-municating the value of good design to our bottom line, especially because we don't use focus groups. I've become more careful about looking at past projects and their results when making a case for a new initiative. I also read graphics and marketing trade and industry publications that address this topic and use their explanations when making a pitch."

"There are an immense number of things that must occur, especially when we are talking about promotional build out of products in our manufacturing facility," says American Crew's Austin Baskett. "We have an entire project management system that helps us track and keep up-to-date on when items need to be produced by."

"I work closely with the president and vice president of sales to justify all programs and projects," Baskett adds. "No decision is made just by one person. We all weigh the pros and cons and decide to move forward or not based on the benefits, spending, revenue, sales goals and other considerations."

The legalities and financial aspects of working in-house brings up more of those "there are no stupid questions" situations. If you personally don't know the specifics of a particular situation, take the time to clarify the matter with the people who have the knowledge—or simply defer to those who can better explain the details. You will save yourself a lot of stress and grief in the

process. It may also save your in-house department—and thus the entire company—a great deal of money.

SOME OF MY BEST FRIENDS ARE ACCOUNTANTS AND LAWYERS

Designers may not be the best business people. Some are. But many aren't. Even the independent designer needs a fine-tuned "team" of business professionals to assist and advise in day-to-day operations and all major business transactions. Ed Gold, in *The Business of Graphic Design*, suggests a support system he refers to as "the Gang of Four."

"Longstanding relationships are worth building not only with your banker, but with three other key professionals as well: your accountant, your lawyer and your insurance agent," writes Gold. "All four can be important advisors and supporters. It is worth the effort to find persons in each field with whom you feel rapport and trust."

Today the average support "gang" may need to include more than just four members. How should one go about finding lawyers, accountants, bookkeepers, tax specialists, business coaches, marketing professionals and others to help your business? The best advice is to ask others in the business what outside resources they use on a regular basis.

After many years—with tax laws seeming to change on a weekly basis—I came to the conclusion that only a fool would do his own business taxes. When I needed an accountant, I asked two of my friends and they both recommended the same person. The man in question not only worked for a wide variety of small business operations, he also had experience dealing with those in the graphic design profession. Finding someone with such experience is a major advantage. You will not be spending your time educating the individual on the unique—and sometimes odd—aspects of the design business.

Some designers, like Travis Tom of TNTOM Design, don't have to look far for such resources. "I have three family members who are accountants and two of them are CPAs. My aunt is a CPA in town and she handles my year-end tax forms."

Amy Stewart of Stewart Design, confesses, "I think that learning to value my time and price it according to its value was a hard lesson to learn. I used to routinely underbill my time out of guilt, inexperience and insecurity. As I became more established, and with the help of my husband and business partner, I finally started charging what I was worth, and finally feeling like what I charged was worth it. My husband, a chartered accountant, is really the one responsible for making our design business into a proper and profitable business.

Enlisting the help of an accountant was essential."

Local chamber of commerce groups, business organizations, Small Business Development Centers and the Small Business Administration may also offer opportunities to come in contact with the professionals you may need to take on a particular business task.

Any designer who claims to be capable of successfully handling all aspects of a business is basically insane. Bring down the stress level, allow yourself time to actually design and maintain some degree of sanity by letting go of some of the duties that may be better executed by the experts.

FROM THE OUTSIDE
LOOKING IN

While it may be helpful for some of your business supporters to have an understanding of the particulars of the design field, it is also an asset to have reliable outside resources, who can look at your needs primarily from a business perspective.

Michelle Elwell says, "We have a close team with diverse backgrounds. That helps in making business decisions. When there are times that an outside opinion is helpful, we do have a diverse cast of associates and friendships outside our firm that we can go to. It aids in giving a broader overview of the market in general and that of our clients."

Rebecca Kilde also stresses the value of consulting with those not associated with the daily business operations. "I rely on my sister, a successful business-owner, and my friend, a CFO, for most of my financial advice. Theo Williams' *The Streetwise Guide to Freelance Design and Illustration* and the *GAG Handbook of Pricing and Ethical Guidelines* have been major resources for me."

It's often helpful to have the input of design industry peers who have experienced the same, or similar, business challenges. In this case, Internet forums can be a wonderful resource.

Catherine Morley, of Katz <i> Design Group, says, "If I have a business problem, I generally e-mail a growing group of design friends from around the globe, or I post on the about.com Graphic Design web site."

Not only do I have my own "gang of four" in place; I also have a tremendous network of friends, clients and others who make up the support group for my business. These are experts in their own fields whom I can call at any time for a quick answer to a business question or an unbiased perspective on a particular issue. Work to develop your own support network, and you will be able to overcome any obstacle.

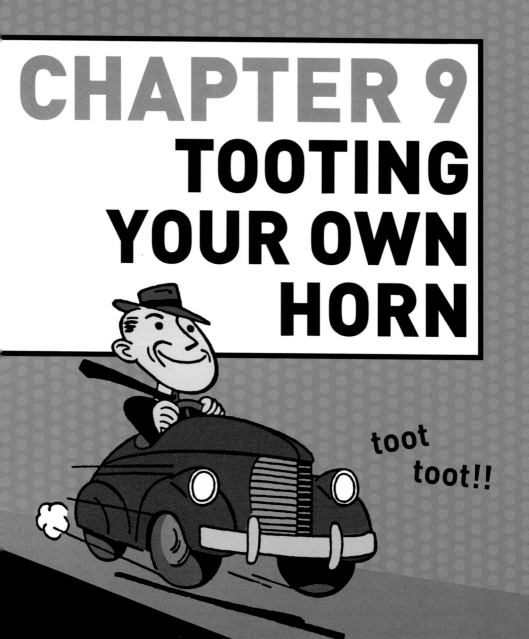

"If you build it, they will come" was the haunting message from above in the movie *Field of Dreams*. However, clients are not going to magically appear unless they know what you have to offer. The reality of the business world—including the design world—is a bit harsher than Hollywood, with its instant, magic following. That is where marketing principles come into play. Designers must consider a myriad of methods to get the word out, from direct mail to press releases.

"I figured that if I said it enough, I would convince the world that I really was the greatest."

Muhammad Ali

"Early to bed, early to rise, work like hell and advertise."

Ted Turner

"The business that considers itself immune to the necessity for advertising sooner or later finds itself immune to business."

Derby Brown

PRESS FOR SUCCESS

Designers must constantly promote themselves—especially when conditions are at their best, so work will be coming in the door when the economy takes a turn for the worse. I think the biggest mistake regarding self-promotion that most designers consistently make is to wait until there is no work on their desks before beginning their own marketing efforts.

In *BRAG! The Art of Tooting Your Own Horn Without Blowing It*, Peggy Klaus writes: "Promoting ourselves is something we are not taught to do. Even today, we still tell children, 'Don't talk about yourself; people won't like you.' So ingrained are the myths about self-promotion, so repelled are we by obnoxious braggers, many people simply avoid talking about themselves."

Still, you must make your potential client—or employer—aware of who you are, your capabilities and what you have to offer. Doing so may require walking a fine line between coming across as an obnoxious braggart and presenting a finely honed, savvy marketing message.

WHAT WORKS FOR YOU?

Hey, this marketing thing really works. Do good work, put an unusual spin on things, schmooze a little, make others aware of what you are up to—or even be a bit outrageous—and people will take notice.

You don't necessarily have to use tried-and-true methods simply because that's what everyone else is doing—or has done in the past. Test various marketing tools over time, determine what you are comfortable doing and evaluate the results on an individual basis. Do what works for you and give whatever methods you select some of your own personality.

OPEN YOUR MOUTH AND SAY...

Word of mouth is a great form of advertising. A happy client telling a potential client about your work brings that individual to you with a "stamp of approval" from a trusted source.

Julia Dudnick-Ptasznik, of Suazion, solicits favorable word-of-mouth referrals from satisfied customers. "I think past a certain point—once you are established within the industry and if your work is good—you start turning away business, which generally pours in on word-of-mouth referrals. When I first realized I had more work than I wanted to be doing about five years ago, I gradually phased out the least profitable and least interesting accounts, mainly by passing them on to younger designers."

"Then I realized that there was something more here, and started thinking along the lines of 'this is the kind of work I need to be doing,' says Dudnick-Ptasznik. "Then I started marketing, but quite simply—by ask-

ing my best clients for referrals in a very informal manner. Now I try to ask for referrals at least twice a year. Given the personal recommendations of happy clients, securing new assignments is usually as easy as sending an e-mail with a PDF attachment of a corporate profile."

Something else to consider is that word-of-mouth can also be your worst form of advertising. A customer who has had a bad experience with a business is much more likely to convey negative feelings and comments to a wide circle of contacts.

Business networking falls into that word-of-mouth category. Often it needs to be the "word" from your own "mouth." Get out there and meet people. Let everyone you know, including your neighbors and relatives, really understand what you do for a living. This is not the time for the "I'm just a graphic designer" response to the question "What do you do for a living?"

Join business organizations to increase the public profile of your business. With a little research and "test driving," determine what type of organization will bring you in direct contact with potential clients. When considering involvement in an organization, or actually attending a association activity, ask yourself this question: "Are the members of this group in a position to need graphic design, purchase my services and possibly tell others what I have to offer?" If not, find a group that fits the bill.

Wendy Constantine, of W.C. Design Studio, is an advocate of face-to-face networking. "I've found that most of my clients either initially meet me personally and want to work with me, or are referred to me from a client, friend or associate," Constantine says. "I attend all sorts of networking meetings, and the fruits are rarely seen immediately. Eight months later it is not unusual to get a call or e-mail from someone who learned of me from a contact I met at a networking event. There is no substitute for face-to-face marketing when you are building trusted client relationships."

If membership is not for you, meet those associated with the group by attending their events, seminars and conferences and "work the room."

Successful marketing and promotion does often require that designers push themselves away from their desks and wander out into the real world. It may not be the most comfortable of activities for many creative types, but personal interaction with others is a great sales tool.

NEITHER SNOW, NOR RAIN, NOR HEAT, NOR GLOOM OF NIGHT...

The U.S. Postal Service motto assures us that the mail will be delivered, but is that mail being read? Direct mail can be a very effective method of marketing and promotion for any

"HOW DO I GET CLIENTS?"

Networking

Make everyone aware of what you are doing: family, friends, neighbors, former clients, local businesses, etc. Join a local business organization, chamber of commerce or industry-related organization and network with people who may need your services.

Direct mail

Target the businesses with which you would like to work and send them a postcard, brochure or flyer about your services. When I did this, I had ten new clients within several weeks and was still getting work from the one mailing five years later.

Web site

If you don't have a web presence, you had better get one established. Your potential clients will expect you have one. Most of my clients come to me by way of my web site after learning of me elsewhere—and 80 to 85 percent are from outside my home state.

E-mail marketing

E-mail press releases and newsletters are a great way to keep former clients, current clients, potential clients, vendors, family and friends aware of your accomplishments and capabilities.

Online directories

Make use of free and paid online directories to get your name and contact info out there.

Work with nonprofits

A good way to promote your business is to do pro bono, or discounted, work for nonprofit causes you support. You should get a credit on all the pieces produced for the organization. You also have the opportunity to meet community business leaders who serve on the board.

Become "the expert"

Writing articles for publications, making yourself available to the media as an industry expert and being a speaker are all excellent methods of promotion. I have been contacted by potential clients four to five years after speaking at a presentation or being quoted in an article.

Press releases

One of my major methods of marketing and self-promotion is sending out press releases about my work. I go into depth about this marketing vehicle in this chapter.

Industry design competitions

The largest portion of my marketing budget goes to cover entry fees in industry design competitions. I have at least one potential client a week contact me because my work has been noticed in a design book at a local bookstore.

Specialty self-promos and gifts

Everybody loves freebies and useful marketing specialty items like hats, T-shirts and office items. Give clients, vendors, potential clients and others self-promotional gifts that market you on a daily basis.

designer—provided that designer knows what he or she is doing, successfully identifies the target audience and has realistic expectations of the possible results.

Many years ago I put a tremendous amount of time, energy and money into what turned out to be the only major direct mail piece of my career. At the time I was doing business under the moniker "Jeff Fisher Design," and my marketing tagline had become "Jeff Fisher Has Done It Again!" The piece was a booklet of logo designs done over the previous years. The cover read "Jeff Fisher Has Done It Again!" Each subsequent page, headlined "...And Again!" displayed a large number of identities. The 8.5" × 11" booklet was mailed in a white catalog envelope featuring a caricature of myself done by internationally recognized animator and Oscar-nominated filmmaker Bill Plympton. I still remember that printing five hundred booklets and envelopes cost me over $700—a huge amount of money at the time.

I mailed the bulk of my self-promotion piece to a list I had been compiling myself over the previous months. The list was made up of individual business and organizations addresses collected from the local newspaper, area business publications and from library research sources such as *Contacts Influential*. When I needed a name or address confirmed, I quickly called the business and was supplied the correct information by the receptionist. My research paid off, in that less than ten of the pieces were returned due to incorrect mailing addresses.

Within two weeks I had five new clients. After a month I had ten. I was still getting calls from the one promotional mailing five years later. I basically created a situation where I became so busy that I didn't need to do another direct mail piece.

Direct mail has been very successful for others as well, but with many marketing methods, I think most people using direct mail have expectations that don't always jibe with reality. As with other advertising vehicles, repeated exposure is often what it takes to get a potential client to act. The direct mailer needs to remember that a return of 2 to 5 percent is a success.

Postcards are becoming an increasingly popular and effective method of marketing. Such mailers are easily designed and produced, with cost-effective printing through local or online resources. In addition, postage costs less than for a traditional letter or a larger self-promo mailing. Multiple postcards printed at one time can make sending out a series of cards a very economical venture.

Icon wizard Travis Tom's promotional mailing for TNTOM Designs, which included a grouping of postcards, passed a similar test at the offices of *HOW*. "I purchased the

Artist's and Graphic Designer's Market book by Writers Digest Books and used this resource to send out fifteen self-promotional packets in envelopes in January 2001," he recalls. "In March I received a call from the art director at *HOW* Magazine and was commissioned to design and illustrate fourteen icons for their Self-Promotion Annual to be used in the 2001 and 2002 issues."

"If you've priced out display advertising or Yellow Pages listings, you know that they can add up to big money in a hurry," says Martha Retallick, the self-proclaimed "Passionate Postcarder." Quite often, these valuable promotional tools are beyond the budgets of many small and home-based businesses. "I've found a way around this dilemma by using four-color postcards. Postcards have been an essential part of my marketing toolkit for years, and they've brought thousands of dollars' worth of business to my web design studio here."

Retallick has become an expert on using postcards for marketing and has self-published two e-books, entitled *Postcard Marketing Secrets* and *Resources for Postcard Marketers.* She is a one-person industry and unofficial spokesperson for this marketing method, with a tremendous understanding of the need to carefully target any direct mail effort to your specific audience.

"First and foremost, your best mailing list is the one you already have," says Retallick. "You have friends, family, colleagues, former classmates, former co-workers, clients, vendors, military buddies and neighbors. All you need to do is get their names, addresses and other pertinent info into a database program, like Act!, Excel or Goldmine, and you have yourself a mailing list."

"And, furthermore, you have the best kind of mailing list there is, because it's made up of people you know. They're going to be much more interested in what you have to offer than a list that's made up of a bunch of strangers," adds Retallick.

"Second, the quality of your mailing piece makes all the difference," she reminds us. "By this, I mean that you should produce a first-class mailer, whether it's a postcard, CD-ROM, or box of recipes. The first-class production values thing should come easily to us. After all, we're professional designers, right?"

Traditional marketing methods may not be for all designers. However, industry professionals give a variety of promotion tools a try before completely writing them off. The "I tried it and it didn't work for me" defense is much better than not having tried a new promotion method at all.

THE WEB WE WEAVE

Traditionally a strong portfolio of past and current work will give potential

The design, texture and impact of the Whiplash Design Tiki Book would draw the attention of even the most jaded creative director.

clients an idea of your talents, skills and range. These days, instead of lugging around a bulky valise of possibly tattered project samples, it is almost expected that you will have an online portfolio for review by potential clients.

I created a web site as a portfolio resource for a primarily regional clientele without giving much consideration to the global potential. Initially, my site went up over a weekend out of an immediate need to meet the deadline of a newspaper doing a feature story about my business. I was thrilled to begin that following week with an online portfolio resource for my local clients. Imagine my surprise when potential clients started to contact me from throughout the United States and literally around the world. I felt as if I had created a monster.

In addition to the world-wide potential of a web site, there is the fact it can serve as an excellent alternative to more expensive local advertising if you market it as such.

Designer Judy Litt, the guide of the About.com Graphic Design site, states: "You can reach out to a larger audience—the entire world. Of course, some designers say they only want to work locally and you will get inquiries from local companies that didn't know you existed before your web site. I have found that local companies often look for designers on the web. There seems to be a belief out there that if you're on the web, you're on top of things."

The web is one of the most incredible marketing tools in existence today, but most people are not taking full advantage of it despite easy access 24/7 from computers already sitting on their desks!

In the 2001 *HOW* Magazine Self-Promotion Annual, Ilise Benun, author of *Self-Promotion Online*, explains: "The extraordinary hype surrounding the Internet has pushed expectations of the web out of the ballpark. Many people still think all they have to do is post a web site and qualified prospects will magically visit and instantly bestow projects. But as with all marketing, you can't just sit back and wait for people to come to you."

With an informative, well-designed and easy-to-navigate web presence, the sky's the limit. Stop making excuses for not having a web site and get out there and market the hell out of the thing.

AT THE CLICK OF A MOUSE

E-mail is an immediate source of marketing. Literally at your fingertips you have the ability to promote your business to millions of people. Be sure to review the "E-mail Etiquette" tips from chapter five. What you consider to be a harmless e-mail promotion may come across as spam and annoying, rather than intriguing, to a client or potential customer. E-mail newsletters and cyber press releases need to be handled with the same degree of professionalism as any other business correspondence.

"Whether you call it marketing or not, every single contact you have with a client or prospect is a marketing

ONLINE PORTFOLIO OPTIONS

Here are several web sites offering online portfolio options. Some are free, or offer a minimal directory listing at no cost. Others are fee based.

About.com Graphic Design
http://graphicdesign.about.com

Creative HotList
www.creativehotlist.com

Graphics.com
www.graphics.com

The I-spot
www.theispot.com

Portfolios.com
www.portfolios.com

opportunity, as is every e-mail message you send," writes Benun in the August 2003 issue of *HOW* Magazine. "So whether you're researching a prospect, following up after a meeting or delivering a proposal via e-mail, treat this correspondence as a marketing tool and it'll have a stronger impact."

Benun adds, "Relationships are built upon the back-and-forth of communication, including e-mail. It makes you visible, keeps you connected to your market and literally motivates people to respond. If you do your e-mail marketing right, your recipients will actually look forward to receiving your messages."

For my own business, e-mail is one of the most effective, least expensive and minimally intrusive marketing methods that can be put into action. With one promotional e-mail, I am able to convey a message and re-establish a connection with clients, former clients, potential customers who have been added to my data base, vendors, writers, editors, friends, family and others. One mouse click may ignite the spark of an idea in someone receiving the e-mail, leading to possible projects, articles or other business ventures.

WRITING AND TALKING

The media are always looking for experts—and you probably fit the bill. When I had been in the design business for about 20 years, I started getting calls from writers who wanted to quote me for stories, editors interested in having me write articles for magazines, newsletters or webzines, and organizations wanting me to speak at meetings, luncheons or conferences. At first I was a bit stunned that anyone would be interested in what I might have to write or say. Most amazing to me was the fact that, in many cases, someone was willing to pay me to write or speak—something I'd been doing for free for years.

In *Off The Wall Marketing Ideas: Jumpstart your sales without busting your budget*, Nancy Michaels and Debbi J. Karpowicz write, "When you make yourself—and your business—visible, it not only sets you apart from the competition, it also establishes you as a credible, reliable source of information about your field. It takes your expertise and puts it to the forefront, where it's apt to get noticed. Not only does visibility impress others and lift your status; it can also lead to increased consumer confidence and a healthier bottom line."

"Remember—experts are always in demand," they add. "And there are two tried-and-true ways to make yourself into an expert: writing and public speaking."

Writing has always been fairly natural to me. I was editor of my high school paper and have always enjoyed writing personally. To get the design courses I desired in college, I had to take the journalism curriculum—which added to my skill set. My

writing on the topic of graphic design began innocently on Internet design forums. My postings attracted notice and I was asked to write articles for several webzines. Some of those pieces were read by editors for industry publications and reprinted in magazines. That was followed by a few magazines hiring me to write pieces.

The exposure from writing can impact your design work in many ways. Whether bringing clients, articles about your business, or new journalistic opportunities your way, writing can turn into a major marketing vehicle for your work. The natural progression from writing for a webzine or association newsletter to newspaper or national magazine can be an effective promotional tool for any creative business.

The same can be said about public speaking. Getting in front of an audience, and addressing topics you know well will give you tremendous validity in your profession. With that in mind, it's not always about talking in front of audiences made up of individuals in your own profession. If you are truly interested in marketing your business you may often find yourself talking to totally unrelated groups—related to graphic design only as potential clients. As a designer speaking before an unrelated group of novices, you enjoy a unique position. You can educate the audience about the field while subtly selling your services and abilities.

THE GIFT THAT KEEPS ON GIVING

Marketing specialties can be a very effect way to promote your design business—whether the item produced has a short or long life span. The success of such a marketing effort often depends on the quality and usability of the item. We've all received items from clients or vendors that were pretty worthless. They may have been cost-effective promotional pieces; but very ineffective in relaying a positive, lasting message to a potential customer.

One of the most effective marketing items I have seen lately was a cube of self-stick notes given to me by a local business. Constantly on my desk, the notes are within reach for posting on anything needing a quick memo before I send it out the door—and the marketing for the company continues when it is received by the person to whom I've sent the note.

Several years ago I donated a logo design for a summer elementary school project. As a thank-you, the school offered to have a bunch of T-shirts produced on which my logo would be printed. I paid for additional shirts; in all, about 60 were printed. I gave them to friends, clients, family and others. I often wear one myself. In effect, I turned all these people into walking billboards for my business in a enjoyable manner. Many projects have come my way as a result of people seeing the shirts—on me or on others.

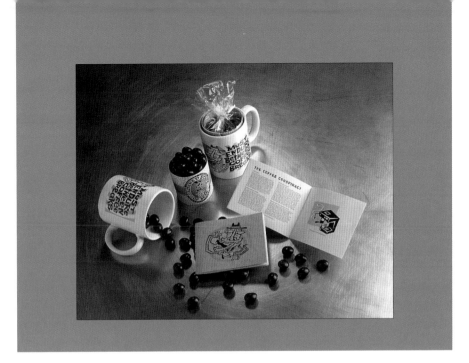

Von Glitschka's unique coffee-themed self-promotion helps those receiving it survive the time between coffee breaks with chocolate-covered coffee beans.

When considering promotional items for your marketing plan, give serious thought to the end users. Do they really need another ballpoint pen or Frisbee? What happened to all those squeezable rubber coin purses, adorned with company logos, given out to potential customers when I was a kid?

MARKETING TO THE OFFICE
DOWN THE HALL OR UPSTAIRS

Marketing one's design abilities, efforts and accomplishments does not always mean establishing campaigns or programs to take on the world at large. For the in-house designer, there is often a need to prove the value of one's work to the "suits" in the head office of a corporation, business or organization. Such marketing may take the form of one-on-one meetings or large gatherings in a conference room.

It's important that in-house design departments learn to promote themselves within the corporate structure, to foster greater understanding of what they are doing at their computers on a daily basis. Most of the firm may see the end product of a project some time after its completion, have little knowledge of how it evolved, who was involved and the result of the completed effort.

"It's a matter of selling our value to upper management. I've learned that I need to manage up as much as I manage down," says Andy Epstein, creative

director for Gund, Inc. "That means I take time to meet with the VPs in our company, both formally and informally, to discuss their needs even beyond the established relationships we have and to find ways to help them. I also proactively take on brand- and marketing-related projects and research and present them to upper management at every opportunity."

"Open your doors, get involved in projects that aren't assigned, and people will see what you and your group can offer," suggests Austin Baskett, brand manager for American Crew. "You become known as the place to solve people's communication problems."

TOOTING YOUR
OWN HORN

Getting your name out to potential clients does not always mean lugging a heavy portfolio around to numerous art directors, making cold phone calls or producing a slick and expensive direct mail piece. These traditional methods of introducing yourself to your target audience can be time-consuming, produce limited results given the relatively small audience, and be very frustrating to a designer trying to work at the same time.

A much more effective way of promoting yourself may be through public relations. When you translate your efforts into what the traditional media consider "news," you create

the possibility of free publicity—and we all know that "free" is a very good thing.

As often as twice a month, I send press releases to the business editors or writers of the major daily newspaper in my area, local business newspapers and magazines, community weeklies and design publications. If the news involves a client in another city, I also send the information to the media of that market.

Winning a design award or being profiled in a book are, perhaps, at the top of the list of subjects considered newsworthy by such publications; however, other situations may arise in the course of a designer's day-to-day business that create publicity opportunities. Being retained by a new client is one of them. You may have seen newspaper notices announcing that an advertising firm has been retained as the agency of record for a particular client. Why should a designer or design firm be any different?

The completion of a project is another perfect opportunity. Press releases containing information on a few completed projects—accompanied by camera-ready black-and-white prints of the finished products—are particularly well received by the smaller local papers. It's always nice to have a graphic element to include with the news item.

The advantages here are obvious. This incredibly low-cost marketing method gives you the opportunity to

"toot your own horn" and get your name seen by thousands of potential prospects. More important than the quantity of such exposures is their quality—these local papers can put your name in front of the people most likely to hire you. Finally, clients are thrilled to see their companies' names and logos in print.

PREPARING A SUCCESSFUL
PRESS RELEASE

Format. For some, the most difficult hurdle to overcome with this form of marketing is the actual writing, but help is available. Many libraries have marketing guidebooks with examples of press release formats for you to follow. Or you can hire a writer or public relations professional to establish the initial template specifically for you and your business. You then can simply plug in the pertinent information as needed. You might consider trading your design services with those of a PR professional or company.

Content. When preparing a release, the most important thing to remember is to include all of the necessary information in the first paragraph. Most editors or writers don't have the time to read any more than that paragraph. The rest of your release should just be background that supports your first statement. You should close the release with your precise contact information, should the editor or writer wish to reach you.

Contact. Be sure you send the press release to the editor of the most relevant section, such as small business or business marketing. You will have a better chance of having the information published if the person who actually makes editorial decisions personally receives the press release. The names of such individuals are readily available in each newspaper or magazine. However, if you are unsure to whom it should be sent, a phone call to the publication should provide an answer.

Strategy. You may want to use some kind of gimmick to attract additional attention to your press release. This may be an attention-grabbing envelope design or paper color—but don't get too carried away. For the most part, business editors are fairly conservative, serious creatures.

Delivery. In this age of technology, it may be tempting to send your press release via fax or e-mail; however, most editors and writers appreciate receiving information the old-fashioned way—by snail mail. In fact, they usually receive fewer press releases by regular mail, so your announcement may get a little more attention than that sent by other means.

Whether you send your release via snail mail or e-mail, do send it

out in a timely manner. I usually send my press releases via mail, but broadcast it to my e-mail address list of clients, vendors, publications, peers and friends as well. The idea is to get your name out there. You have no way of knowing who is going to come into contact with someone needing a graphic designer.

Time and money. Press releases may be sent to a mailing list that includes about twenty publications. It may help to have three or four sets of pre-addressed envelopes on hand to save time. Writing the release, printing, envelope stuffing and stamping should not take more than about an hour after you get good at it. The postage for such a mailing usually is less than $8.00—an inexpensive investment considering the potential results. You might also want to consider using services like PRWeb.com, which requests a donation for their distribution service.

Reaping the rewards. Don't be surprised if your first few releases have limited results. The process often requires cultivating a relationship with publication editors. It might even be worth your while to introduce yourself personally to specific editors. After receiving several press releases from your company, the editors and writers will begin to realize that you are a "real" business with serious intentions. Once that hap-

pens you are more likely to see your announcement in print.

Any designer or design firm can benefit from self-promotional press releases. As businesspeople, designers should employ the creative marketing techniques used by others in the corporate world—not to mention utilizing their own creativity to take those concepts one step further in the quest for personal success.

A WINNING
STRATEGY

When I began thinking about entering design competitions, I figured that I did not have the time or the money to spend on such contests. I simply could not justify the cost of the entry fees—especially in the case of my pro bono design efforts. When I was paid nothing for the finished project, how could I afford to pay an entry fee for a design competition?

By reallocating my traditional advertising and printing budget to include the cost of competition entry fees, the prospect of becoming an "award-winning designer" suddenly seemed more attainable. I realized that the return on the investment might be much more than a certificate to hang on my studio wall; it could be the validation creative types require on a regular basis.

Those in the creative occupations of writing, advertising, public relations, marketing, design, illustration, photography and related fields may

wish to pay more attention to industry award possibilities. The results can have a dramatic impact on the promotion of your personal creative efforts, or those of a client's company.

BENEFITS TO THE DESIGN INDUSTRY

While it may be personally gratifying for an individual designer to build a wall of award certificates, some question whether design competitions are of value to the industry as a whole. Their primary contribution to the field seems to be motivating designers and their studios to higher levels of creativity, artistic merit and client satisfaction.

"While there are many benefits of competitions, I think the greatest benefit is that design competitions offer third-party validation of excellence," says Maya Draisin, executive director of The Webby Awards—a competition considered by many to be the industry standard for web design. "This translates into a stronger portfolio, higher rates, and a sense of accomplishment and recognition."

Industry awards, and the attendant publicity, can offer designers working in-house for larger firms and organizations a chance for recognition. A high-profile award can help build respect for the value of design as a communication tool for the entire company.

Andy Epstein, of Gund, Inc., is testing the idea of promoting potential design honors in-house, "We've only recently begun to enter competitions after realizing that this may be a good tool for gaining respect from upper management," he says.

BRAGGING RIGHTS

Receiving an industry award gives you the immediate opportunity to promote your business through a press release announcing the achievement.

"I discovered early in my career that awards from meaningful competitions were excellent marketing tools," says Kentucky-based designer David E. Carter. "When I won my first Clio, my sense of pride was overwhelmed by the amount of 'sizzle' that gave my sales presentations when I sought new clients. I think that meaningful awards give the creator a sense of accomplishment, but they also give excellent credibility for marketing."

The Summit Creative Awards web site provides a wealth of resources to assist designers in getting the best mileage from their awards. The site provides winning designers with a press release template, examples of prior winners' promotional efforts, low-resolution images for web sites and electronic press releases and high-resolution award images for printed materials.

"At The Webby Awards, we spend time educating our nominees on how to make the most of their nomination from a marketing and PR perspective," contributes Maya Draisin. "The larger organizations or savvier developers know how to do this already, but there are a lot who just think (the award) is nothing more than a pat on the back. When you add the marketing elements, however, it makes the whole entry fee worthwhile."

"BOOKING" IT TO INTERNATIONAL RECOGNITION

The competitions most valuable to graphic designers are those that result in their work being featured in a design annual or a graphic design book on a specific topic.

As a young student with hopes of becoming a successful graphic designer, I spent a great deal of time in libraries poring over the designs of professionals from around the world. I dreamt that some day my own design efforts might appear in those glossy publications that I could not afford to purchase. I looked at the books as sources of design inspiration, not a future method of marketing and promotion. At the time, I was much more interested in the ego strokes that might eventually come with being a published, award-winning designer.

Nearly 20 years later the proverbial light bulb went on in my head when a client mentioned that she had spent the previous evening researching illustration annuals for an artist with the style she sought for a current project. I had never before seriously considered such publications as marketing tools that could advertise my creative work worldwide.

Today at least 40 percent of my business is due to identity examples that have been published in design annuals or books resulting from design competitions. Numerous times potential clients have said, "I was in my local bookstore and came across examples of your work in a design book..." As with my media releases, this exposure also led to articles about my business, inclusion in other books, and requests to write articles or be quoted as an industry expert.

"Industry awards also build reputations," adds Travis Tom. "I scour the design annuals every year looking at work for inspiration and to familiarize myself with some of the firms and designers producing this great work. Large clients want the best they can get for their money and they tend to look for the very best."

THE HAPPY CLIENT

Clients are usually thrilled to have their work win an industry award. They enjoy seeing their names in print, or their projects published in an industry annual when the award is promoted. Winning an award often provides tremendous validation for the client's project choices. The recognition also showcases the client's

The beautiful poster design and award-winning illustration work of Shadowland Studios' Dave Gink results in each piece going out into the world as a self-promotion or marketing tool.

efforts within the company's own industry, increasing visibility among its peers. Such an award may also increase the value of a creative professional's work in the client's eyes.

"I always ask permission to show client work in my portfolio and prior to entering the work in design competitions," says Travis Tom. "This communicates to the client that I am constantly in the pursuit of design excellence."

Clients may be an excellent source of information about competitions that are specific to their own industries. Research such opportunities with client contacts, the marketing specialist or the public relations director for the firm. Most industries have yearly competitions that may be announced through trade publications, industry associations or Internet resources.

Many industry award organizations provide certificates or plaques for both winning designer and client. Others offer trophies or certificates at a cost in addition to the entry fees. Often, the expense provides yet another marketing opportunity—this time utilizing the reception-area wall in an appreciative client's office.

SERIOUS CONSIDERATIONS

Often the awards offering the most promotion "mileage" will be those with established reputations and longevity in a field of expertise, or in the business arena of a given client. With that in mind, greater considera-tion should be given to competitions sponsored by respected industry organizations.

Annual honors presented by major industry publications, such as the *HOW* Self-Promotion Competition, *HOW* International Design Competition and *HOW* Interactive Competition, *Print*'s Regional Design Annual, the competitions of *Communication Arts* and *Graphis*, among others, carry a lot of prestige. An added bonus is that winning work is usually published in the magazine that accompanies competitions conducted by publications.

Be leery of competitions that seem to offer recognition to nearly everyone who enters. The value of most awards is dependent on the idea that only a limited number of entries are honored.

"An 'award for purchase' defeats the purpose of having noteworthy experts take notice of your work and validate it," says Maya Draisin. "It is not simply receiving awards, but receiving credible and objective awards that adds value."

"Research competitions to understand which are most valued," suggests Draisin. "Look carefully at the criteria, the judging process and the judges of any competition you consider entering. Only participate in those that are credible and offer real honors."

Jocelyn Luciano, creative director of the Summit Creative Awards, adds, "In the end, it is up to each designer to determine if an awards program is

right for their recognition objectives. Not all awards are for all designers. Many competitions segment themselves geographically, by specific industry, by size restriction, etc. Some awards use a ten-point scale to evaluate the creative and give out an unlimited number of awards, while others have the creative compete amongst all of the entries submitted and limit the quantity by percentage of award recipients. With the increase in 'buy an award' competitions, designers must look at the quality of work being recognized, the caliber of judging panels and of course, how the quantity of winners is limited."

"The 'awards for sale' competitions rarely show all the winners. The best competitions have an annual publication showing the winners," says David E. Carter. "They have the best reputation, and are compelled to choose only excellent work."

DRAWBACKS TO COMPETITIONS

When asked about the drawbacks of competitions, Jocelyn Luciano responds, "I think the greatest drawback is the worry that the creative trend will pull (only the) best, and that juries won't look beyond and take into consideration the diversity of audiences and appropriate tones of voice."

"To me the greatest drawback of any competition is that when picking a limited number of the best, there is inevitably some fantastic work that is not recognized," says Maya Draisin.

Tadson Bussey, of the University and College Designers Association, adds, "If you select a different group of judges, they will select a different group of winning pieces. Maybe competitions should not be 'good design' driven, but 'appropriateness' driven instead."

"The only drawback of the good competitions is that the judges simply don't know why any particular piece was created, so judging is done based on first visual impressions," says David E. Carter.

There will most likely be complaints about every design competition because such contests are so subjective. The selection of winning entries often is selected based on the personal preferences or biases of the individual judging the competition— and that judge may have been selected based on a friendship with the administrator of the event, and so on and so on. Many design competitions are not much more than "beauty pageants" founded on the tastes of certain individuals at a given time in history.

Another drawback is entering award competitions can be expensive. Carefully weigh the value of the possible result against the cost of submitting examples of work. In my case, entry fees replaced previous budget expenditures related to print advertising and direct mail.

In addition, it also may become necessary to consider the value of pay-

Lift Communications' award-winning gift tag self-promotion piece stood out among the annual avalanche of holiday mailings.

ing a publication fee once a project has been selected for an honor. These are fees sometimes charged by award organizers or publishers to print recognized work in the annual or another book promoting the honorees and the contest. Such fees help the producers recoup some of their production, administrative and market costs.

Some competitive events also charge a hanging fee for the installation of winning entries in a gallery setting, or in conjunction with an industry trade show or conference. Again, the value of such a fee lies in potential exposure to professional peers and potential clients. A client particularly pleased with your efforts on a project may be willing to assist with competition fees by sponsoring your work in an industry-specific contest.

A MEASURE OF SUCCESS?

The strategy of advertising my business through industry awards has paid off in a big way. Since 1995 I have received over 450 design honors, providing many opportunities for promotion. My work has also been displayed in over 65 newspapers, magazines, design annuals, graphic design books and volumes on the marketing of small businesses. I've been asked to speak to industry organizations, business associations and schools across the country. With "award-winning designer" a seemingly permanent addition to my name,

many new clients come my way due to the designation. Still, especially with limited wall space for the display of design honors, a satisfied client is always the best reward.

"Award-winning always helps differentiate a designer from the pool. It indicates that they have stood out in competition, and so their work is likely to be of a high caliber," says the Webby's Draisin. "While that may catch someone's eye, you have to back that up with a credible award—recently received—and a portfolio of great work to show that you are not a one-hit wonder."

"For the national or international competitions, the entrant whose work is selected gets immediate credibility as being more than 'just another local design firm,'" according to David E. Carter. "For those competitors whose work is displayed in a book, the design firm has an additional marketing tool as it seeks new clients. Even for those not entering, the book shows work whose level meets national or international standards, thus giving all readers a sense of what it takes to reach that level of achievement.

"The phrase 'award-winning' is meaningless without some definition of just what award was won. The *Communication Arts* competitions can literally be a springboard to a designer's career," says Carter. "Being included in my two annuals, *Creativity* and *American Corporate Identity*, carries a certain amount of credibility

within the creative community. But being an 'award-winning designer' from a competition with no credibility doesn't mean a great deal. And for some of the 'awards for sale' competitions out there, listing that on a resumé is a negative to many people who are hiring a designer."

According to Michelle Elwell, "the only awards (SolutionMasters) really uses to market ourselves with are those from the *Business Journal*—mostly because it's an entity our clients will recognize. Although an award from *HOW* may be widely recognized among other designers, our clients are going to recognize the *Business Journal* and it will mean more to them."

Windmill Graphics' Rebecca S. Kilde has mixed feelings about the marketing value of industry awards for a designer in a small Wisconsin community. "I think that a well-known industry award could be a selling point for some clients, although for some folks around here, it would actually be a disincentive. As a self-taught designer, I think an award would be pretty sweet—recognition that all those books and articles I've studied have managed to sink in."

ALWAYS
BE PREPARED

A good self-promoter must be prepared when a marketing or promotional opportunity comes flying from out of left field. Take a quick look at the big

picture of possible major exposure and the large number of potential clients that could be reached by the opportunity—then jump into action.

In her book, *BRAG!* Peggy Klaus writes, "It's not going to happen unless you make it happen, and the créme-de-la-créme opportunities to self-promote are going to come your way when you least expect them."

As soon as you receive a major design award that you've won, sit down and take the time to crank out that press release. If an editor calls wanting an interview for an article, make the time immediately. Should a business association call asking if you can make a presentation in two days because a scheduled speaker canceled, start practicing your speech. If a publisher needs you to put together a few illustrative elements for a future book, reschedule that appointment and get the requested items (or more than they requested) as soon as possible.

No matter how you opt to market yourself, do it now! Set aside a couple of hours each week specifically for dealing with possible promotions. Sketch out that that self-promo you've been thinking about for months. Call the business editor of the local newspaper and ask if he or she would like to meet for coffee to discuss your business and what you could do to get a little press coverage. Write and fine-tune a press release—or an article based on your experiences and knowledge. Research a few design

competitions and find out what may be appropriate for your work. Even if you are swamped with work, take the time to pay attention to your marketing needs—*now*! If you don't, you may not be swamped two weeks, or two months, down the track.

In the end, designers must not forget the true goal of their endeavors. Marketing and promotion are necessities; awards and pats on the back are all gravy. However, as Art Chantry sum-marizes, the most important thing is "the work itself. There is nothing more thrilling for me than doing good work. In a way, it's the ultimate triumph."

CHAPTER 10
CHECKING YOURSELF INTO DESIGNER REHAB

We all make mistakes. A graphic designer has the opportunity to make incredibly visible and costly mistakes in the course of project work and career decisions. Unfortunately, there is no trendy rehab center in the desert for design industry members. Hopefully, we do actually learn from our design and business errors. We also can take a lesson from the potentially career-breaking mistakes of others.

"I haven't failed, I've found 10,000 ways that don't work."

Benjamin Franklin

"It is better to fail in originality than to succeed in imitation."

Herman Melville

"To err is human; to create something positive from the situation is design."

Jeff Fisher

HAVING THE STOMACH FOR
THE DESIGN BUSINESS

A major career error can seriously impact a designer's self-confidence and limit one's ability to move beyond it. Reputations can be damaged by a stupid mistake or perceived screw-up. Business finances may face serious repercussions of an unwise decision or project gone bad.

In *The Design of Everyday Things*, Donald A. Norman investigates why people make errors. He finds that errors can be divided into two categories: *slips*, which occur in automatic behavior; and *mistakes*, which occur when we consciously choose the wrong goal. As professionals, we can't afford to beat ourselves up over any type of snafu. We must salvage the situation if possible, learn from the experience and do all that is necessary to avoid a reoccurrence.

In this chapter, a few brave designers share anecdotes of career screw-ups as lessons for us all. If we can't always learn from our own mistakes, perhaps we can absorb the knowledge from those of others.

For years, my desire to work with a particular client or put food on my table took priority over trusting my own instincts. On numerous occasions, I accepted project assignments despite the nightmares I knew lay ahead. My desire to please others was stronger than my need to maintain some degree of sanity. (There should have been a twelve-step program for designers like

myself: "Hello, my name is Jeff and I'm a compulsive multi-tasker.") I finally broke that destructive with a dramatic decision, one that was definitely the best for my business.

When I was recommended for a certain job, I was warned that the client could be difficult. Still, a complete identity project for a very visible institution was an intriguing proposition.

I called to set up an initial meeting with the marketing director and the executive director of the nonprofit educational facility. Over the course of the next week, the marketing director called three times to change the appointment date and time because it was "incredibly important" for the executive director to attend. The rescheduling required me to juggle other appointments already on my calendar.

When we finally met, the marketing director and I seemed to click immediately. However, as I began to present my portfolio, the executive director picked up a magazine and began to flip through its pages, paying no attention to the fact that I was there for a meeting she had requested.

As the meeting came to an end, I told the marketing director, "I don't think I'm the right designer for your project. I rearranged my busy schedule three times so the executive director could attend this meeting and she has spent the entire time reading a magazine. If she is to be one of the primary contacts for this project, I

seriously question my ability to work effectively with such a person." The marketing director thanked me for my honesty and the meeting came to an end. The executive director was too stunned to even say anything.

I was shaking by the time I got outside to my car, but amazed that I had reacted to the situation with such professional confidence. At my studio, an apologetic message from the executive was waiting. We spoke again, and she repeatedly apologized for not paying attention during the meeting. She asked that I reconsider my decision to decline working with her organization.

I told her I really had to go with my intuition about the situation, but I would happily recommend some other designers for the project. I called several designers, told them why I was not taking on the job and asked if they would like be recommended. Two agreed to meet with the client and one accepted the project. Later, I learned that it had become the project from hell. Since then, if a particular client situation or project doesn't feel right, I politely decline and walk away from it.

Semiretired graphic designer and life/work coach Ann Strong explains that, "our heads carry a lot of knowledge. Our bodies have access to the knowledge in our heads as well as wisdom far beyond our limited, rational (head) understanding. When we make choices with more of the resources available to us, we live more from our true selves and less from all

our 'shoulds,' rules and other people's ideas." In other words, when the hair stands up on the back of your neck, a stomach cramp stops you in your tracks, or a splitting headache momentarily blinds you in a business situation, pay attention!

Few people would consider graphic design a physically dangerous occupation. In pre-computer days, the greatest dangers lurked in the form of errant craft knife blades or fumes from aerosol fixatives or adhesives. Today it seems that too many designers allow their quest for professional success to impact their health, financial well-being and personal lives.

Neil Tortorella of Tortorella Design found himself in the comfortable position of working on a regular basis with a Fortune 500 firm. Nearly $70,000 in future projects had been lined up for his business. However, when a new chairman took the helm of the client firm, his first order of business was to audit the company, putting many projects on hold in the process. Graphic design expenditures were at the top of the list. Tortorella says, "On Monday, I had roughly $70,000 worth of work with them. On Tuesday, I had zip."

The situation put Tortorella's business on the edge of bankruptcy. As the sole proprietor, Tortorella himself went over the edge. His blood pressure went through the roof and depression set in. Tortorella lost his inner motivation, finding it difficult to

sell, work or play. He had to lay off staff and find ways to cut overhead.

In striving to come back from his personal and financial disaster, Tortorella found himself literally in rehab for substance abuse and therapy for depression. The outside help allowed him to put all the issues in perspective and begin the process of salvaging his business. He moved his company back to its original home base, working with previous staff and others as independent contractors. A few of the original client projects proceeded, allowing the business to slowly come back, now with a new business model.

"Never, ever, ever put too many eggs in a single basket!" says Tortorella. "No single client should ever account for more than 25 to 30 percent of a designer's business." Tortorella also now keeps overhead as low as possible. Anything that isn't going to add to profit is scrutinized carefully. To avoid impulse purchases, he suggests putting off any major expenditures for a month or two, proceeding only if you then feel that the item is truly needed.

St. Louis designer Art Chantry also faced challenges that affected him personally. "At one point in my 'career,' when I was finally at my breakpoint in my health, stamina, and emotional and personal well-being, I made the very self-conscious decision to *not* do work with assholes just for the money," he says. "What that means is that I only chose work based on interest (the project, the client, the cause, etc.) and not on money. I reserve the right to say *no*."

"I thought that such a dramatic course would destroy me professionally and I would simply fade away." Chantry continues. "But, interestingly, several strange things happened: I began to enjoy my work more, I began to do much better work, I began to win the accolades of my peers, I began to affect the community around me, I began to get much more work, and—strangest of all—I began to make much more money than ever before."

These are not unique situations. Is a graphic design career, or one particular client, worth the risking to your health and personal well-being?

Listen to that "inner voice" when it is yelling at you. If the client, employment or project situation does not feel right, it most likely isn't. Get a second opinion if you are not sure that you are making a wise business decision. Run the particulars past a friend, co-worker or peer to get a different perspective on the issues.

Pay attention to your body as well when dealing with stressful work situations. Working outrageously long hours, with little sleep, will not allow you to maintain a high level of creativity for long. When your body starts sending you serious signals that something is wrong, it is time to step back, regroup, then move forward with improved mental and physical health.

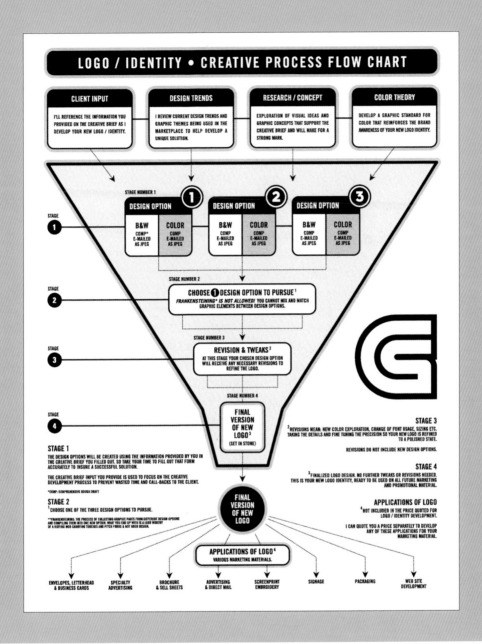

Von Glitschka's handy flow chart is an essential tool for educating the client about the design process and what they can expect to happen at each step along the way. This can eliminate much confusion and save numerous headaches for both designer and client.

IT'S ALL RELATIVE

Working for family and friends may prove to be the ultimate test—and biggest mistake—for any designer. Those in the design profession tend to make special allowances when beginning work on such efforts. A laundry list of problems, hurt feelings and fragile relationships can be the result.

Years ago, I quit working on a contract basis with other design firms and ad agencies for a variety of reasons. I did feel, however, that I could continue working with the ad agency owned by my sister. Even though I knew better, I continued to work with her firm without a project agreement spelling out all the hows, whys and what-ifs of a commissioned job.

On one project, I was asked to work with another account executive because my sister was too busy with other projects. Something was just not clicking on the job. Supposedly it was a rush, but I wasn't getting the feedback necessary to complete the logo in a timely fashion. My phone calls to the account executive went unanswered and the project was not proceeding.

My sister called me, angry about the situation, and before I was able to express my concerns or explain what had taken place, I was fired from the job. Now we were both ticked off at each other. Neither of us spoke to the other for some time. It wasn't until the account executive in question left the firm that my sister finally learned the truth about how he had handled the project. Blaming others for all problems and delays was his modus operandi—and my sister had chosen to believe his tall tales.

Avoiding such situations is relatively simple. Although a designer may make allowances in the costs of projects for family and friends, the process of executing such projects should not vary from that of other clients. A project brief should be developed to detail all aspects of the job. A contract or project agreement should be used in every case. Don't pretend you have the ability to read such a person's mind throughout the project process. Clarify all aspects as you would for any other creative effort. By treating projects for those nearest and dearest to you as you would any other job a lot of grief, anger and frustration may be avoided.

FOOT-IN-MOUTH DISEASE— OR, THEY SHOOT DESIGNERS, DON'T THEY?

Design professionals should emphasize their own strengths and talents; rather than criticize the perceived weaknesses of the competition. Bad-mouthing the design efforts of a potential client can backfire dramatically. Often the owner of the business, his wife, his child or someone else intimately involved may have created the work being criticized. Putting down the work of others in such cases

can reflect negatively on the designer pitching an account by angering or embarrassing the business owner.

Chris Gee, creative director of Cube Interactive, was working as a junior designer for a studio in New York City over a decade ago. While the firm's partners were on vacation, Gee and another designer found themselves working directly with a very demanding client. One night, after leaving the usual project-status voice-mail message for the client, they began to complain to each other about the client's unreasonable requests and demands. What the designers didn't realize is that the phone had not properly disconnected at the end of the status report, and was continuing to record their conversation.

When the partners returned from Europe, a meeting was held to review the completed project. As the presentation concluded, the client politely asked the two designers to excuse themselves so that she could speak privately with the partners. She then told the story of receiving the project-status voice mail from the designers—along with the additional twelve minutes of their complaints.

"The partners were able to laugh about the incident with the client while we waited outside," according to Gee. "Of course, while our jobs were spared, it did not spare us from a very thorough tongue-lashing."

You never know who is sitting at the next table in the restaurant, eavesdropping in a nearby room or who knows whom within the industry. It's best to think through the consequences of what you plan to say before opening your mouth and letting the words escape forever.

When presenting your work experience or design capabilities, focus on promoting your strengths and explaining how you can solve the design problem at hand. Gossip, put-downs and destructive criticism about others in the industry—or those in competition with you for that prized design assignment—will come back to bite you in the rear end at a later date.

DESIGN-BY-COMMITTEE DEBACLES

If one person can make a good decision, does it follow that many people can make an even better choice? It is my experience that any time more than three people provide input on a project design, at least two opinions usually result. Somehow that expands exponentially as you increase the number of people. "Design by committee" may be one of the most dangerous career situations for any graphics professional

In nonprofit organizations, government agencies and larger businesses, "design by committee" situations are common. A designer needs to establish guidelines for project procedures to ensure a successful outcome. Try to deal with only one contact person. The immediate advisory committee should be made up of only three, pos-

sibly four, members. Members of the advisory committee will review all designs, choosing only one or two options to submit for the final approval of the larger group.

Take control of such situations. Client who utilize committees need your advice as well as the design services for which you have been hired. Inform client contacts that for the best results they must work within the structure you have established for completing such projects.

THE CLIENT IS ALWAYS RIGHT—EXCEPT WHEN
HE IS REALLY WRONG

The client is not always right. At times, clients can be really wrong. As a designer, it is important to insulate yourself from the fickle finger of blame by having the confidence to speak your convictions and the smarts to cover your rear end with the proper documentation.

Designers are frequently handed piles of text and images to create materials for industries about which they have no prior knowledge. Industry-specific text, in particular, can make little sense to a designer creating the finished materials. For that reason, it's important to make sure that the client is responsible for all text when designing for gobbledygook industries like insurance or finance.

On a series of brochures I created for an insurance company, the marketing director approved each

brochure layout before 50,000 copies of each were printed and mailed to the target market. Then the phones started ringing.

Senior citizens all over the state had received the mailing. In a section explaining payment for medical treatments, the brochure read "Nothing" in the column for what Medicare would pay for the procedures. "Nothing" was also listed as the amount to be paid by the insurance policy holder. The amount to be paid by the insurance company was also listed as "Nothing," rather than the actual "100%" it was supposed to be. The company now had 50,000 senior citizens concerned about who was going to pay their medical bills—and a designer who luckily had documentation that the brochure had been approved by the marketing director.

Good documentation is a must for every project. When I was hired to design the identity for Portland's Governor Hotel, I had trouble figuring out who was actually in charge. I was answering directly to the manager of the future hotel; but the interior designer seemed to have input on every aspect of the project.

During my initial tour of the construction site, I kept noticing an inlaid Arts & Crafts bell ornament throughout the building's original woodwork. The manager had repeatedly explained that he wanted the hotel's identity to convey the history of the structure and the Pacific Northwest; I felt that the inlaid

bell image would be a perfect icon. The interior designer said she felt it was not the image they were seeking; but the manager liked the rough design I had created adapting the bell image and told me to proceed with it.

Eventually I was hired to design every piece of printed material for the hotel, using the logo adapted from my original concept. When the stationery package was finalized, the interior designer again stepped in, offering her color expertise. I had suggested subtle, historic colors; she wanted something more vibrant. This time I lost the battle, and the stationery was printed in a horrible orange. Somehow, despite my frustration over the choice of colors, I remembered to have the hotel manager sign off on the interior designer's recommendations.

When the printed stationery package materials—in quantities of 10,000 each—were delivered to the hotel, it was immediately apparent that the manager and staff were not happy with the orange identity. Someone soon dubbed the look the "Taco Bell Hotel," and all items had to be reprinted in the colors I originally recommended at a huge expense.

These projects showed me the importance of documenting all decisions throughout any project. In either situation, if I had been held financially responsible for the mistakes made by the client (who supposedly is always correct), my one-person business would have been devastated.

Designers need to stand up for what they feel is correct in the design process. After all, the client has hired the designer as the expert on how to best accomplish the desired result. Still, after all possible avenues of client education have been exhausted, it is at times necessary simply to allow the client to screw up royally—just make sure you have her signature.

TO THINE OWN SELF—AND THE CLIENT—BE TRUE

It is a mistake for a designer to be dishonest in any business practices. Being up-front and above-board in all of your business dealings will help you establish a stellar reputation for ethics in the business community.

These days, it is easier than ever to misrepresent the work of others as one's own. The Internet provides unlimited access to an incredible online archive of design work for those unscrupulous enough to "borrow" the published creativity of others. There have been numerous situations where those surfing the net have stumbled across web designs stolen from other, sometimes high profile, sites. In some cases, the exact coding, with references to the original site, have been lifted to create the copycat image. Imitating another's design may be flattery, but claiming another's work as your own is nothing less than theft.

Catherine Morley, of Katz <i> Design Group, offers a humorous but cautionary tale. In rather unusual cir-

cumstances, Morley got caught stealing a design from herself and ended up in an uncomfortable situation.

She explains, "A client requested mock-ups for five party gift bags with the intention of printing 25,000 bags. Three themes were required for each but I decided to round it up to four just to pad the presentation and make myself look good. This was quite effortless because a year ago I had designed a new look for another client incorporating a batik pattern. In a fit of madness, I added this design to a couple of the bags. And yes, to my horror, the batik design was picked for two of the bags."

The designer was panic-stricken by the possible implications of her rash decision to borrow from another client's work. Should she contact the second client and admit that the chosen designs had been developed for another business? Should the original client be made aware of the situation?

After a couple of sleepless nights, the designer called the first client and confessed to the mess she had created. "Luckily they were quite sympathetic and agreed that the second project could proceed without any problems," says Morley, but she learned a lesson from the enormous stress, sleepless nights and panic attacks. Now she is careful to present only original work to all clients.

Finding yourself in the situation of having stolen your own designs is rather funny. However, it could easily turn sobering if either party becomes angry and refuses to cooperate. It just goes to show, that—once again—honesty is always the best policy.

We all screw up. It's simply human nature. Add up the general craziness of the design business, the intense desire to please all clients, the long hours with often unrealistic deadlines and the quirkiness of the average "creative type," and designers are bound to get themselves into some royal messes. However, such situations don't bring about the end of the world and seldom bring a business to its knees. We will survive; we will go on (I think I hear Gloria Gaynor singing in the background). We will make other mistakes in the future, but we will learn from those mistakes.

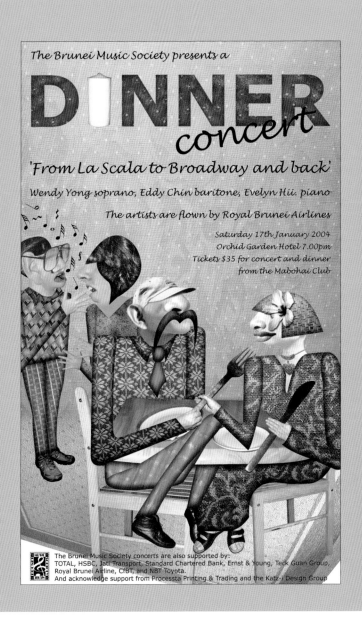

The straightforward approach used these days by Catherine Morley in dealing with clients has resulted in successful projects such as this poster for the Brunei Music Society. The event poster has also been a successful marketing piece for the designer.

CHAPTER 11
WHAT GOES AROUND COMES AROUND

Giving back to the community or taking on social causes can dramatically impact your business. Such work can increase your own visibility in the community in addition to helping organizations focused on the social issues that reflect your personal passions. Designers can't give all their time away, but a minimal investment of knowledge and talent can result in great returns—with long-term interest in your own design efforts.

"Don't just do good design: do some good."

The message of the Design Cares program of the Society of Graphic Designers of Canada

"Design that moves others comes from issues that move you."

Jennifer Morla, Morla Design

"Shut the hell up. What we are doing is something important here."

attributed to Lucianno Benetton in response to critics of Colors magazine and the advertisements shot by Benetton's infamous photographer, Oliviero Toscani

DESIGNS ON THE COMMUNITY?

Is a paycheck the only reason to design? Do designers have a social obligation to actually make a difference in contributing to a cause in which they strongly believe? Should designers groom a social consciousness for themselves and the design industry?

The late Tibor Kalman led the design department for bookseller Barnes & Noble for over a decade. Later, his firm, M&Co, developed an international reputation for its efforts for corporate clients and publications. He may be best known for his work with Benetton, as founding editor of the controversial *Colors*. It was the magazine with a conscience.

Kalman once stated: "As I succeeded, I ran into my own conscience. I had my choice of jobs and choices about which way to work that a lot of designers don't have. Most designers are making a living, a few are winning awards. But there's few who are feeling comfortable enough to think maybe there's a better way. It all comes from privilege. I think that even generosity comes from privilege."

In a 1998 interview with *Adbusters* magazine, Kalman said, "There is no salvation for corporate America if a company's only intention is to manipulate its stock price upwards, or for the principals to make more money. There is nothing in that. That is shit.

What you need is to go in there and create a corporate conscience, to make corporations feel like they ought to spend money on things that make their workers' environments nicer, or make the world nicer, or help people outside their corporation. The only thing you can do is try to trick corporations into doing the nice things."

At times we need to trick ourselves into doing "nice things." Donate project services to a cause you deem worthy. Contribute time to an organization or event that you feel makes a difference. Extend a helping hand to that design student who is as lost as you once were.

For many designers, there comes a moment when that light bulb goes on over their head, and they see the purpose of their work in a new light. Rather than Kalman's "corporate conscience," it may be a moment of "designer conscience"—that split second when a designer figures out what is important in life and the direction his or her work may take.

PRO BONO IS NOT CHASTITY BONO'S YOUNGER BROTHER

It can happen to almost any designer on a daily or weekly basis. When you least expect it, you are asked to produce a project for a nonprofit client—for free! Your response to the request may depend on a variety of issues. Often you will react emotionally with an immediate "out of the goodness of

your heart" positive answer. Pro bono—a shorthand version of the term *pro bono publico* (meaning for the public good)—work can be a great marketing and networking tool for any designer. However, when it comes right down to the nitty-gritty, the decision may be based on the age-old question, "What's in it for me?"

Given that you have the time and desire to assist a nonprofit organization's marketing and promotional efforts, you need to assess the personal value and rewards of doing such work. Do you have a passion for the cause? Do you have the time to devote to making the project a success?

With the large number of requests I received for pro bono work, I realized that I needed to create some personal guidelines about donated time. I now consider donating my services only if the project is related to education, nonprofit performing arts groups, children's causes or issues in which I have a strong personal interest. I also take on only a limited number of pro bono projects in any one calendar year.

Unfortunately, our friends at the Internal Revenue Service don't see a great deal of value in the giving of time, talent or services. The Internal Revenue Service states: "Contributions you cannot deduct at all include the value of your time or services. Although you cannot deduct the value of your time or services, you can deduct the expenses you incur while donating your services to a qualified organization."

Some design firms and ad agencies circumvent this regulation by asserting they are providing a "product" rather than a service. A deduction is then claimed for the value of the "product." However, this may raise a red flag for the IRS, which may decide to conduct a complete audit.

Even so, there are tremendous benefits (in addition to those warm, fuzzy feelings) in donating your services to nonprofit organizations.

A DEDICATION TO SOCIAL
RESPONSIBILITY

Many individual designers, design firms, advertising agencies and school programs spend countless hours and a great deal of money to create highly visual—and often provocative—marketing and promotional materials for organizations promoting social causes. Some go above and beyond the call of duty.

Saatchi & Saatchi, the international communications firm, has produced some of the word's best advertising on social issues. The often controversial public awareness campaigns address child abuse, road safety, sexually transmitted diseases, war, racism, drugs, torture, contraception, censorship and the environment. Much of this work is highlighted in *Social Work: Saatchi and Saatchi's Cause Related Ideas*, a great resource for any civic-minded

creative. The firm's dedication to social issues has brought international attention to both the causes and the firm creating the campaigns.

The firm Design for Social Impact may not be as well-known, but its focus on nonprofit causes is no less passionate. Ennis Carter founded Design for Social Impact in 1996 after working for many years in the nonprofit sector.

"After college, I spent ten years working for a nonprofit environmental organization as an organizer, campaign manager and administrator," says Carter. "When you work for a nonprofit organization, resources are tight, so you end up doing most of the work yourself. I had to create my own materials and get them produced myself. As my expertise grew, I started designing materials for other programs within the same nonprofit group—and onto a national level."

"At that time, other nonprofit groups started calling to find out who was doing the design work. It became clear to me that there was a real need in the public interest, nonprofit community for good design, that was affordable and also appropriate to the needs of nonprofits."

"So, I decided to set up Design for Social Impact to serve that need. I am in business as a mechanism for wanting to provide a service to a community that I think needs it," Carter adds. "The drive to have a business didn't come first, but provides a stable base for me and my staff to continue doing the work we do and to expand as much as possible."

Design for Social Impact serves nonprofit and community-based organizations exclusively. All work is fee-for-service, with a sliding scale to accommodate the budgets of various groups. Each project is custom-planned and custom-priced. The firm does have a few for-profit clients: locally owned businesses dedicated to conducting business in a way that is socially responsible and serves a public need.

"Every project we work on makes us part of a team on the issue or campaign," explains Carter. "I truly believe that the work we do to help tell the stories of our clients—the people trying to find a cure for AIDS; the people who find a host house for a person who has to travel for emergency medical procedures; the people protecting clean air standards—helps them succeed by reaching out to the public. So, we have a great sense of accomplishment as our clients reach their goals. Over the last seven years, Design for Social Impact has grown to a large family of people dedicated to making this world a better place. As I say on our website, 'The work we do *has* made a difference in the work of our clients. I know that to be true. I also am satisfied knowing that every day we strive for a fair and just society in the best way we know how—

through beauty, story and service to the community.'"

PureVisual of Cambridge, Massachusetts, is another firm that focuses its energy and efforts on nonprofits. Its mission statement reads: "We are dedicated to providing organizations with knowledgeable, affordable, and friendly communications services. Our goal is to raise the design and communications standards in the nonprofit community. Many organizations believe that quality services are out of reach due to high costs and inaccessibility. We can eliminate these obstacles. We combine design, technology, and marketing to help you best communicate with your clients, donors, and volunteers."

The vision of PureVisual founders Donnie Baker and Ed Broach is a noble goal—and exactly the message that nonprofits, unsure of their own design savvy, need to hear when inviting a design firm to assist in marketing and promotional efforts.

"Working with nonprofits started with volunteering" recalls Baker. "During my initial volunteering, I was also working for a for-profit design firm as a designer. The firm had a few pro bono projects but they were not seen as important clients. They were treated as 'favors' and were not given a 100 percent effort. I wanted to found a firm that worked specifically with nonprofits so that we could make the most impact on raising the design standards and knowledge about design within the nonprofit community.

"Although it varies from month to month, on average about 25 percent of PureVisual's business is strictly pro bono. The firm still has a few for-profit clients left over from our early days," Baker continues. "We are always open to working with socially responsible for-profit clients if it feels like a good fit with our mission. We have specifically marketed ourselves to the nonprofit community for the past three years."

TAKING—OR GETTING— CREDIT FOR YOUR EFFORTS

Doing creative work for a local nonprofit organization can be a great way to promote your talents and abilities. These projects can be part of the marketing plan for your own business.

"I find pro bono an excellent way to market my business while giving something back at the same time," says Catherine Morley of Katz <i> Design Group. "Before I took over the designs for the Brunei Music Society, they could fit their audience into a small room at the Sheraton. The organization now requires much larger halls. And, as the posters generally go out ten or eleven months out of the year, that's constant publicity for my company."

When a nonprofit asks you to donate services or produce work using a discounted rate structure, don't be

PROJECT VALUE SHEET

JEFF FISHER
LOGO
MOTIVES

Date: _____ Job Number: _____

Company: _____ Contact: _____

Address: _____

City, State, Zip: _____

Phone: _____ Fax: _____

PROJECT DESCRIPTION:

COSTS:

DESIGN/ILLUSTRATION _____ hrs. @ $ _____/hr. = $ _____

ART DIRECTION _____ hrs. @ $ _____/hr. = $ _____

COPYWRITING _____ hrs. @ $ _____/hr. = $ _____

PRODUCTION _____ hrs. @ $ _____/hr. = $ _____

CONSULTATION _____ hrs. @ $ _____/hr. = $ _____

RESEARCH _____ hrs. @ $ _____/hr. = $ _____

MISC. CLIENT SERVICES _____ hrs. @ $ _____/hr. = $ _____

LABOR SUBTOTAL = $ _____

RC PAPER/FILM/NEG OUTPUT = $ _____

SCANS/CAMERA SERVICES = $ _____

CONVERSIONS/COMPUTER SERVICES = $ _____

MISC. MATERIALS/SHIPPING = $ _____

TOTAL = $ _____

Deposit **– $** _____

Discount(s) **– $** _____

TOTAL = $ _____

Post Office Box 17155
Portland, OR 97217-0155

Phone: 503/ 283-8673
Facsimile: 503/ 283-8995

NOTE: This **IS NOT** an invoice, but rather a documentation of fair market value of work done as a
donation by **JEFF FISHER LOGOMOTIVES**. Thank you.

jeff@jfisherlogomotives.com
www.jfisherlogomotives.com

*The author presents pro bono clients with a Project Value Sheet upon completion of a project to
convey the worth of the effort.*

shy about asking for credit in return for your efforts. This may be a simple credit line on a photograph or graphic; or a byline on an article you have written. It may be in the form of an acknowledgement in the program for an event, or a mention in the group's newsletter. You may receive a verbal thank you from the organization at a public gathering or dinner.

If the nonprofit has a membership directory, newsletter or event program, an appropriate expression of appreciation might be a print ad in the publication. A link from the client's web page to your own can be a very profitable gesture. A complimentary membership or admission to an event is often a welcome gift.

I also suggest having the client sign a contract or project agreement to outline all aspects of the project. Even if the group is not paying for your services, the project should be treated as a "real" job to avoid potential misunderstandings or miscommunication. I also have created a project value sheet to present to pro bono clients upon completion. Basically, this is an invoice-like form showing the value of the time spent on the project at my billable rates for each task involved. Of course, there is no balance due. However, conveying this information to the client has resulted in greater appreciation for my work.

When conducted with professionalism, and respect, the relationship between a writer, photographer, graphic designer or other creative and a nonprofit organization that needs the services of such an individual, can result in a beneficial situation for all parties. The organization can obtain quality creative work that it may not not be able to afford otherwise, and establish a positive relationship with a talented individual. The creative individual can feel good about assisting the nonprofit group with marketing or promotional efforts, in addition to creating a new audience for his or her own work, and generating more business in the process. Hopefully their combined efforts will make a difference in the community as well.

MAKING FRIENDS AND MEETING INFLUENTIAL PEOPLE

One of the major benefits of doing pro bono work is the people with whom you come in contact during the course of the projects. Many of these people may become strong advocates and allies for your business efforts.

The staff of a nonprofit organization is a terrific source of word-of-mouth promotion following a successful project. Over the years, I have developed long-term business relationships with individuals who have moved from one nonprofit to another throughout the course of

their careers. With each move comes the potential for a renewed client relationship.

Most groups have a board of directors, made up of civic-minded business people who may have a need for your services themselves. These same board members also travel in a variety of business and social circles.

Neil Tortorella, of Tortorella Design, explains: "Typically the folks that are on the boards for these groups are local movers and shakers. I've gotten a few projects from pro bono efforts and some nice pieces for show-and-tell. A few have converted from pro bono to paying clients."

Often the donating of services to a client will lead to paid work in the future. It's often the "gravy" for pro bono projects. When contributing my services to any group, I always make them aware of the fact that they will qualify for my nonprofit rates on all future paid projects—20 percent lower than my usual fees.

The return on donated services from a client can take a variety of forms. A local residential care facility for AIDS patients was the beneficiary of my design skills for several years. The development director then took it upon herself to get funding for a monthly stipend to cover my services. Each year the stipend was reviewed—and increased—as the financial situation of the organization improved.

ALWAYS HELP THOSE COMING UP IN THE RANKS

Making a deposit in a karmic "debt bank" doesn't always mean contributing your design services to social causes. On occasion, it simply means donating your time to helping others.

As a young designer trying to break into the ranks of those in the business world, I had an information interview with John Kobasic, a principal in a Portland design firm. As mentioned earlier in this book, he advised me to always be willing to take the time to share my knowledge with those coming up behind me in the design field.

This has become a major way for me to "give back" to the design community over the years. I have taken the time to do so through portfolio reviews for design students, judging industry competitions, answering the literally hundreds of e-mails I get seeking career advice, participating in online design forums and speaking before student groups.

Others also find themselves mentoring design students or contributing to the design community in similar ways.

Neil Tortorella taught a Junior Achievement class at the local high school for a few years. He also assisted a high school career center's design class in developing a logo for a township. "I mentor my butt off," says Tortorella. "I've taught at the local

schools and I've done speaking engagements at a local university. I also get a ton of e-mail from newbie designers needing help. Most of this comes from online forum activity and articles I write. I guess this is one of the responsibilities that comes with age. There really isn't a direct business payback. I do it for personal reasons. Beyond that, mentoring helps to keep me sharp and I learn a lot."

Icon specialist Travis Tom has had similar experiences. "I've spoken once at my alma mater. The only personal gain was the good feeling of helping students in the design program," he says. "When I was in school, I was always trying to absorb as much information from professors and speakers as possible. It's time to give back."

Designer Wendy Constantine finds herself encouraging others in a more casual fashion. "I do regularly encourage designers starting out freelancing, and provide them any feedback or resources I can. I will occasionally venture onto discussion forums and respond to queries. In general, the business return is minimal, but I personally find it rewarding to break out of the isolation of working alone all day and provide a helpful word for someone else."

States Michelle Elwell of Solution-Masters, "It [mentoring] allows me to give back, but with a very flexible time schedule. It's something that is very important to me. There have been occasions where business has come my way from it, but often indirectly—typically from a third party that witnessed replies over a period of time and felt I conducted myself in a manner of someone they'd like to work with."

CREATING COMMUNITY WITHIN THE COMMUNITY

The sense of community many of us seek in our work can be found in many ways. Participation in community or business organizations— whether related to the design industry or not—can result in a big return on a contribution of time and energy. Internet forums can be a source of networking, mentoring and potential new clients. The Internet has brought about interesting designer collaborations benefiting all participants.

The Creative Postcard Club was the brainchild of Travis Tom. Founded in 2000, the club started out as a fun hobby with a few members and has grown into a creative community that spans the globe. The idea was to establish a club in which designers, illustrators, students and creatives alike would send and receive creative postcards to one another.

What started out as a simple, creative networking exercise has turned into a world-wide action of mentoring, inspiration and fellowship for designers in numerous countries— many of whom work alone and have

little physical interaction with others in their field.

A relatively new form of networking is the online forum. For a designer in any type of career position and any geographic location, it is a link to the worldwide graphic design community. Such forums provide an opportunity to share ideas, get almost immediate answers to almost any business-related question, and mentor those in need of encouragement. For design students, the forums are an incredible educational resource. Forum participation can also be a welcome daily break from running a one-person design business. Moreover, it can result in the development of friendships with designers around the world.

"The global aspect helps keep a wider view on what is happening in the world in relation to not only the design industry but business in general," states regular forum visitor Michelle Elwell. "At times we can become too insulated in our own region's economy. Seeing things from a global perspective can open you up to new marketing possibilities."

CONNECTING WITH THE COMMUNITY AT LARGE

Many designers donate time within their communities by serving on the boards of nonprofit organizations. For instance, Windmill Graphics' Rebecca Kilde serves on the boards of her local library and home-school association. "It has a positive impact on my character," according to Kilde.

The danger of serving on organization boards is the amount of time that can be consumed by the organization very quickly. Overextending yourself with a professional organization is also something to be on the watch for when contributing time.

ONLINE FORUMS: THE CYBER WATER COOLERS

An online search will help you find a wide variety of forums for networking with designers worldwide or for simply getting an answer to a design question. The following are some of the most active and resourceful:

HOW Design Forum
www.howdesign.com/forum

About.com Graphic Design Forum
http://graphicdesign.about.com/mpboards.htm

Creative Ireland Forum
www.creativeireland.com/forum/cgi-bin2/Ultimate.cgi

Typofile Forums
www.typophile.com/cgibin/discus.pl?pg=topics

The Designers Network
www.designers-network.com

Designers Talk
www.designerstalk.com/forums

Speak Up
www.underconsideration.com/speakup

www.CreativePostcardClub.com

Round 11 Series of 4 Stamps

Travis Tom, of TNTOM Design, produced a T-shirt to promote the efforts of the online design community and to raise funds for future efforts.

Years ago, I was on the founding board of a new nonprofit organization. We spent a great deal of time and energy establishing all the guidelines and procedures for the group. In addition, I was responsible for designing the association's identity and all marketing, advertising and promotional items on a volunteer basis.

Many of these responsibilities continued during my two-year term on the board—all while I was trying to run my own business. At the conclusion of my term, I felt as if I had been chewed up and spit out. While I'm still a member of the organization, it's been almost ten years since I have attended a meeting or group event.

Travis Tom sees potential value in the traditional business-organization format: "I am considering joining the chamber of commerce to network and meet other business owners who might need creative services. Networking with other professionals is important for growing a

business—especially for exposure and making new contacts."

Business-organization events are not for everyone. Chamber-of-commerce type events don't do anything for Michelle Elwell. "Perhaps I'm just not the rubber-chicken-lunch type gal. I find these meetings to be stuffy and often attended by non-decision-makers," says Elwell.

"I belonged to the area chamber (of commerce) and our local Rotary club," says Neil Tortorella, who has mixed feelings about such groups. "The chamber was really a business-card orgy, with people trying to sell me this and that. Rotary was pretty good and they did some good projects for the community."

Design or advertising industry associations offer many designers the opportunity to network, reap potential clients and even participate in organization-sponsored nonprofit projects. The American Institute of Graphic Arts (AIGA), Graphic Artists Guild (GAG) and American Advertising Federation are just a few of the major national groups, and all have local chapters scattered throughout the country. Other organizations, such as the University & College Designers Association, focus on a more specialized segment of the design community.

For some, industry groups have great value. California-based Peleg Top suggests that designers "join a professional association like the AIGA and the Graphic Artists Guild. It is through networking that you will be able to grow your business best."

"I make a point to attend AIGA events regularly to keep in touch with my peers, and feel the pulse of the industry," says Wendy Constantine. "It is always encouraging to learn that there is exciting work being done out there, and reassuring that others are feeling the effects of the economy in their business as well."

Others, while realizing the potential benefits of participation, find their time spent better elsewhere, often due to geography or economics.

"I've belonged to both AIGA and the GAG, but neither really did me any good," says to Neil Tortorella. "Neither have local chapters. The closest AIGA is in Cleveland—about fifty miles north. I had trouble getting to the meetings. GAG did offer group health insurance, though. Pricey, but a good policy."

Travis Tom contributes, "I was once a member of AIGA right out of school, but have not been a member lately because of the high fee structure and living two hours away from the Atlanta chapter meetings. I'll join back some day when the time is right."

For almost all designers, particularly those isolated by their status as one-person firms or their geographic locations, getting "out there" in person or online will benefit business in some manner. More importantly, the act of giving back, whether it be

A COLLECTION OF DESIGN ORGANIZATIONS

American Advertising Federation (AAF)
www.aaf.org
aaf@aaf.org
800.999.2231

American Institute of Graphic Arts
(AIGA)
www.aiga.org
comments@aiga.org
212.807.1990

Graphic Artists Guild
www.gag.org
membership@gag.org
212.791.3400

Society for Environmental Graphic
Design
www.segd.org
segd@segd.org
202.638.5555

Society for News Design
www.snd.org
snd@snd.org
401.294.5233

Society of Graphic Designers of Canada
www.gdc.net
info@gdc.net
877.496.4453

Society of Illustrators
www.societyillustrators.org
si1901@aol.com
212.838.2560

Society of Publication Designers
www.spd.org
mail@spd.org
212.983.8585

The Society of Typographic Aficionados
www.typesociety.org
info@typesociety.org
541.922.1123

Type Directors Club
www.tdc.org
director@tdc.org
212.633.8943

University & College Designers
Association
www.ucda.com
info@ucda.com
615.459.4559

with donated work, mentoring others, contributing time or simply participating in some activity outside normal boundaries, will be of tremendous benefit personally and professionally.

CONCLUSION

GROWING PAINS OR
GROWING UP?

After twenty-five years as a professional designer, I still love what I do for a living. Yes, I can bitch and moan with the best of them about laughable budgets, client problems or problem clients, and those pesky deadlines. But I always try to keep my ultimate goals in sight. If you don't speak—or write down—your goals, dreams and desires, you will not be developing a plan to make the future you want a reality.

In the process of putting this book together, I had the opportunity to interact with a wide variety of design industry professionals. All were incredibly interesting and very talented individuals. Some whom I considered icons in graphic design were very gracious in answering my requests for input for the book. I was very curious if these individuals had become what they wanted to be when they "grew up."

I think the answer I enjoyed the most came from Jack Anderson of Hornall Anderson Design Works. Anderson took the time to meet with me in his Seattle office. When I asked if he had become what he had always wanted to be, he very quickly responded, "I haven't grown up."

"I don't want to grow up," he adds. "If you don't acknowledge lessons learned in life, you're just stupid. Innocence and spontaneity should be treasured. Don't take yourself too seriously. I'm most proud of my friendships and relationships. My life is balanced by successfully juggling three things: profession, home and 'Jack.' To be OK with yourself allows you to ultimately bring more to all aspects of your life."

"I am who—and what—I wanted to be when I grew up," replies David Lemley of Lemley Design Company. "It is a major blessing in life to be allowed to pursue the desires of your heart. And life is a wonderful gift when the universe acknowledges your efforts—and society allows one to make a living at it."

Sheree Clark of Sayles Graphic Design says, "I knew I never wanted to be an entrepreneur. My parents owned a business—it was a bus company—and I saw how hard they worked and all the anguish they went through. I swore I would never do that to myself.

"But, once I arrived in the corporate world, I saw the bureaucracy, the inefficiencies and the 'ladder' I'd have to climb to get to a point where I had the autonomy I knew I wanted," she continues. "I wanted the 'buck' to stop with me. So, I've arrived at the place where I wanted to be...I just didn't know what it would look like when I was a twentysomething."

California designer Petrula Vrontikis feels she has become the person she

wanted to be while in high school—with lots of help along the way from teachers who made sure she was in the right place at the right time.

A sense of humor seems to play a major role in the success of many of the designers contributing to this book—and to their chosen profession.

"When I was seven, I was an altar boy and I wanted to become a priest," says New York's Stefan Sagmeister. When I was fifteen, I was in a bad band and I wanted to design album covers. By the time I got around to actually doing it, I was thirty; they had shrunk and came in a brittle plastic box. But still..."

Peleg Top's childhood desires to be involved in the music industry have also become a reality. "I always wanted to work in the music industry and I am living my dream," says Top. "I cannot tell you how great it feels to walk into a record store and see my work on display there."

"I originally wanted to study anthropology and archaeology," Art Chantry of St. Louis responds. "After the twisted path I've followed, I feel I've reached my goal."

Connecticut-based Nigel Holmes recognizes that he has become what he wanted to be, "but I'm never completely happy with anything I've done—there's always something that would make any job better."

When I asked Clement Mok if he felt he had become what he wanted to be when he grew up, he simply said, "Yes."

In my own case, the dreams of that high school art student who used to spend hours in the Salem Public Library leafing through design books have been far exceeded by the realities I have experienced. I have actually become what I wanted to be when I grew up—and I didn't necessarily have to "grow up" in the process.

WHACK!

In *A Whack on the Side of the Head!: How you can be more creative*, Roger von Oech writes, "We all need an occasional 'whack on the side of the head' to shake us out of our routine patterns, to force us to re-think our problems and to stimulate us to as the questions that may lead to other right answers."

It is my hope that this book—and the advice, anecdotes and experiences of the nearly one hundred design industry professionals who contributed—will be the "whack on the side of the head" needed to spur many designers onto the right track, whether they be students dreaming of a future career, newbies trying to find their way in a somewhat overwhelming graphics field, or designosaurs wallowing in a seemingly inescapable tar pit-like rut. Best wishes for a killer career.

BIBLIOGRAPHY & RESOURCES

CHAPTER 1:

Arden, Paul. It's Not How Good You Are, It's How Good You Want to Be. *Phaidon Press, 2003.*

CHAPTER 2:

Faimon, Peg. Design Alliance: Uniting Print + Web Design to Create a Total Brand Presence. *HOW Design Books, 2003.*

Glaser, Milton. Art Is Work: Graphic Design, Interiors, Objects, and Illustrations. *Overlook Press, 2000.*

HOW Design Conference
www.howconference.com

International Association of Business Communicators
www.iabc.com

Mind Your Own Business Conference
www.myobconference.com

Peter Miller Books
Seattle, Washington USA
www.petermillerbooks.com

Powell's City of Books
Portland, Oregon USA
www.powells.com

CHAPTER 3:

Lasky, Julie. Some People Can't Surf. *Chronicle Books, 2001.*

Shapiro, Ellen. The Graphic Designer's Guide to Clients: How to Make Clients Happy and do Great Work. *Allworth Press, 2003.*

Vrontikis, Petrula. inspiration=ideas: A Creativity Sourcebook. *Rockport Publishers, 2002.*

CHAPTER 4:

Kidd, Chip. The Cheese Monkeys: A Novel in Two Semesters. *New York: Scribner, 2001.*

Lyman, Rick. "Going Hunting in Seinfeld Country," New York Times *(September 15, 2002).*

CHAPTER 5:

Carter, David E. Blue is Hot, Red is Cool. *HBI, 2001.*

Gordijk, Nigel. "Working Remotely," *www.creativelatitude.com, posted 2002.*

Ulrich, Bettina. "Email Nightmare," *www.novumnet.de, posted 2004.*

CHAPTER 6:

Acito, Marc. "On the Right Track." Just Out. *2000.*

Cole, Kenneth. Footnotes: What You Stand For Is More Important Than What You Stand In. *Simon & Schuster, 2003.*

Foote, Cameron S. The Business Side of Creativity: The Complete Guide for Running a Graphic Design or Communications Business. *W.W. Norton and Company, 2002.*

Howard Bear, Jacci. About.com Desktop Publishing Forum. *desktoppub.about.com/, posted 2003.*

Karpowicz, Debbi J., Nancy Michaels. Off-The-Wall Marketing Ideas. *Adams Media Corporation, 2000.*

Pigtail Pundits. Mumbai, India. *www.pigtailpundits.com, posted 2003.*

CHAPTER 7:

Crawford, Tad and Eva Doman Bruck. Business and Legal Forms for Graphic Designers. *New York: Allworth Press, 2003.*

Dudnick-Ptasznik, Julia. "The practice: What's wrong with spec work?" Design Exchange *(Fall 2000).*

Graphic Artists Guild Handbook of Pricing & Ethical Guidelines, 10th Edition, *North Light Books, 2001.*

Tortorella, Neil. "How do you rate?" . *http://graphicdesign.about.com, posted 2002.*

Williams,Theo Stephan. The Graphic Designer's Guide to Pricing, Estimating & Budgeting. *New York: Allworth Press, 2001.*

CHAPTER 8:

Chambers of Commerce
www.uschamber.com

Creative Business
http://www.creativebusiness.com

Formichelli, Linda. "Are Your Prospects Worthy," www.1099.com, posted June 2000.

Gold, Ed. The Business of Graphic Design. New York: Watson-Guptill Publications, 1995.

Shapiro, Ellen. The Graphic Designer's Guide to Clients. Allworth Press, 2003.

Small Business Administration
www.sba.gov

Small Business Development Centers
http://www.sba.gov/sbdc/

Williams, Theo Stephan. The Streetwise Guide to Freelance Design and Illustration. Writer's Digest Books, 1998.

CHAPTER 9:

Benun, Ilise, "Can't Miss Marketing," HOW Magazine (August 2003).

Benun, Ilise, "eSelf-Promotion," HOW Magazine. (October 2001).

Business Journals
www.bizjournals.com

Cox, Mary, editor. 2004 Artist's and Graphic Designer's Market. Writer's Digest Books, 2003.

Karpowicz, Debbi J., Nancy Michaels. Off-The-Wall Marketing Ideas. Adams Media Corporation, 2000.

Klaus, Peggy. Brag!: The Art of Tooting Your Own Horns Without Blowing It. Warner Books, 2003.

Litt, Judy, "Websites for Print Designers," http://graphicdesign.about.com, posted April 2000.

PRWeb
www.prweb.com

CHAPTER 10:

Norman, Donald. The Design of Everyday Things. New York: Basic Books, 2002.

CHAPTER 11:

Casey, Allan. "First Things First: An Interview with Tibor Kalman," Adbusters (Autumn 1998).

Colors Magazine
www.colorsmagazine.com

Internal Revenue Service. Publication 526 (rev. December 2003). Charitable Contributions.

Internal Revenue Service. Topic 506 – contributions. http://www.irs.gov.

Junior Achievement
www.ja.org
www.jrcan.org
www.jaintl.org

CONCLUSION:

von Oech, Roger. A Whack on the Side of the Head! How you can be more creative. Warner Books, 1998.

CONTRIBUTORS

John D. Aikman
Graphic Arts Department
Linn-Benton Community College
Albany, Oregon USA
www.lbcc.cc.or.us

Jack Anderson
Hornall Anderson Design Works
Seattle, Washington USA
www.hadw.com

Larry Asher/Linda Hunt
School of Visual Concepts
Seattle, Washington USA
www.svcseattle.com

Habib Bajrami
Bytehaus Studio
Mississauga, Ontario, Canada
www.bytehaus-studio.com
www.creativelatitude.com

Donnie Baker
PureVisual
Cambridge, Massachussets USA
www.purevisual.com

Austin Baskett
American Crew
Denver, Colorado USA
www.americancrew.com

Jacci Howard Bear
About.com Desktop Publishing Forum
http://desktoppub.about.com

Travis Bellinghausen
mindart
Omaha, Nebraska, USA
www.mindartdesignlab.com

Ilise Benun
The Art of Self-Promotion
Hoboken, New Jersey, USA
www.artofselfpromotion.com
www.selfpromotiononline.com

Tadson Bussey
University & College Designers Association
(UCDA)

Smyrna, Tennessee, USA
www.ucda.com

Bill Cahan
Bill Cahan & Associates
San Francisco, California, USA
www.cahanassociates.com

David E. Carter
Ashland, Kentucky, USA
www.logobooks.com
www.americancorporateid.com
www.global-ci.com

Ennis Carter
Design for Social Impact
Philadelphia, Pennsylvania, USA
www.designforsocialimpact.org

Art Chantry
Art Chantry Design Company
St. Louis, Missouri, USA
www.artchantry.com

Beth Cherry
The Study of Design
Charlotte, North Carolina, USA
www.thestudyofdesign.com

Sheree Clark
Sayles Graphic Design
Des Moines, Iowa, USA
www.saylesdesign.com

Wendy Constantine
W.C. Design Studio
Somerville, Massachusetts, USA
www.wcdesignstudio.com

Juliet D'Ambrosio
Iconologic Brand Design
Atlanta, Georgia, USA
www.iconologic.com

Gary Dickson
Epidemic Design
North Bend, Washington, USA
www.epidemicdesign.com

Maya Draisin
International Academy of Digital Arts and
Sciences/The Webby Awards
San Francisco, California, USA
www.webbyawards.com
www.iadas.net

Julia Dudnik-Ptasznik
Suazion
Staten Island, New York, USA
www.suazion.com

Keely Edwards
Carter BloodCare
Public Relations Department
Bedford, Texas, USA

Michelle Elwell
SolutionMasters, Inc.
Matthews, North Carolina, USA
www.solutionmasters.com

Andy Epstein
Gund, Inc.
Edison, New Jersey, USA
www.gund.com

Peg Faimon
Miami University
Oxford, Ohio, USA
www.fna.muohio.edu/artweb

Jeff Fisher
Jeff Fisher LogoMotives
Portland, Oregon, USA
www.jfisherlogomotives.com
www.savvydesigner.com

Sue Fisher
TriAd
Bend, Oregon & Benicia, California, USA
www.triad-agency.com

Steve Fleshman
DR$_2$
Falls Church, Virginia, USA
www.dr-2.com

Linda Formichelli
Blackstone, Massachusets, USA
www.twowriters.net

Tim Frame
Tim Frame Design
Cedarville, Ohio, USA
www.timframe.com

Christopher Gee
Cube Interactive, LLC
Kew Gardens, New York, USA/Munich, Germany
www.cube-interactive.net
www.creativelatitude.com

Dave Gink
Shadowland Studios
Milwaukee, Wisconsin, USA
www.shadowlandstudios.com

Milton Glaser
Milton Glaser, Inc.
New York, New York, USA
www.miltonglaser.com

Von R. Glitschka
Glitschka Studios
Salem, Oregon, USA
www.vonglitschka.com

Genevieve Gorder
double-g
New York, New York, USA

Nigel Gordijk
Common Sense Design
Brighton, UK
www.nigelgordijk.co.uk
www.creativelatitude.com

Elise Gravel
Elise Gravel, Illustrator
Montreal, Quebec, Canada
www.elisegravel.com

Chuck Green
Glen Allen, Virginia, USA
www.jumpola.com
www.ideabook.com

Bruce Heavin
Lynda.com
Ojai, California, USA
www.lynda.com
www.stmk.com

Karen Heil
spOt creative
Annapolis, Maryland, USA
www.spotcreative.net

Steven Heller
School of Visual Arts
New York, New York, USA
http://design.schoolofvisualarts.edu

Charles Hinshaw
[r]evolve
Direction + Repertoire
Indianapolis, Indiana, USA
www.everydayrevolution.com/

David Hollenbeck
Ohmeda Medical
Laurel, Maryland, USA
www.ohmedamedical.com

Nigel Holmes
Explanation Graphics
Westport, Connecticut, USA
www.nigelholmes.com

Amy Johnson
Lift Communications
Portland, Oregon, USA
www.liftcommunciations.com

Debbi Karpowicz Kickham
Westwood, Massachusetts, USA
www.myfauxchateau.com

Rebecca Kilde
Windmill Graphics
Glenwood City, Wisconsin, USA

Bob Kilpatrick
Ben & Jerry's
South Burlington, Vermont, USA
www.benjerry.com

Cindy King
King Design Group
Rosemont, Pennsylvania, USA
www.designisking.com

Judy Kirpich
Grafik
Alexandria, Virginia, USA
www.grafik.com

Peggy Klaus
Klaus & Associates
Oakland, California USA
www.klausact.com

Karen Larson
Larson Mirek Design
Lathrup Village, Michigan, USA
www.lmstudio.com, www.palmart.us

David Lemley
Lemley Design
Seattle, Washington, USA
www.lemleydesign.com

Judy Litt
QuaLitty Design
Austin, Texas, USA
www.qualitty.com/

Jocelyn Luciano
The Summit Creative Awards
Portland, Oregon, USA
www.summitawards.com

Brandon Luhring
Luhring Design
Evansville, Indiana, USA
www.luhring-design.com

Morgan Mann
1 Design Source
Littleton, Colorado, USA
www.1designsource.com

John McWade
Before & After Magazine
Roseville, California, USA
www.bamagazine.com

Christian Messer
Whiplash Design
Portland, Oregon, USA
www.whiplashdesign.com

Nancy Michaels
Impression Impact
Lexington, Massachusets, USA
www.impressionimpact.com

Kathy Middleton
Opolis Design
Portland, Oregon, USA
www.opolisdesign.com

Clement Mok
The Office of Clement Mok
San Francisco, California, USA
www.clementmok.com

Bryn Mooth, Editor
HOW Magazine
Cincinnati, Ohio, USA
www.howdesign.com

Jennifer Morla
Morla Design, Inc.
San Francisco, California, USA
www.morladesign.com

Catherine Morley
Katz <i> Design Group
United Kingdom & Brunei
www. katzidesign.com
www.creativelatitude.com

Elizebeth Murphy
Emspace Design Group
Omaha, Nebraska, USA
www.emspacegroup.com

Anita L. Parks
Graphic Design Instructor
Metro Technology Centers
Oklahoma City, Oklahoma, USA
www.metrotech.org

Sara Perrin
Director of Marketing
Dark Horse Comics
Portland, Oregon, USA
www.darkhorse.com

Martha Retallick
"The Passionate Postcarder"
Postcard Marketing Secrets
Tucson, Arizona, USA
www.PostcardMarketingSecrets.com

Stefan Sagmeister
Sagmeister Inc.
New York, New York, USA
www.sagmeister.com

John Sayles
Sayles Graphic Design
Partner & Art Director
Des Moines, Iowa, USA
www.saylesdesign.com

Ellen Shapiro
Shapiro Design Associates Inc.
Irvington, New York, USA
www.visualanguage.net

Amy R. Silberberg
Elvis Presley Enterprises, Inc.
Memphis, Tennessee, USA
www.elvis.com

Amy Stewart
Stewart Design
Richardson, Texas, USA
www.stewartdesign.com

Ann Strong
Life/Work Resources
Wheat Ridge, Colorado, USA
www.annstrong.com

Valarie Martin Stuart
Wavebrain Creative Communications
Dallas, Texas, USA
www.wavebrain.com

Ranajit Tendolkar
Creative Zealot
Pigtail Pundits Web Solutions Pvt. Ltd.
Mumbai, India
wwwpigtailpundits.com

Travis N. Tom
TNTOM Design
Augusta, Georgia, USA
www.tntomdesign.com
www.creativepostcardclub.com

Peleg Top
Top Design
Los Angeles, California, USA
www.topdesign.com

Neil Tortorella
Tortorella Design
North Canton, Ohio, USA
www.tortorelladesign.com
www.creativelatitude.com

Tracey Turner
The Creative Group
Menlo Park, California, USA
www.creativegroup.com

Bettina Ulrich
novum
Munich, Germany
www.novumnet.de

Joe VanDerBos
Joe VanDerBos Illustration
Guerneville, California, USA
www.joevanderbos.com

Petrula Vrontikis
Vrontikis Design Office
Los Angeles, California, USA
www.35k.com

Lynda Weinman
lynda.com
Ojai, California, USA
www.lynda.com

Theo Stephan Williams
Global Gardens Gifts
Los Alamos, California, USA
www.globalgardensgifts.com

Mark E. Wilson
Mark of Design
Houston, Texas, USA

John Wingard
John Wingard Design
Honolulu, Hawaii, USA
www.johnwingarddesign.com

Les Woods
progressive edge
Aintree, Liverpool, UK
www.progressive-edge.co.uk

Ben Woodward
Perpetua Interactive
Raleigh, North Carolina, USA
www.perpetuainteractive.com

Jeremy C. Wright
studio:coco
Etobicoke, Ontario, Canada
www.studiococo.com

THE BEST IN GRAPHIC DESIGN
INSPIRATION IS FROM HOW DESIGN BOOKS!

Turn an impossible deadline into a realistic schedule. Identify problem areas before you start working. Master software and production techniques that save time and money. Produce good design on even the tightest budget. Pat Matson Knapp shows you how to do all this and more to beat project constraints and create head-turning designs every time with *Designers In Handcuffs*.

ISBN 1-58180-331-1, hardcover, 192 pages, #32297-K

Through informative tutorials and illuminating exercises, Bryan Peterson shows you how to express and anchor your concept with the design elements of line, type, shape, texture, balance, contrast, unity, color and value. In *Design Basics For Creative Results*, 2nd edition, he also provides examples from some of the world's top designers that show these elements in action.

ISBN 1-58180-425-3, hardcover, 144 pages, #32589-K

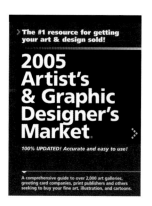

The single most important reference you'll ever own! With the *2005 Artist's & Graphic Designer's Market*, you'll learn how to build a successful career by selling, publishing, and licensing your work more often, for more money. Inside you'll find more than 2,000 completely updated market listing and industry contacts, including such hard-to-find information as art director names, guidelines for getting in touch, type of work desired, pay rates, product specialties and more. Nine comprehensive sections cover every possible opportunity, including greeting cards & gifts, magazines, posters & prints, book publishers, galleries, advertising & design markets and more!

ISBN 1-58297-278-8, paperback, 688 pages, #10925-K

The Logo, Font and Lettering Bible provides modern, up-to-date information that puts the power of logo and type creation in your hands. Learn to develop a discerning eye for quality lettering and logo design, create innovative logo design traditionally and on the computer, design custom-made fonts and build a profitable business with logo design work

ISBN 1-58180-436-9, hardcover, 240 pages, #32633-K

Designing Websites for Every Audience has more than 50 examples of well-known web sites to illustrate good and bad design and functionality, outlining clear guidelines for meeting the end user's needs. You'll also find chapters on developing effective site maps and other crucial navigational elements, as well as advice for designing with video, animation, audio and interactive technologies.

ISBN 1-58180-301-X, paperback, 144 pages, #32237-K

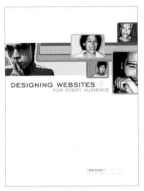

Graphically Speaking breaks down designer-client dialogue into something both parties can understand. It details 31 buzzwords (such as "innovative" or "kinetic") related to the most-requested design styles. Each entry is defined both literally and graphically with designer commentary and visual reference materials, ensuring clear designer-client communication every time!

ISBN 1-58180-291-9, hardcover, 240 pages, #32168-K

THESE BOOKS AND OTHER FINE HOW DESIGN TITLES ARE AVAILABLE FROM YOUR LOCAL BOOKSTORE, ONLINE SUPPLIER, OR BY CALLING 1-800-448-0915.